The Art and Craft of
LEATHER

Maria Teresa Lladó i Riba
Eva Pascual i Miró

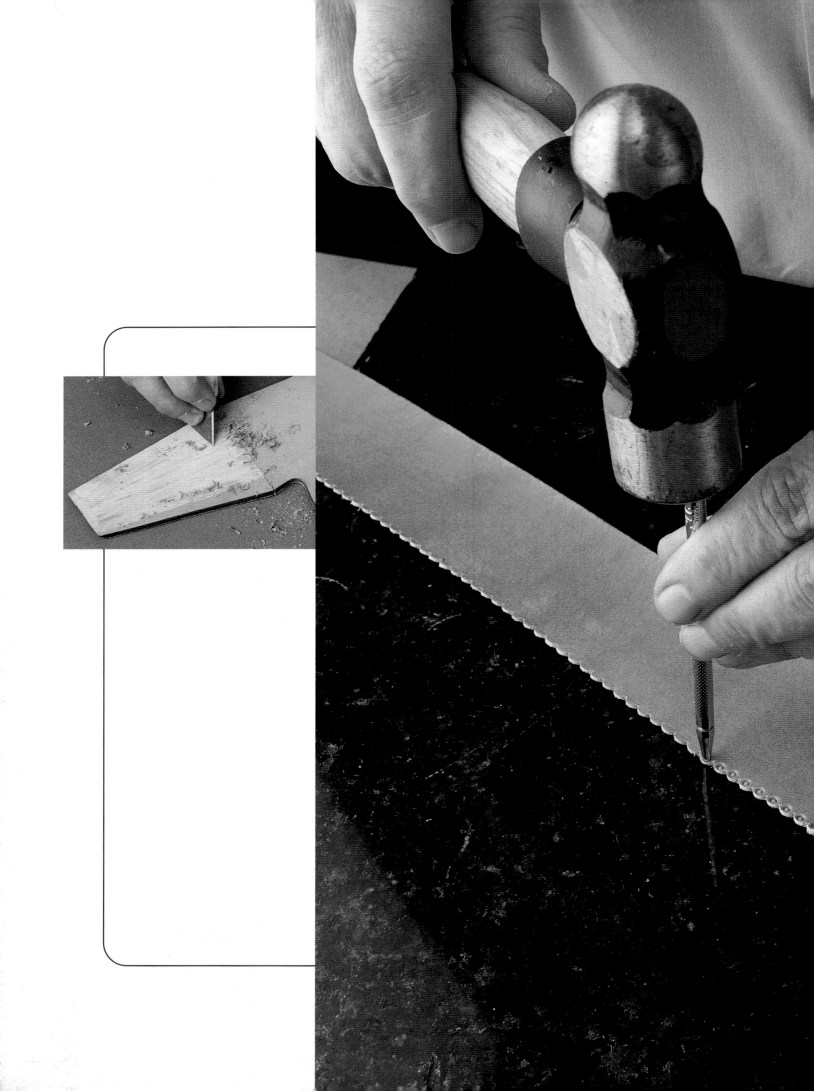

The Art and Craft of
LEATHER

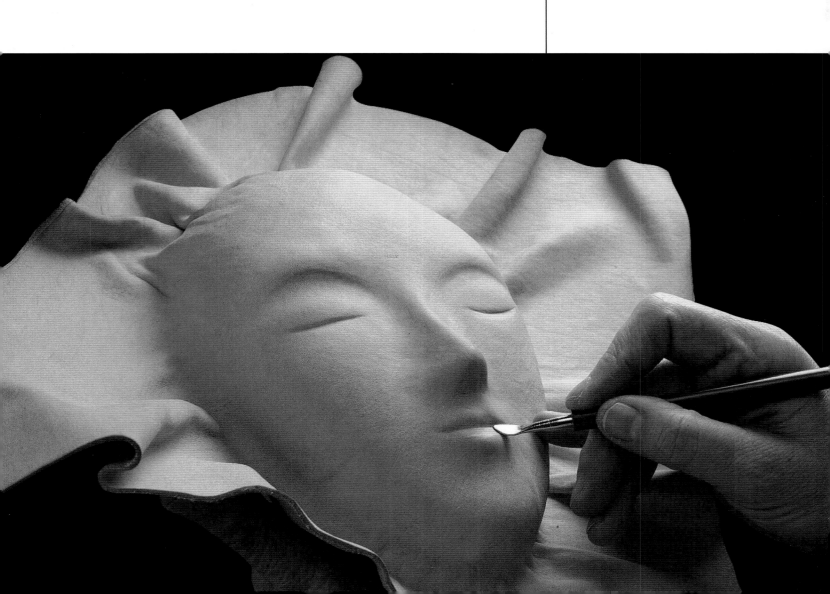

The Art and Craft of Leather

Project and realization by
Parramón Ediciones, S.A.

Editor in Chief:
María Fernanda Canal

Editor:
Tomàs Ubach

Assistant Editor and Picture Archives:
Mª Carmen Ramos

Texts:
Eva Pascual i Miró in collaboration with Félix de la Fuente and Anna Soler in "El arte en la piel" (Art in Leather), and Felipe Combalia and Jaume Soler in "El curtido" (Hides).

Exercises by:
Maria Teresa Lladó i Riba in collaboration with José Luis Bazán, and Artenazari in "Bandeja con mosaico" (Tray with Mosaic) and "Vacia-bolsillos" (Coin Tray).

Collection Design:
Josep Guasch

Photography:
Nos & Soto, Museu de l'Art de la Pell, de Vic (History), Felip Combalia (Hides) and Sergi Oriola (page 21).

Infographic Drawings:
Jaume Farrés

Layout:
Estudi Guasch, S.L.

Production Director:
Rafael Marfil

Production:
Manel Sánchez

Original title of Spanish book: *El Cuero*
© Copyright Parramon Ediciones, S.A., 2006-World Rights
Published by Parramon Ediciones, S.A., Barcelona, Spain

Translation: Michael Brunelle and Beatriz Cortabarria

English edition © copyright 2008 by Barron's Educational Series, Inc.

All inquiries should be addressed to:
Barron's Educational Series, Inc.
250 Wireless Boulevard
Hauppauge, New York 11788
www.barronseduc.com

ISBN-13: 978-0-7641-6081-3
ISBN-10: 0-7641-6081-8

Library of Congress Control Number:
2006940626

Printed in China
9 8 7 6 5 4 3 2 1

Con

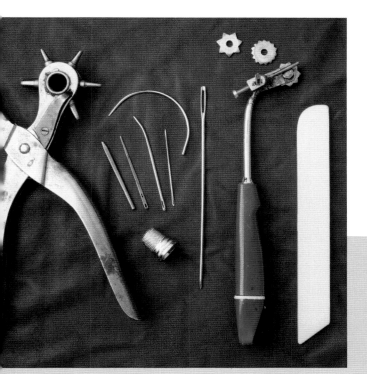

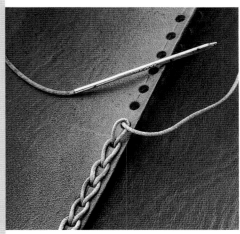

ents

Introduction

Animal hides have been used by humans since the dawn of time, even before fabric. The use of hides created the need for adapting them, turning a perishable material into a durable one, possibly one of the first transformation processes of material carried out by humankind. But beyond their original use, which obviously had practical purposes, a sense of prestige and class has been attached to leather, together with the esthetic features inherent in this material, a feeling that has survived to this day. However, nowadays, there is great controversy involving the industry and manufacture of leather with respect to the kind of donor animals used as well as the tanning processes involved. Therefore, out of respect for the preservation of nature, this book will only deal with hides from animals used as a source of food, and will exclude other animals outside of this category and those raised in captivity for their hides. The book pertains mainly to works on hides and, for the most part, on vegetable-tanned hides. The latter, in addition to being a more environmentally friendly process than others, is the most suitable for working in the studio, and is friendlier to humans as well.

This book offers detailed information on the history of the use of leather as an art form and on tanning processes, as well as the main techniques for working with leather. These are explained simply and clearly, but accurately nonetheless. The book also presents detailed information on the technical processes as a way to ease comprehension. Where appropriate, old-fashioned methods and tools are presented, with the intent to preserve tradition; otherwise, more contemporary techniques are offered for practicality.

The book is divided into four large chapters. In the first chapter, we present a brief history of leather as an art form and of the tanning of hides, offering an interesting overview of these subjects. The following chapter deals with materials and tools. The main types of hides are introduced, paying attention to the tanning process, the characteristics used for their identification and their properties, as well as the possibilities presented in terms of working techniques. Then, the various materials and tools used with the different techniques are shown, grouped together according to use. In the third chapter, the processes of the main techniques for working hides are explained in detail, and examples are offered as references. We do not attempt to cover all the techniques available due to the limitations of this book, but will present only the basic ones. Finally, the step-by-step chapter includes eight projects where the complete creation process is explained in great detail. These exercises, presented for their artistic value, do not deal with fashion and leather accessories, but focus directly on artistic creation. The idea here is to offer a new approach for working with leather. Many such approaches are reflected in the examples from various artists whose work illustrates the chapter on techniques, and in the interesting gallery of work by artists from all over the world. A glossary with definitions of the main concepts, and a complete bibliography can also be used as references for those who wish to explore the subject in depth.

This book does not intend to be a manual of the basic techniques for working with leather, but to offer a concise and clear view of a field that requires constant research. We challenge the reader to get started in this exciting field, to explore and experience it, and to create unique works of art based on an individual approach.

Maria Teresa Lladó i Riba is a multifaceted artist who has chosen leather as a vehicle for expression. Following a family tradition she entered the world of leather and hides. She worked in different art disciplines and later completed studies in the art of leather design at the Taller d'Art d'Igualada, secció d'Art del Centre d'Estudis d'Igualada. Her approach is based on a constant search for different ways of expression using leather and hides, and she has developed a large body of work. She teaches beginning courses in leather working for the general public, and also gives seminars on specialized techniques for artists. She has had solo shows of her works in temporary exhibits in museums and public art centers as well as in private galleries. She has been a guest on several television programs showing viewers how to work with leather step by step. Presently, her production concentrates on custom orders, and she has created many works for public institutions in Catalonia (Spain), as well as for private clients. Her work can be found in many private collections in Spain, Portugal, Germany, France, Switzerland, Japan, the United States of America, and Argentina, among others.

Eva Pascal i Miró has a degree in Art History from the University of Barcelona. She completed Museum, Design, and Restoration Studies at the Polytechnic University of Catalonia and has also specialized in Preventive Conservation at the Autonomous University of Catalonia. She completed studies in marketing and management of cultural institutions. Following a family tradition, she began her education in the world of antiques, Catalonian furniture in particular and medieval objects in general, subjects on which she based her subsequent research. During her professional career she has worked for several museums and cultural institutions in Catalonia documenting furniture collections and decorative art, and as an exhibits coordinator and director of national artworks. She has also worked in companies offering comprehensive services for cultural institutions, and has written numerous articles about Catalonian medieval furnishings. She has taught courses in history, documentation, and criteria for furniture restoration, and is co-author of *Restoring Wood, Decorating Wood, Restoring Paintings,* and *Stained Glass,* all books belonging to this series.

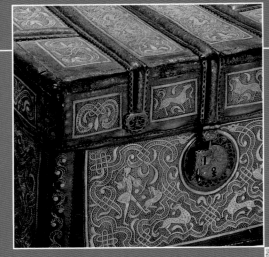

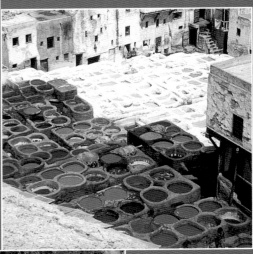

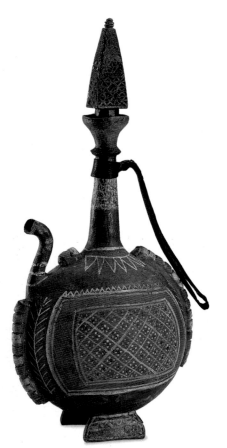

The use of leather has been recorded since the most distant prehistoric times and can be found in cultures and peoples from practically the entire world. Its use has been frequently associated with connotations of nobility and prestige, which makes it more appropriate for the creation of artistic and cultural objects. To cover the study of leather in a universal manner is a task of monumental proportions and extends beyond the scope of this book. The framework of this introduction will be determined by the context of the closest cultures like Western Europe, with special references to the Mediterranean and Latin American worlds, and will touch on a few other cultures that used this material for specific artistic expression. As we know, leather constitutes the outer coat of animals and, therefore, requires a process of transformation to turn it into a lasting material, which generally is tanning. The intrinsic characteristics of the resulting leather are determined by the kind of animal involved and the method used. From the combination of these two factors we will obtain two very different products, which will also determine the type of technique and artistic approach that are appropriate. As far as artistic techniques are concerned, we can say that they are almost limitless and that they have undergone huge variations and adaptations over time. In this book alone, the reader will find a good repertoire of the main techniques, as well as examples of the ones most commonly represented in the collection of the Museu de l'Art de la Pell, of Vic.

Art in Leather and Tanning

The Noble Mission of Leather: The Support

We know that leather always comes from animals. However, the final product varies widely, as do the techniques for working it and using it.

In general, the thick, dense hides of large herbivores are suitable for making shoe soles, containers, durable furniture, as well as implements and even protective gear. On the other hand, small hides are more appropriate for footwear, clothing, accessories, for covering furniture and boxes, and for writing and for artistic creations.

The way that many of the hides and skins are referred to relates directly to the kind of animal they come from and even to its size (cowhide, calfskin, horsehide, goatskin, kidskin, chamois…).

We can also find products that are completely different based on the conservation used: **rawhide**, **vegetable tanning**, and **mineral tanning**.

Parchment is a rawhide used for certain musical instruments, for shadow puppets, and for illuminated manuscripts. But the most common practice in the entire Eurasian region is vegetable tanning from which a wide range of skins and hides for all kinds of uses, from the practical to the most sophisticated, are derived. Depending on the regions, the animal species, and local practices, we could point out some types of vegetable tannage are historically reserved for sumptous objects, such as Spanish **cordovan leather** and **sheepskin**, **Moroccan leather** from the southern part of the Mediterranean region, and **Russian** or **Muscovite leather**. From **mineral tanning** come very fine, velvety, and flexible leathers ideal for clothing: the famous Spanish *baldeses*, **chamois**, **suede**, or the fur skins.

Material and Artistic Applications: Cordovan *Versus* Guadamecí

In literature related to art, and even in specialized books, the concepts of support and applied technique are often confused. However, documented sources leave little room for confusion: **Cordovan** leather was goatskin resulting from the careful curing process (with sumac) and tanning with fat. Therefore, it was relatively small in size, it displayed elasticity, softness, durability, fine texture, and plastic quality, and could be dyed with bright and homogenous colors. Such characteristics made it especially suitable for different artistic techniques such as carving, embossing, gilding, etc. But Cordovan is not an art technique. It was especially sought after for clothing, high-end footwear, bags, hunting bags, belts, and also for covering sumptuous objects: cases, chests, trunks, saddles, sword sheaths, pillows, and books. The name, since the high Middle Ages, is a direct reference to its origins when Cordoba was the capital of the caliphate. In all of Europe, the name Cordovan was equivalent to Spanish leather.

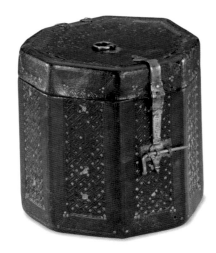

► Octagonal case covered with Cordovan leather and gold appliqués, decorated with strips of interwoven Mudejar. Al-Andalus, 11th–15th centuries.

▼ Trunk covered with Cordovan leather and decorated with carvings and iron reinforcements and lock, richly decorated. Spain, circa 1500.

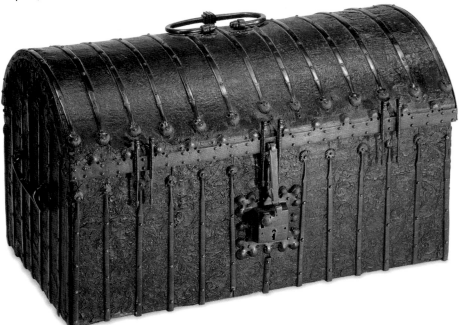

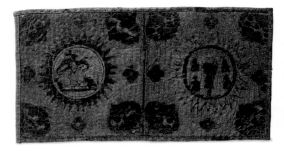

▲ Burse (corporal-case) in embossed leather. It depicts the *Agnus Dei* and the five wounds of the Passion. Spain, 16th century.

Unike Cordovan, **guadamecí** (also *guadamecil* or *guadamacil*) is an art technique that flourished in the Iberian Peninsula between the 15th and 18th centuries and spread throughout Europe, Latin America, and even Japan. We know about the manufacturing process and its use through documents, illustrations, and literary sources.

Originally, this art technique consisted in covering the surface of leather with a fine sheet of metal (gold and silver leaf, etc.) in order to create a stable surface for the application of many colors and various varnishes, as well as **ferreteado** with small gravers. This is the support for the decorative process that leaves the concealed material exposed. Pieces of leather were cut into regular rectangles and gilded, and sewn together to make up the desired surface.

The origin of the term *guadamecí*, which is common in the Peninsular Romance languages, is unknown. In other European languages, the term refers to technique or appearance (French, *cuir doré*; English, *Gilt-leather*, Italian, *corami d'oro*; German, *Goldleder*, Dutch, *Goudleer*), similar to Spanish **oropel**, which simply means gilded, smooth leather without any color added. More recent etymological studies reinforce the Spanish Arab origin of the term **guadamecí** from the root *masra*, which means "to be covered with bouquets," or "to

cover something with bright and blazing colors." It is no surprise that Spanish descriptions from the 16th century refer to *guadamecí* as "vegetable drapery." The adjective *misr* specifies something that has a very colorful dye. Both meanings convey the concept of this art technique and its function.

The oldest preserved objects date back to the 15th century, while the earliest references to the term are found in the 12th and 13th centuries. However, the basis for the *guadamecí*, the gilding of leather, was already known since ancient times, as proven by numerous objects from the Egypt of the Pharaohs, or references in documents and literature from Rome and Byzantium. In the few medieval manuals about techniques and guilds, the technique of gilding leather is also documented albeit briefly, especially in those manuals that contain Roman and Byzantine samples. In fact, several Coptic bindings in leather with gold appliqués are known from the 8th or 9th centuries. Also, beginning in the 10th century, numerous writers flourished in Europe who produced manuscripts on parchment paper. These miniatures are based on similar procedures and on the use of similar materials. Also pieces of clothing with gilded leather are found throughout Western Europe beginning in the 12th century. These include footwear, belts, hunting bags, and caps.

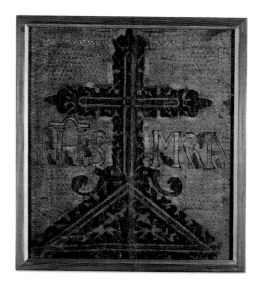

▲ *Guadamecí* piece, polychrome with *ferreteado* work. Representation of a florid Gothic-style cross. Spain, end of the 15th century, beginning of the 16th.

Beginning in the 14th century, references to *guadamecí* that designate sumptuous objects, such as bed and seating pillows, liturgical covers and cases, altar fronts, images for veneration and other such pieces, including luxurious indoor coverings (mural drapery, door and window dusters, curtains, bed spreads, table coverings, canopies, ornamental covers for dais...) begin to appear less frequently in royal Hispanic documents.

At the end of the 15th century, references to master *guadamacileros* and their productions are frequent, and beginning in the first quarter of the 16th century the guilds in many cities begin to regulate rules of the trade, thus making it possible to learn about their technical processes, productions, tools, raw materials and, in some cases, the motifs represented. Also, the main production centers at the time became known (Seville, Granada, Cordoba, Valencia, Ciudad Real, Valladolid, Madrid, and Barcelona), as did the names of several masters. Unfortunately, the shop production was not signed, making authorship virtually unknown, except in a few cases. Patrons placed their commissions with the artisan who, in turn, subcontracted the creative part to a painter.

▼ Fragment of a wall covering of Spanish *guademecí* from the 16th century, with painted motifs and *ferreteado* with a design inspired by a late-Gothic cloth. Spain, 16th century.

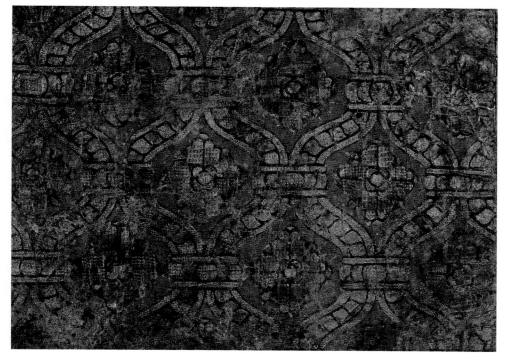

Leather Art in Europe

Guadamecí Wall Coverings

The use of *guadamecí* wall coverings in the decoration of palaces and noble houses was common in the Iberian Peninsula in the 16th and 17th centuries. Artistically, they are characterized by a smooth, flat surface, with profusely *ferreteado* backgrounds. The most frequently represented motifs incorporate Renaissance themes such as pilasters, capitals, arches and grotto columns, although themes in the Mudejar and Gothic traditions continued to be depicted. Their artistry generally mimics the textile designs of the time, reproducing the decorative themes of the luxurious contemporary brocades and damasks.

Leather covered the bare walls and provided insulation against harsh weather, thereby creating comfortable and warm interiors. In this sense, leather became a more affordable substitute for the tapestries embroidered in silk, gold, and silver, imported products that were limited to the aristocratic and merchant elites.

During the first part of the 17th century, a novel production system developed in the Netherlands, and by the middle of the century had spread throughout Europe. It consisted of stamping the gilded leather with a relief using engraved blocks. Afterwards they were painted by hand. This made it possible to produce uniform sections to cover large wall surfaces; as illustrated in some Baroque paintings, even complete rooms have been preserved.

This process led to the demise of Spanish leather-working shops, and in time the process itself gave way to the spread of painted wallpaper late in the 18th century.

In summary, *guadamecí* is one of the specific Spanish contributions to the history of world art, although nowadays it is almost forgotten.

▼ A sample of wall covering made of *guadamecí*. The Netherlands, 18th century.

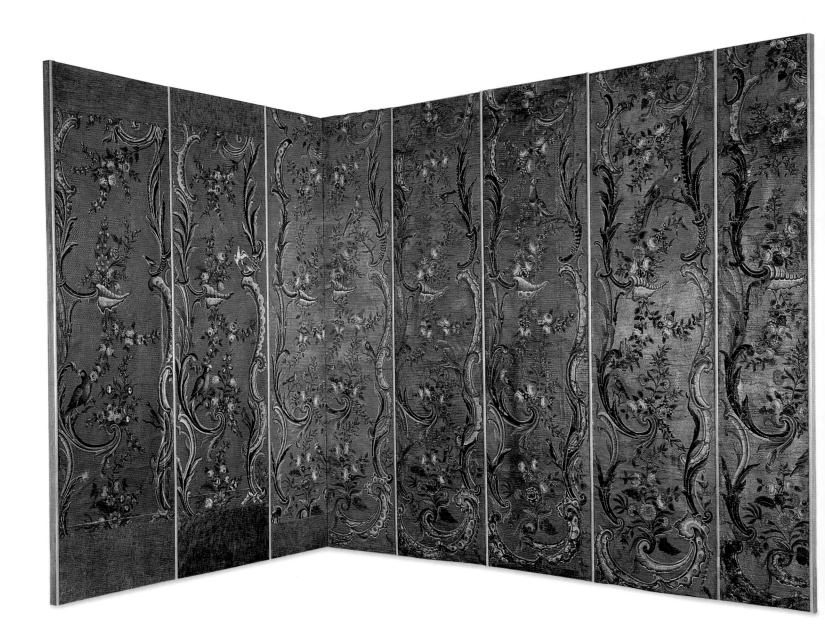

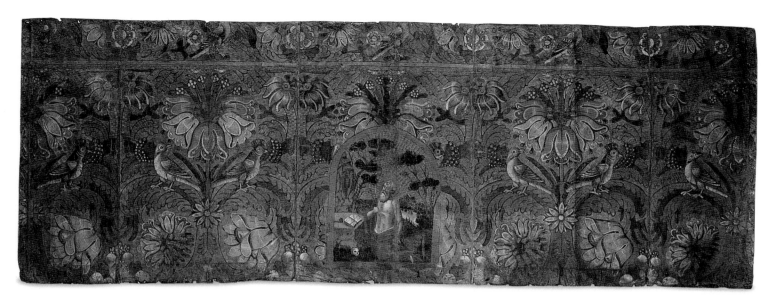

Ecclesiastical Objects in Guadamecí

In the 16th and 17th centuries, it was common to produce ecclesiastical objects with the *guadamecí* technique. These included burses, pillows, tabernacle and altar covers, chasubles, prayer images, and even an occasional altarpiece. Many churches had altar fronts, according to inventories found in church records, since they were relatively affordable. They were made of several pared down leather pieces sewn together (in later eras they were pared down and glued). They followed the same design as the embroidered frontal pieces with the main image located in the center framed by ornamental, geometric, or floral motifs.

The devotional images represent either a single person or a complex scene composition. Of these, we only occasionally know the author, as is the case of the portrait gallery of the cathedral in Valencia, Spain, from the shop of Juan de Juanes. There are a great variety of themes, depending on the church dedications and the chapel for which the pieces were made. In Spain, the Holy Veil and Saint Veronica were deeply venerated, especially towards the end of the 16th and beginning of the 17th centuries. The pieces always followed the same compositional design, with a very repetitive iconography, which only varied in the quality of the final execution. The most frequent motifs in ecclesiastical objects were those related to the Eucharist, such as the *Agnus Dei*, the anagrams of Jesus and Mary, and the symbols of the Passion.

▲ Altar frontispiece with the *guadamecí* technique from the 17th century, with a polychrome representation of Saint Jerome in the center and the floral and bird motifs on the sides.

▼ Prayer image in *guadamecí* with the gilded figure of Veronica, painted on a gilded background and decorated with *ferreteado*. It has a border done in the Mudejar tradition. Spain, 16th century.

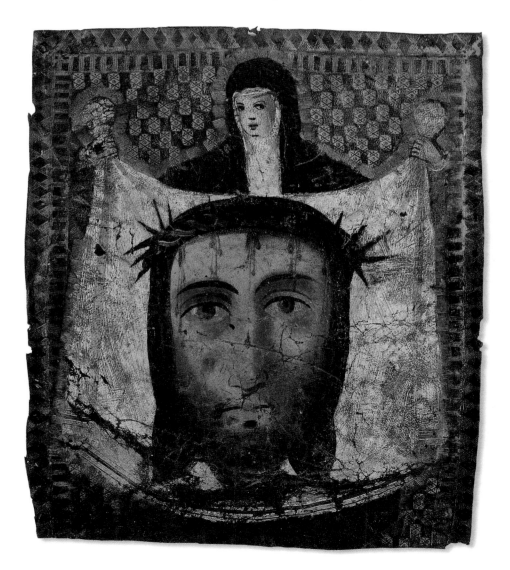

Storage Pieces: Chests, Boxes, and Trunks

Since medieval times storage pieces (chests, boxes, and trunks) were often made of wood and covered with leather. This protected the interior from humidity and insects, and, at the same time, gave the piece prestige and luxury. The leather could either be smooth or decorated with polychrome motifs, stamped, embossed or gilded, or could have tacks and gold, silver, and *ferreteado*, as well as a lock and handles. Boxes and chests were used to store objects of sentimental or intrinsic value, including jewelry and documents. They themselves were already jewels in their own right, transformed into symbols of love and matrimonial commitment. They can also be found as ecclesiastical containers for relics, chalices and the host, crosses, the books of hours, etc.

In the Western world, the production of leather-covered chests reflected three traditions. The first one stemmed from Andalusian heritage and was defined by Mudejar-inspired motifs, with clear influence from the Hispano-Arab ivory boxes and containers characterized by prominent interlocking and arabesque detail work.

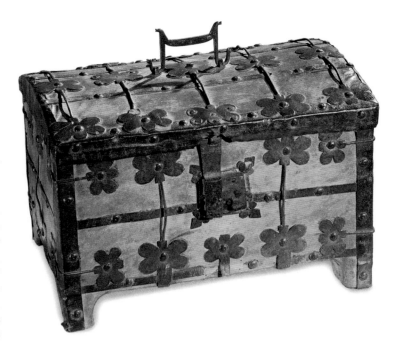

◄ Wood chest covered with a rawhide and quadrilobe motif iron reinforcements. Catalonia, 14th century.

Another group of chests belong to the northern peninsular tradition, which is characterized by simplicity, functionality, and durability. The structure is covered with leather, raw or cured, reinforced with iron bands, whose contrast is the only decorative element. The Catalan chests from the 14th and 15th centuries belong to this group.

A third group reflects the northern European tradition, which emphasizes the decorative and esthetic approach. The chests with stamped Cordovan, covered with embossed leather or decorated with other techniques stand out. Cordovan is generally covered with incised patterns, geometric and plant designs of Gothic inspiration, or representations of saints, anagrams, and ecclesiastical writings. The iron pieces around the chest become decorative elements in their own right, making it smaller and enhancing the decoration. In the 15th century, these were very common in Castile, Aragon, and Catalonia and were referred to as "cajas de Flandes" or "Flanders chests."

In inventories and descriptions throughout Europe, references to "leather-covered chests" and chests covered with Cordovan or raw hides were very common. Trunks are storage pieces especially designed for travel. They have a curved lid for protection against the rain and handles for carrying. They could also be found in homes for storing household items. During the 15th and16th centuries, the leather is decorated with engravings and their structures reinforced with elaborate ironwork. But beginning in the 17th and 18th centuries, their shapes and decorations became more austere to suit their functions, and are sometimes decorated with studs of different shapes, sizes, and materials.

In addition to the applications already mentioned, there are a series of luxury items for the aristocracy, where the leather acquires the status of a jewel and is associated with precious materials. They are small symbolic, commemorative, and decorative appliqués such as medals and plaques, portraits, covers, swords, relic holders, etc.

▼ Chest with gilded, embossed, and polychrome leather, representing scenes of gallantry. Catalonia or France, circa 1400.

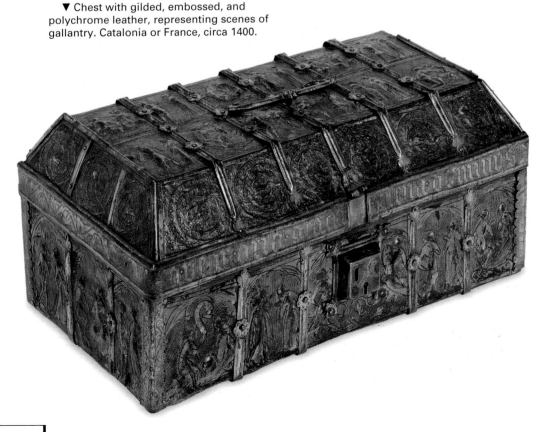

New Types of Furniture: Writing Desks and Folding Screens

The Renaissance in Europe brought about changes in the way people lived that affected furniture as well as decorative pieces. The *arquimesa*, or writing desk, made its appearance, often covered with leather and decorated with embossed ornaments in gold or polychrome. These pieces usually had geometric or organic designs, but sometimes they exhibited figurative subjects that had a mythological and heraldic tone inspired by epic cycles.

Towards the middle of the 17th century, as a result of the import of Oriental objects and furniture, a new type of furniture became popular in interior designs. This was the folding screen, which became part of the furnishings of large palaces and mansions of the latter part of the 17th century and the 18th century. The folding screen consisted of a wood frame covered with leather, which made it very light. At the beginning of the 17th century, leather covers still can be seen on book bindings from the time, with embossed ornaments and gilded iron pieces. In the second half of the century, however, the technique of covering walls with *guadamecí*, with naturalistic themes and designs of exotic inspiration, was adopted. Later, in the 18th century, a taste for Oriental objects such as *chinoiserie*, although made in England, becomes prevalent.

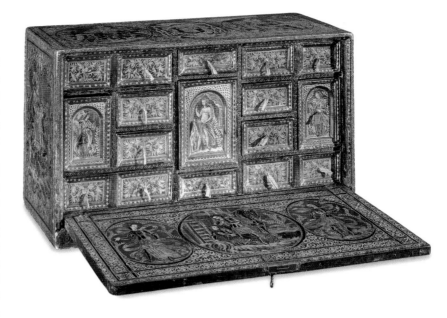

▲ Writing desk covered with dyed leather and embossed in gold with painted mosaic appliqués depicting epic and mythological scenes. Italy, circa 1625.

▼ Folding screen made of *guadamecí*, decorated with naturalistic themes and designs of Oriental inspiration. England, first half of the 18th century.

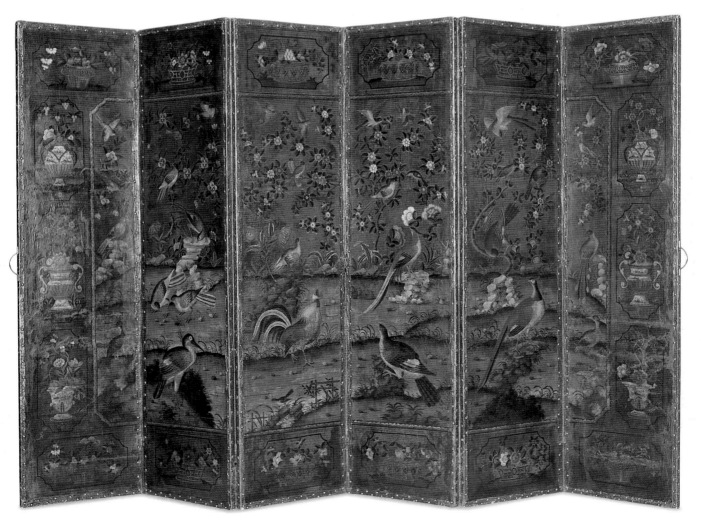

Chairs

Until the 16th century, houses in the Iberian Peninsula had only a single chair, which was used by the head of the family. The other members sat on stools or benches, and women sat *a la morisca*, the Moorish way; that is, on richly decorated pillows placed on a carpeted platform. This custom explains the existence of the dais, or platform covered with mats and pillows made of fabric and *guadamecí*, reminiscent of Islamic heritage.

Chairs made of leather seats and backs had been in existence since the 15th century and could be classified into different groups according to their structure. These included *sillas de cadera*, or chairs with armrests and backs, folding or Jamuga, Portuguese type, *sillones fraileros* or monk's chairs, etc. They were made from the hide of young cows, which was very durable and could have a smooth surface, embossed ornaments, or be formed as a pillow structure with sewn appliqués, as was customary for benches. Portuguese chairs, made of high quality tropical woods in colonial style became very prestigious and spread throughout Europe.

The evolution of the different types of chairs is reflected mainly in the structural shape of the wood and in the decoration of the leather. The decoration, which was initially symmetrical and inspired by plant and heraldic designs, became richer with a large array of subjects, including exotic animals, angels, mythological characters, and human figures.

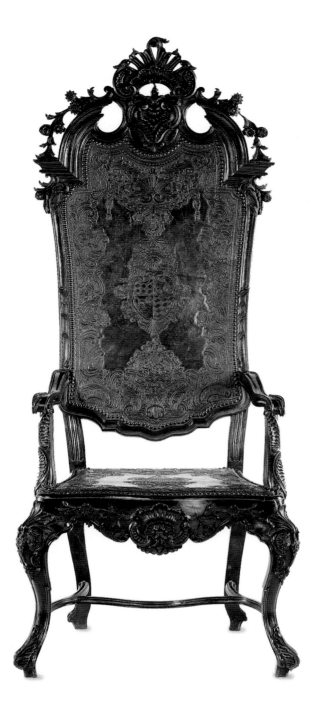

▲ Wood chair made of palosanto and engraved leather, with a completely Rococo design. Portugal, mid-18th century.

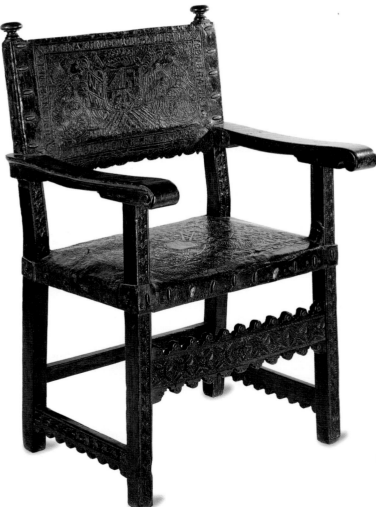

◀ *Sillón frailero*, or monk's chair, with a wooden structure and engraved heraldic designs on the back. Spain, 17th century.

Little is known about applied art on leather from the Pre-Colombian era. Logically, the conquest had an immediate impact on the production of specific leather crafts, which achieved a fusion between the most traditional Hispanic techniques and crafts (wood, iron, vegetable tanning, *ferreteado*, embossing, carving…), and indigenous materials, techniques, and languages (basketry, rawhide, piercing, braiding, etc.). As a result, new truly colonial schools emerged whose best representations were found in the viceroyalties of New Spain and Peru.

Prominent in the area of Mexico is the production of *petacas*. These are containers for storage and transport, equivalent to our trunks and chests. There were no workhorses in this area, so transportation was done by water or on the backs of people, which required light and strong containers of manageable dimensions. Their interior consisted of a wicker structure or plant fibers covered with rawhide. They were usually decorated with different colors, or with embossed work, which highlighted the effect of the colors, and even with appliqués embroidered on a leather strap. During colonial times, they were enriched with appliqués made of iron, silver, velvet, wood, etc. The iconographic repertoire was based on indigenous geometric and symbolic designs, though heraldic, liturgical, and, in all cases, Creole emblems were incorporated.

In the region of Peru, on the other hand, a type of container called *maleta* or *baúl de indiano*, which was a type of suitcase or trunk used by Spanish-Americans, was popular. Technically and formally, this piece reflected European models but included engraved designs on the surface of the hide that mimicked designs on wood, which showed a blend of Spanish traditions with deep roots in the Mudejar style and indigenous traditions, comparable to the Cuzco School.

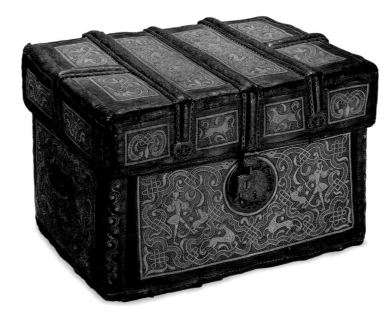

▼ *Petaca* made out of leather embroidered with *magüey* or pita fiber and reinforced with richly engraved and fretted ironwork. Mexico, 18th century.

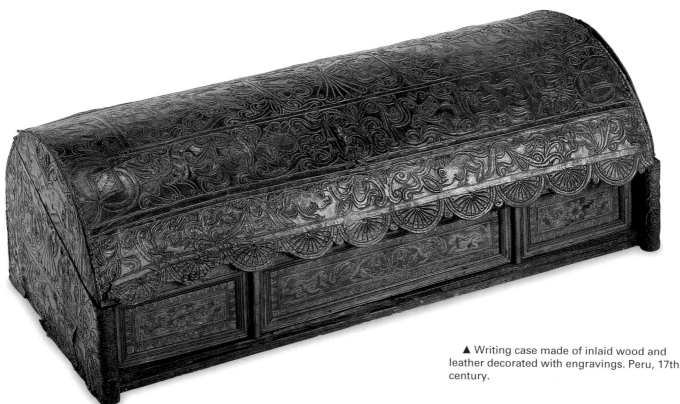

▲ Writing case made of inlaid wood and leather decorated with engravings. Peru, 17th century.

Leather Art in the East

In Eastern cultures, in countries such as India, Indonesia, Thailand, Cambodia, and China, the tradition of shadow puppets is very popular. This is a tradition with a symbolic and religious character that represents the great mythological epics of the *Mahabharata* and *Ramayana* through legendary and archetypal characters such as gods, demons, spirits, animals, and forces of nature. In terms of artistic creation, it combines theatre, literature, and music into representations that are popular. The shadow puppets are made of raw hides, normally cut out and perforated, and then dyed and painted. The translucent quality of this hide gives it a spectacular plastic effect when the multicolored shadows are cast on the screen. In some cases, they have articulated limbs and their heads can be interchangeable.

At the same time, all over the Eastern world and especially in China, there was a very prominent production of lacquered leather pieces including trunks, boxes, and cases. The leather could be painted in gold, red, and black tones and sometimes other materials, such as gold thread, mother of pearl, and tortoiseshell were added and then covered with a durable, thin, glossy, and transparent lacquer, which gave the pieces a highly luxurious appearance.

In Tibet, the production of leather boxes was popular. They were generally painted with interesting ironwork pieces, locks, and bands. Also made were light leather containers, which often were beautifully decorated with designs. Nomad villages of the Asian steppes made outstanding containers with rawhide, some of them of considerable size and thickness, without losing however the translucent quality of the material. The Kashmir region produced bottles and containers made of rawhide and normally painted and used to store oil.

In Japan, toward the end of the 17th century, the *guadamecí* that came from trade with Europe was very popular. Gold and engraved leather was considered a very luxurious exotic product because of its scarcity and high cost. Old European *guadamecí* covers were reused to make expensive pieces like saddles, cases, etc. At the end of the 17th century and during the 18th century, cigar boxes made in this fashion were popular, and having them gave their owners a touch of distinction and social status. Soon after, Japan developed a technique for gold and embossed paper that imitated *guadamecí*, which was very popular due to its affordability and which would later expand into Europe and would end up displacing the production of *guadamecí*.

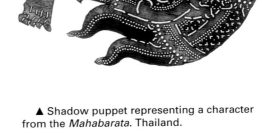

▲ Shadow puppet representing a character from the *Mahabarata*. Thailand.

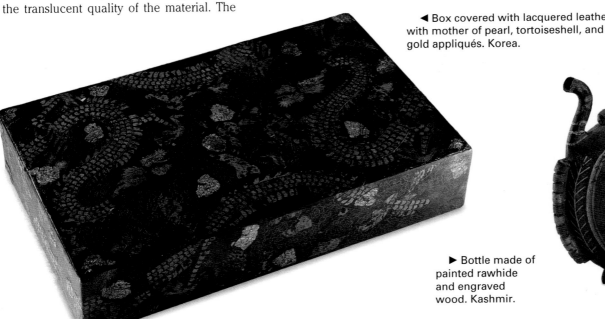

◀ Box covered with lacquered leather with mother of pearl, tortoiseshell, and gold appliqués. Korea.

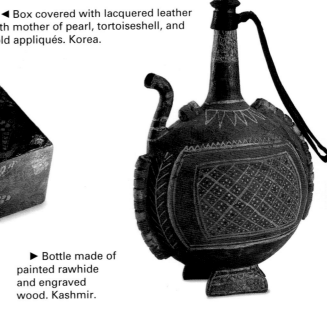

▶ Bottle made of painted rawhide and engraved wood. Kashmir.

From the north to the south of this continent, leather is commonly used for practical items and clothing, almost always with great esthetic sense. Tuareg saddlebags are worth mentioning, as are Sahel craft pieces, Massai and Turkana shields, and Ethiopian illuminated books and scrolls.

Among these groups, the Ekoi stand out, a semi-nomadic people that inhabit the area of the Cross river between Niger and Cameroon, and who are highly artistic and creative, especially when it comes to leather figures. Among these are representations to honor the memory of their ancestors, who ensure the protection of the group, and many masks and figures for rituals to initiate hunters, women, etc.

Technically, these are wood sculptures covered with modeled and dyed antelope leather adorned with various appliqués. These are sometimes mounted on a wicker stand, which is a good way to hold these pieces upright during rituals. The sculptures are made with a meticulous technique and secret formulas preserved by shaman-artists revered by the community. They represent a complex symbolic and imaginary system, like the tattoos and scarifications, forces of nature, and the different levels of social hierarchy: medicine men, hunters, warriors, guardians of relics, and at the top, those who have killed a lion or defeated another warrior.

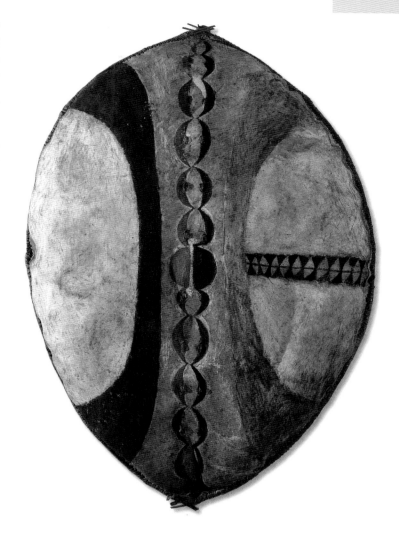

▶ A Massai shield with dyed and painted rawhide, with reinforcements made of plant fibers. Kenya or Tanzania.

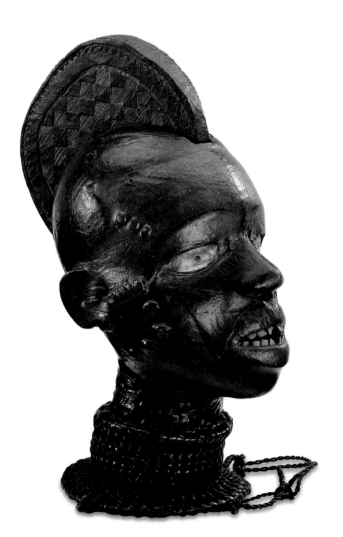

The list is varied and depicts full-body figures, heads of people and animals adorned with elaborate headgear and symbols, multiple horns, head-helmets, *ianus*, animal masks, etc. They are notable for their naturalistic approach and lively expression, the reason why work by these artists is sometimes commissioned by faraway villages. Together with the Benin bronze pieces and the Fang sculptures, the Ekoi pieces can be considered true universal art masterpieces.

Félix de la Fuente
Anna Soler
Director and Conservator from the Museu de l'Art de la Pell, of Vic

◀ Ekoi figure made of dyed leather on wood with a wicker base and cane and metal appliqués. Cameroon-Niger.

Leather: Characteristics and Structure

Skin is the resistant and flexible tissue that covers the bodies of animals. It has a heterogeneous composition, normally covered with hair or fur and formed by several superimposed layers. Its main functions are:
- To act as a protective layer for internal tissues against bacterial attacks.
- To serve as a storage for fatty substances and to help regulate the body temperature of animals.

Skin is a reflection of an animal's life. By observing it, one can obtain a great deal of information about the animal's breed, age, sex, nutrition, when and how it was killed, and any illnesses it may have had.

Structure

The skin has four different parts: the hair or fur, the epidermis, the reticular layer, and the subcutaneous or endodermis tissue.

The part of the skin that can be turned into leather is the dermis. The other parts of the skin are discarded during the first stages of the process. The dermis consists of the papillary and the reticular layers, and is primarily made of the fibers of a protein called collagen, though it also contains other fibers in lesser proportions.

Parts of a Tanned Hide

The hide, depending on its kind and market value, is divided into different sections, as follows.

Shoulder

This is the front part of the animal where the neck and the head are located. Its thickness and compactness are uneven. The shoulder has many wrinkles; the older the animal, the more pronounced the wrinkles will be. This area represents 25% of the total weight of the animal's skin .

Bend

Also called double bend, this part of the skin corresponds to that located in the dorsal and lumbar areas of the animal. It is the most homogeneous (in thickness as well as in its dermal structure), and it is compact as well as the most expensive. This area represents 45% of the total weight of fresh skin.

Belly

This is the hide that covers the under side of the animal. It has an uneven thickness and very spongy fibers. It weighs approximately 30% of the animal's total weight.

Sides

This is the name given to the two halves resulting from the symmetrical split of a hide cut along the backbone.

Methods of Measuring Leather

The surface of a hide is measured by means of mechanical or electronic devices, or a combination of both. Traditionally, the measuring units used are square feet. Shoe soles, on the other hand, are marketed by weight, with pounds and ounces being the usual measurement units.

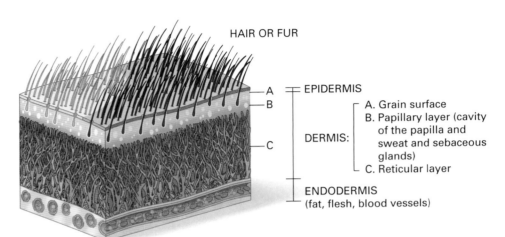

HAIR OR FUR

A — EPIDERMIS

B

DERMIS:
- A. Grain surface
- B. Papillary layer (cavity of the papilla and sweat and sebaceous glands)
- C. Reticular layer

C

ENDODERMIS
(fat, flesh, blood vessels)

▲ Layers of a mammal's skin. The dermis, which represents approximately 85% of a skin's thickness, is used for tanning. The epidermis, the thin layer of cells (about 1% of its thickness), in the outermost layer that flakes off, and the endodermis, in the innermost area, are discarded.

► When the hides are purchased, their dimensions are noted on the margin, in this case expressed in square feet.

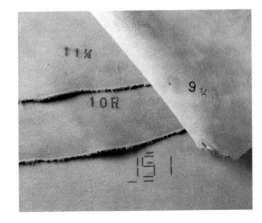

▼ Parts of a tanned hide labeled with the various parts: bend or double bend (A), shoulder (B), belly (C), and sides (D).

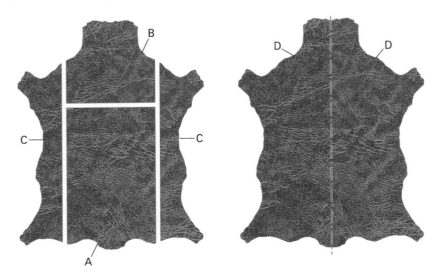

The transformation of an animal hide into leather for manufacturing items such as shoes, wallets, belts, jackets, etc. requires the use of a series of processes beginning with the raw hide, which is universally known as tanning.

These processes are: soaking, dehairing and liming, deliming and bating, tannage, dyeing, fatliquoring, and the mechanical and finishing operations.

Tanning Methods: Traditional and Modern

Stabilizing the skin substance to make it resistant to rotting and to turn it into a beautiful and durable material is known as tanning.

The first tanning probably occurred as a result of curiosity on the part of our ancestors. When they greased a piece of dried-up hide with lard, they saw that its useful life doubled, and that hides exposed to the smoke of their fires were almost cured. Also, when they came across an animal that had been dead for a long time partially submerged in a shallow pool of water and covered with decomposing leaves and branches, they observed that the skin looked intact.

The oldest tanning operations known are those done with oils (chamois-type tanning) and vegetables, which include all the processes that use some type of vegetable extract. Later on, they were carried out with methods that used Rocca alum (double aluminum sulfate and potassium). It was not until the beginning of the 20th century that mineral tanning made its appearance. In the latter, chromium became its greatest exponent.

A classification of the types of tanning in existence is as follows:

CLASSIFICATION OF TANNING METHODS

Tanning	Characteristics
Oil tanning	Only used for making chamois.
Vegetable tanning	There are many types depending on the origin of the tannin used. The most notable extracts come from mimosa, quebracho, chestnut, tally stick, sumac, valonea, pine, gambier (cat's claw), and a combination of all of them.
Mineral tanning	It is done with salts derived from specific metals that have tanning properties. The most notable ones are chromium, aluminum, and zirconium. Of lesser use are salts of titanium, iron, and zinc.
Mixed or combined	These are obtained by combining mineral and tanning vegetable tannins together.
Synthetic tanning	They are the ones that use syntans like aldehyde, glutaraldehyde, synthetic phenolics, naphthalenesulfonic, and resins, among others.

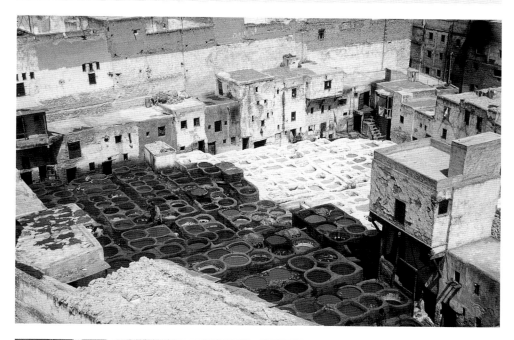

▲ Tanneries in Medina de Fez (Morocco), living testimony of the active leather tanneries and dyeing operations using ancestral methods.

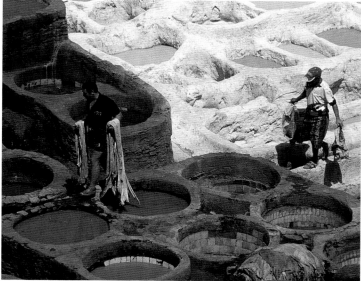

▶ Tanning vats in Fez. After coming out of the active and slaked lime baths, vegetable and animal products (like bird excrement) are used for tanning the hides and dyeing them afterwards.

Preserving the Raw Hides

At the slaughterhouse, the skin is separated from the rest of the body and is subjected to a series of treatments that allow its temporary preservation. The two most common treatments are drying and salting. Both methods prevent the hide from rotting.

Soaking

When the raw hide (slated or dried) arrives at the tannery, the parts, if still attached, that are not suitable for tanning (tail, legs, and head) are removed. Next, the hide is stored in a warehouse, or it goes into the process.

Soaking is a treatment that involves water, which usually requires from 12 to 24 hours, and certain additional products (tensoactive agents, humectants, sodium carbonate, sodium hydroxide, and bacterial agents) that hydrate the skin and remove blood, dirt, microorganisms, and previously added preservative agents.

Once the skin is clean and hydrated, it moves on to the dehairing and liming operations.

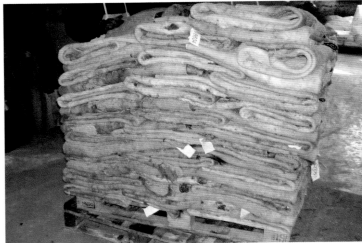

◀ A pallet holding raw hides that arrived from the slaughterhouse.

▼ Salted double cowhide bend with the hair still attached.

▼ Underside view of a double bend. The fat and flesh are still present.

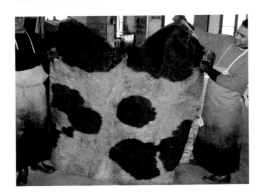

▶ Skins during the dehairing process.

▼ View of the hair before it is separated from the surface of the skin.

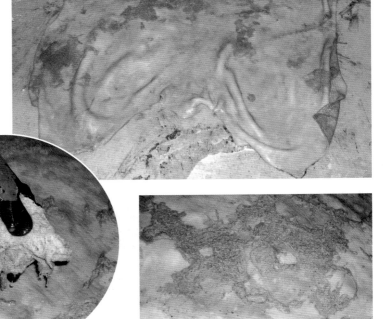

Dehairing and Liming

These are two different operations that are often carried out at the same time. Dehairing consists of removing the epidermis and hair or fur from the skin. Liming applies certain controlled chemical and physical interventions to the skin that create a sponginess in its fibrous structure. The products that are used for depilation are basically sodium sulfate for dehairing and lime for liming.

◀ Detail of the immunized hair. Through immunization, the skin can be dehaired but the hair itself is protected and can be physically extracted. This way, we prevent the contamination of the water for subsequent soakings.

Deliming and Bating

Sulphide and lime are contained inside the hide. During this phase, it is important to remove them because these substances will impede penetration of subsequent tanning agents into the hide. This cleaning process is carried out using mild compound-forming acids that are easy to eliminate by washing in water.

Bating is a process whose main goal is to relax the collagen structure. A method involving pancreatic digestive enzymes or similar products is used.

Vegetable Tannage

The main purpose of this procedure is to stabilize the raw hide through the reaction of tanning products to create a suitable material prepared for later processes that will result in finished leather that is easy to work.

Many plants contain substances called tannins, which are present, in varying degrees, in different parts of the plant. Also, plants contain what are called "non-tannins." These are nothing more than semi-tannins that do not actually do the tanning, but that help the tannins penetrate into the skin. Nowadays, the chemical industry extracts these two products from plants with high tannin levels, to make concentrates that are used in vegetable tannage.

Delimed and bated hides are first subjected to a pre-tanning process with non-tannins,

◄ Double dehaired or pelt bend, names that are given to designate dehaired skins for their turgid and translucent appearance at this point in the process.

◄ View of the underside of a double pelt bend after being fleshed.

which can be either residual baths from previous tannage sessions or synthetic products prepared for this purpose. When the skins have absorbed these products, they are subjected to a progressive process with tannins.

The duration of the process varies depending on the system used. The operation could last from 6 to 10 hours for fine pieces with little tannin, or several days or weeks for thicker pieces, such as those used to make innersoles.

▲ View of several shoulders that were subjected to vegetable tanning.

▲ Double vegetable-tanned bend.

Pickling and Chrome Tannage

Pickling is the process of creating an acid environment for the subsequent chromium tanning. In this process, the skins are treated with saline and acid solutions combined in the same bath.

Chrome tannage is used to treat skins that come from pickling with chrome III tanning salts (generally basic chromium III sulphate). Once the chromium salts have been added, the acidity of the skin and chromium salts slowly becomes more neutralized making them more reactive for the skin, and thus achieving their tanning.

The process lasts from 6 to 8 hours. During that time the bath and the skins undergo progressive warming to promote tanning.

Dyeing and Fatliquoring

Dyeing changes the color the leather has acquired during the tanning process to the desired color of the final piece. Often, the final color is achieved during the finishing process, but with dyeing a color as close as possible to it can be used.

In addition to dyes, other products are also used that help with the distribution and penetration of the colorant into the leather.

Fatliquoring lubricates the fibers, preventing the leather from cracking when it dries and making it more pliable and flexible to the touch. For this process, either natural fatty substances or synthetic products that have a similar effect can be used.

Drying and Mechanical Operations

The goal of drying is to evaporate the water contained in the fibers of the hides. The leather can be dried using hot or cold air and by stretching it. In addition, they may be submitted to mechanical operations prior to finishing that can vary in order and quantity according to the desired final article. The main ones are softening, cutting, buffing, cleaning, and milling.

Finishing

Finishing consists of applying certain treatments to the surface of the leather to give it a proper final appearance for the market.

The finish has a visual and tactile impact, as well as an influence on the physical properties of the leather. Many products are used to finish the leather, including natural or synthetic oils and waxes, or both, and protein and resin binders, pigments, colorants, and lacquers.

These products alone or in combination are applied to the leather in layers of different compositions, letting them dry between applications.

▼ View of a pickled double bend.

▼ Pile of chrome-tanned double bends.

▼ Double bends dyed light brown.

◄ Air-drying hides.

► Pile of dried hides.

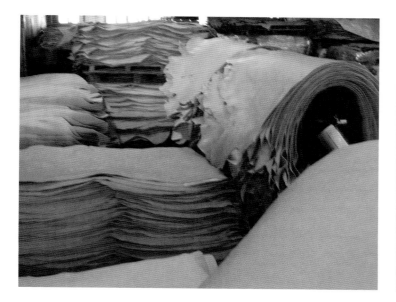

▲ Hides ready for finishing.

▲ Finishing plant.

Tanning and the Environment

Throughout history tanning activities have not been very well regarded. It is a contradiction that leathers and hides were held in such high esteem after tanning, but that tanners had such a poor reputation. Thus, much of the literature on the subject portrays tanners with suspicion and disdain, considering them rough, dirty, and smelly individuals who were forced to live on the outskirts of cities and who were even accused of propagating disease.

This apprehension still exists today, but we forget the fact that the tanning activity exists for the most part as a result of our diet. If we did not consume meat, this industry would not exist. However, the unfairness against this activity and its people does not exempt this industry from being environmentally friendly.

Contaminating Factors

Skinned leathers contain salt, organic residues, and other waste that the tanner must account for even if they do not form part of the final product. This waste, when mixed with the water of the different processes, generates a great deal of pollution. Salt, excrement, and soluble organic material residue dissolve in the water and deplete its oxygen. The trimmings and the hair must be removed in solid form to avoid further contamination of the water.

The products used for tanning, which are soluble in water, also cause contamination. Vegetable tannins, even though they are ecologically sound because they come from plants, cause a high degree of organic contamination.

But mineral tannins, especially chromium, contain metals that are very difficult to purge from residual waste even in low quantities. Fats and other secondary products are also contaminants.

Methods of Avoiding Pollution

In fact, tannage industries could be considered large recycling centers, because one must ask how the thousands of tons of animal skins generated on a daily basis worldwide as a result of meat consumption would be discarded. But this "recycling" carries the contamination mentioned above.

Nowadays, a series of techniques are used to greatly reduce pollution.

• Preserving the leather in refrigerators and not with salt. If this is not possible, the hides should be thoroughly desalted before the process begins.

• Recovering the trimmings and the fat in the slaughterhouse, which is more efficient since they are not contaminated with chemicals at this point.

• Using depilation methods that allow for the hair to be recycled.

• Maximum optimization of water consumption in all the processes.

• Recirculating the tanning baths used for vegetable tannage.

▲ Storage of concentrated vegetable extracts used in tanning, supplied by the chemical industry.

• Greatly reducing the tanning substances used in chrome tannage and rehabilitating effluent waters through chemical processes.

• Using chemical products that are easily diluted.

By using these good practices, contamination can be greatly reduced, but never to the levels that would be completely environmentally friendly. For this reason, all the effluents from tanneries are treated in water-treatment plants until their pollutants are removed completely.

Felip Combalia
Jaume Soler
Professors of the Escola Tècnica
Industrial of Igualada

I n this chapter, we will cover in detail the main materials and tools that are used for working with leather. First, we introduce the two main varieties of leathers based on their tanning process, their main characteristics and properties, as well as their possibilities regarding the working techniques. Then, we present a wide range of the most common types of leathers, indicating their identifying characteristics. There are many more varieties, depending on the animal species in each region, but further explanation is beyond the scope of this book. Of course, the skins of protected animals, those that are not domestic, and those raised in captivity specifically for their skin have been left out.

Then, we will cover the rest of the materials and tools grouped according to their use, thereby allowing the reader to easily find all the tools and materials that are used for a particular purpose or to engage in similar processes. You will find the description for each one of them, the explanation of the possible uses, and any safety advice needed.

Materials
and Tools

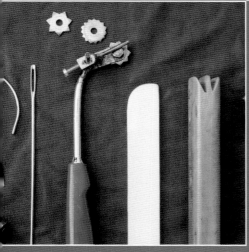

Leather

Chrome-Tanned Leather

The characteristics of these hides are different from those tanned with vegetable extracts. Chromium tannage, in addition to the characteristics mentioned in the previous chapter, is a very versatile procedure because it is possible to do a second tannage or retannage of the hides with the vegetable procedure. In this case, the hides acquire the characteristics of vegetable tannage. However, the most interesting aspect of chrome-tanned hides is that they can be dyed with a wide variety of colors and achieve an infinite range of tonalities, as well as a great number of finishes. The latter are industrial processes to which the tanned hide is subjected to give it certain characteristics, depending on their use. The goal of these treatments is to improve the leather and to give it special properties, like protecting it from scratching, water, dirt, or endowing it with other effects such as color, luster, shading, etc. They are also used to even out the surface color, to conceal imperfections, or to change the tactile feel of the leather.

Therefore, chrome-tanned hides can be treated with a wide range of finishes. They can be dyed (with various substances like aniline dyes, semi-aniline dyes, etc.), have metallic and glazed finishes (by applying sizing that can later be buffed mechanically), bloom finishes (by applying matte sizing on the leather), wrinkled, which results in irregular and uneven surfaces (by applying an astringent substance that contracts leather), speckled (spreading the layer of color regularly or irregularly to produce a mottled effect), embossing finish (by imprinting texture), shadow finishing (applying different intensities of

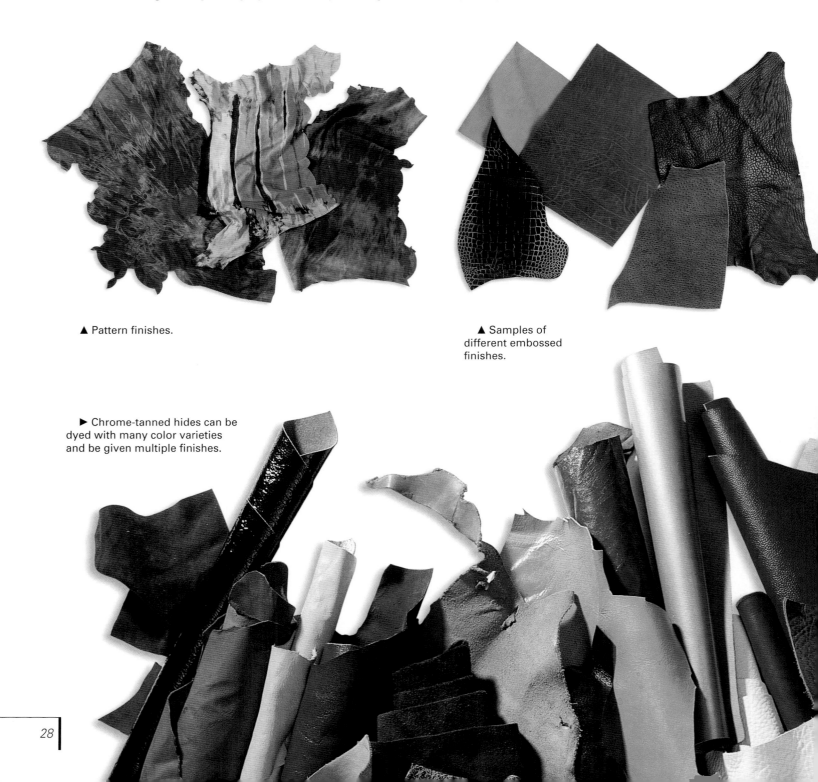

▲ Pattern finishes.

▲ Samples of different embossed finishes.

► Chrome-tanned hides can be dyed with many color varieties and be given multiple finishes.

color to the leather), antiqued (makes the leather look old by darkening the wrinkles and several areas with dyes), with patterns (using different procedures), embossing (pressing the leather with a hot iron), applying nitrocellulose or thermoplastic finishes or patent finish (making the leather extremely glossy by applying synthetic resins and varnishes), among others.

However, the chrome-tanned hides are not as practical as vegetable tanned hides for certain techniques. For example, they are not suitable for stamping, repoussé, general leather working techniques, for molding and for applying some finishes.

▲ Vegetable-tanned hides include a range of colors that are typical of this technique.

Vegetable-Tanned Hides

Vegetable-tanned hides have completely different characteristics than the chrome-tanned ones. They acquire the color of the products used, that is of the vegetable agents (tree bark, plant fruits and seeds) that are used in the tanning process. Therefore, their colors range from white or off-white to pink, including a wide array of browns and beiges. The coloring and dyeing possibilities depend directly on this chromatic spectrum. These hides also provide a certain degree of elasticity to the touch, which is a result of the materials applied to them and the processes used. However, they are not suitable for the wide range of finishes that are possible with chrome-tanned hides.

On the other hand, they have an advantage over chrome-tanned hides in that many techniques and finishes can be applied to vegetable tanned hides, and they are suitable as well for the many artistic techniques presented in this book. In addition, certain finishes, such as hand boarding, can be done in the shop, giving the hides specific effects that adapt perfectly to the creative process and that can be used for specific purposes.

To this, we must add the environmental factor, because vegetable tanning is more environmentally friendly than chromium tanning, which generates considerable residues. Also, vegetable-tanned hides are tolerated better by people, while chrome-tanned ones can produce skin allergies.

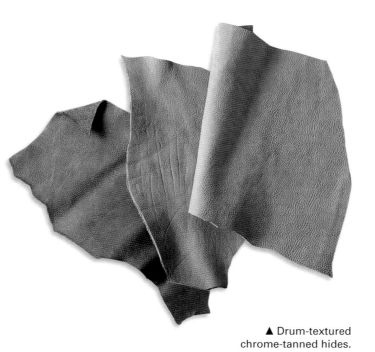

▲ Drum-textured chrome-tanned hides.

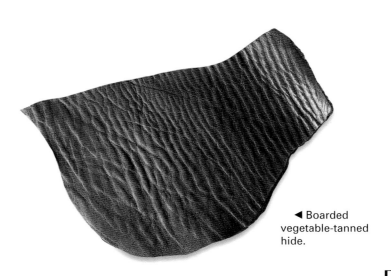

◄ Boarded vegetable-tanned hide.

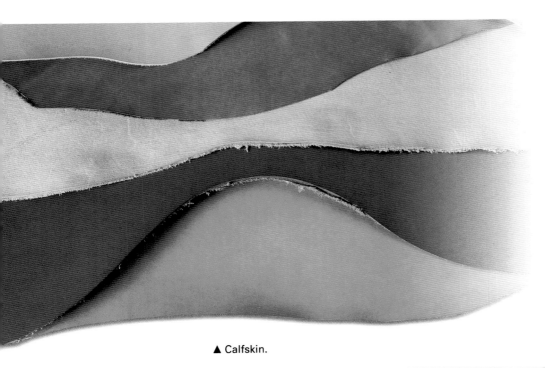

▲ Calfskin.

Calfskin

This is the most commonly used vegetable-tanned hide (also the most widespread) for artistic purposes. Calfskin, also known as vachetta leather, is a cow skin, usually calf, fine and quite supple. Its characteristics, which are derived from the type of tanning employed and from the animal skin itself, makes this the most versatile, interesting, and suitable type of leather for creative work. Therefore, this will be the main material used in this book for the technical processes as well as for the step-by-step exercises.

Hand Boarding

As we explained earlier, one of the many possibilities offered by vegetable tanning is that it allows the manual boarding of the hides. Boarding is a process that basically consists of creating a texture on the grain side of leather and making it more flexible. Folding the leather, generally from the belly area, grain to grain and rubbing the surfaces against each other will achieve a specific texture, which is determined by the leather's type of grain. This is what is called "raising the grain." If the fold is made in one direction only, the texture would be simple and more or less linear. If the fold is at an angle to the previous one, the resulting texture would have a crossed pattern. Finally, if we make a third fold diagonally to the previous ones, the texture will be larger and have a grid shape. After each one of these steps, the leather becomes more flexible and malleable.

▶ **1.** For hand boarding, the piece of leather, generally from the belly area, is folded over, grain to grain and obliquely, and the two surfaces are rubbed against each other vigorously until an even texture is achieved. Then, it is folded obliquely and the process is repeated.

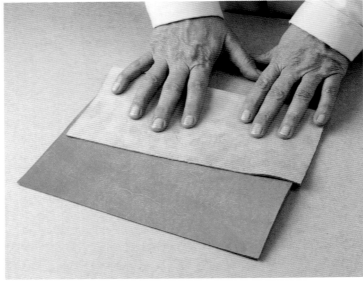

▼ **2.** To finish the process, a diagonal fold is made and the grain surfaces are rubbed against each other.

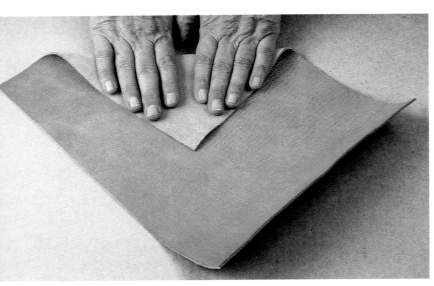

▼ **3.** The piece of hand-boarded leather has a grid texture with a wrinkled surface. Observe the difference with a piece of leather that has not been buffed.

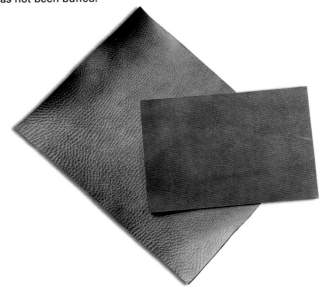

Types of Leather

Parchment

Parchment is a type of leather that has not been tanned. In other words, it is raw leather. The current name comes from the Latin word *pergami num*, which, in turn, comes from Greek. The literal meaning is "from Pergamo," and refers to the town where leather scrolls were made for writing. Therefore, the current name of this variety of leather makes reference to its origin as well as to its use as a writing support throughout history.

Parchment is made with thin lambskin, calfskin or goatskin, although donkey hides can also be used. The hide is washed in lukewarm water, then treated with lime to eliminate the hair, degreased and dried, and rubbed throughout the entire process with rough stones to flatten it out. The result is a type of leather with a very characteristic look and a light yellow color with a very thin and flat surface, a little bit rigid and opaque or slightly translucent depending on the animal it comes from. Parchment leather can have different colors, from white, to yellow-white, and tan.

Sheepskin

This is a vegetable-tanned lamb or sheepskin, often with sumac. Sumac is a bush from the Anacardiaceous family. Sumac has reddish fruits and seeds that give it its name (from Aramaic *summa q*, red, which later passed on to Arabic). It is used in tanning due to its high tannin content. Sheepskin is a thin, very flexible, smooth, and soft leather that is pleasant and attractive to the touch.

Chamois

Chamois is made of oil-tanned sheepskin. Originally the skin of the chamois was used (giving the material its name), but now sheep and goatskin are used as well. It is a type of leather whose grain has been separated by scraping and then cured through a combined tanning method or just oil tannage alone. The combination includes a preliminary chromium phase followed by a second oil process. Oil tannage, either combined or by itself, is what gives this skin its final look. Fish or marine mammal oils are used. These cure the leather through a process of oxidation and other chemical changes in the oils, creating a chemical combination of the oil substances with the skin.

Chamois is a high-quality leather of a creamy yellow to off-white color, with a velvety look and feel on both sides. It is extremely soft and flexible, with an overall appearance that is reminiscent of fabric, and is washable.

◀ Parchment is an off-white leather with a smooth surface and opaque appearance.

◀ Seen against the light, parchment has a characteristic translucent look. In this picture we can see the marks left by the veins of the animal and the center of the back, where the skin is thickest.

▼ Chamois.

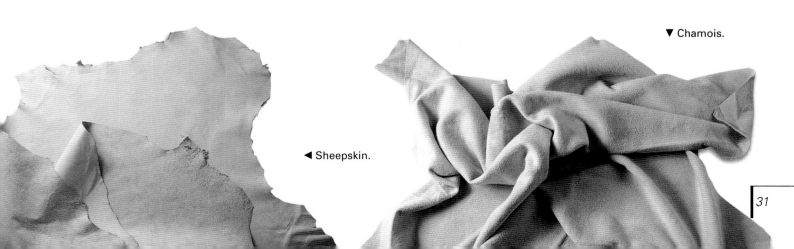

◀ Sheepskin.

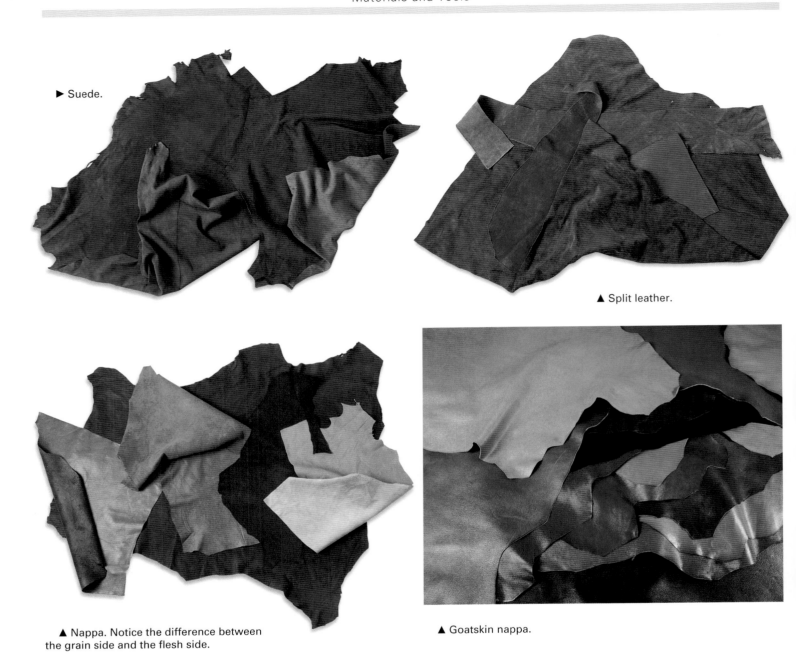

► Suede.

▲ Split leather.

▲ Nappa. Notice the difference between the grain side and the flesh side.

▲ Goatskin nappa.

Suede

Suede was originally made from tanned antelope or gazelle skin, with a velvety finish on the flesh side, and sometimes on the grain side of antelope leather. The soft finish has a velvet-like appearance and the surface of the hide looks like felt as a result of the abrasive action.

The name suede is applied universally to chrome-tanned sheep, goat, and pig skins, whose grain has been completely removed by the tanning process and whose flesh side has been given a velvety finish. Suede is a thin, flexible, and smooth leather with a velvety look and feel on both sides, with qualities that are somewhat reminiscent of fabric.

Split Leather

This presentation, also called flesh split, is the intermediate layer, or the layer from the flesh side, that results from splitting the skin into two layers, using the splitting machine. The name of split leather is given to bovine skins whose grain side has been eliminated.

It can be grain split, which has a finish and pigmentation, or split suede, which has a felt-like finish that gives it a velvety appearance. Split suede has a look similar to suede, but, unlike the latter, split suede is not as flexible and soft and feels heavier to the touch.

Split leather is somewhat thick, a little bit rigid, and feels heavy to the touch.

Nappa

Nappa is a split cowhide or a full-grain goat and sheepskin leather that has not been split. In other words, the grain has been left intact and unfinished on that side. These are chrome-tanned hides or combination tanned and dyed by complete penetration, not only on the surface, or partially, but all the way through.

Nappa is a thin, soft, and supple leather. The grain side is smooth and soft with a satin gloss and visible pores, while the flesh side has a velvet-like appearance.

Goat nappa is a high-quality leather. It has a characteristic appearance because the pores are more visible than in other types of leathers due to this animal's peculiar hair.

Sole

This leather is made from non-split vegetable-tanned or combined (or mixed) cowhide. This leather is very thick and coarse, not supple at all. It is heavy and smooth, highly resistant, and durable.

Insole

This is a vegetable-tanned layer of leather between 5/8 and 1 inch (1.5 and 2.5 cm) thick, made from split hides and mainly used in the shoe industry. The bottom layer of the shoe, the insole, is later covered with an inner sole. It can also be used in the shop as a base for some leathers or to reinforce them.

Pigskin

This type of leather is sometimes referred to as peccary, although this denomination refers strictly to the skin of an animal with the same name that lives in Central and South America.

This name is also given to boarskin tanned on the grain side.

Pigskin is chrome-tanned and finished on the grain side. It is thin, supple, and smooth to the touch, and has very visible pores.

Hair-on Leather

It is also possible to find leathers that still have the animal's hair. They are usually sheepskins, although there are others from animals like rabbits, which are subject to a type of tanning that leaves the hair intact.

Sheepskins that have been tanned without dehairing (that is, leaving the hair or wool intact), dyed and finished on the flesh side, which is what constitutes the exterior of the leather, are called double face or shearlings. They are also sometimes referred to as "full sheep."

▲ Samples of various sole thicknesses and colors.

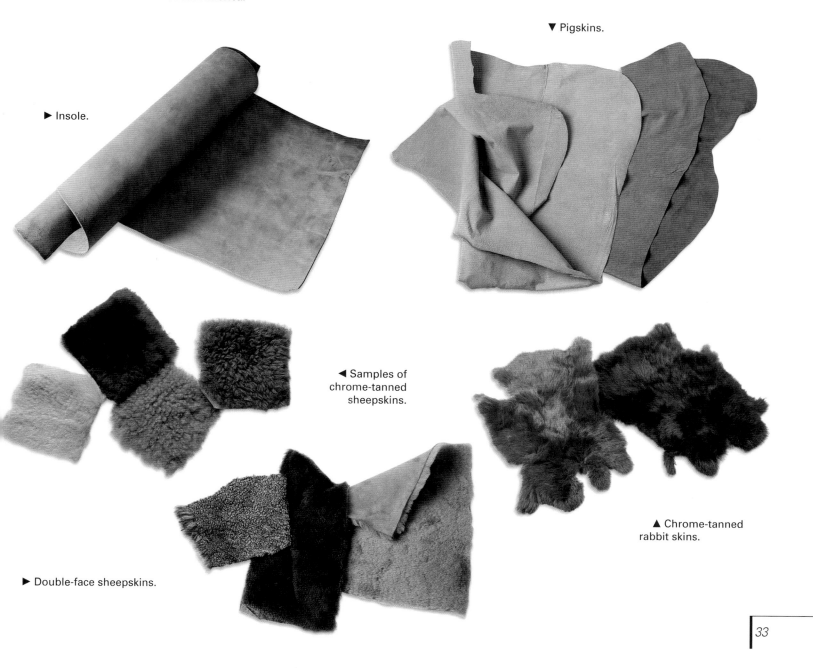

▼ Pigskins.

► Insole.

◄ Samples of chrome-tanned sheepskins.

▲ Chrome-tanned rabbit skins.

► Double-face sheepskins.

Additional Materials

▲ Various widths, thicknesses, and finishes for lace and cord.

For Joining

Twine and Threads

These materials are used to join the leather by sewing the pieces together. To do this, cotton, linen, and hemp threads and twine or synthetic material that has a wax coating can be used. This makes inserting the material through the holes in the pieces of leather easier and avoids damage to the leather. Nylon threads are also suitable for sewing decorative motifs or for small areas that need to be reinforced.

Lace and Cords

These are specifically made for the leather industry. They are used for sewing and for decoration. Laces are flat and narrow, while cords are round.

Specialized stores carry a great variety of lace and cords, in a wide range of colors, thicknesses, and widths, and with different

▶ Leather lace and cords.

finishes (even with hair). They are presented in various formats including braided, beveled on the flesh side, etc.

Special needles are used for sewing joints. The needles used with cords are round and open on the bottom end to insert the cords. The needles for lace are flat and have a sharp point that secures and holds the lace firmly in place.

◄ Needles for lace (A) and for cords (B).

► Cords and thread.

Adhesives

Cyanocrilate Adhesive
This adhesive is very liquid and has low viscosity. It glues instantly, making it impossible to make last minute corrections. Complete drying time, though, can take 24 hours. It is suitable for gluing small pieces and decorative motifs that require quick adhesion. The joints created with this adhesive are very durable.

White Glue
Also called carpenter's glue, vinyl polyacetates ($CH_3COO\ CH{:}CH_2$), commonly known as polyvinyl acetates or PVA, are transparent, soluble in certain organic solvents. They have great adhesive power, form a very flexible film, are resistant to light, and are stable in the presence of certain products. They are applied on the reverse side (flesh side) of the leather to make it stiff, which helps maintain the desired shape. Drying is complete in 24 hours.

Contact Cement
As its name indicates, this adhesive works on contact. It is an adhesive made from synthetic gum (generally neoprene) dissolved in a solvent, which, on evaporation, produces the curing of the adhesive. It must be used in a room with good ventilation and kept away from any heat sources. It has high viscosity and great adhesive power, and is very resistant when it dries. It adheres instantly, which makes corrections difficult. Contact cement is applied on both surfaces that need to be glued, and is left to dry for a few minutes (the time varies depending on the glue and the brand) until the piece is no longer sticky. This can take between 5 and 15 minutes, during which the adhesive layers

that may look dry can still be stuck together. The complete hardening takes place after 72 hours.

Rubber Cement
This is an adhesive made from natural rubber (a hydrocarbon extracted from the latex of some tropical trees) or from a synthetic material dissolved in solvent. It should be used in a well-ventilated area and kept away from heat sources. Synthetic rubber adhesives are made from the polymerization of butadiene or isoprene or by-products such as chloroprene (polychloroprenes). Rubber cement has a honey color, different from natural rubber, which is bone white.

Natural rubber cement is preferred to synthetic rubber adhesives for gluing leather. It has great viscosity and plasticity in addition to great adhesion and resistance properties. Last-minute corrections are possible. After application and contact, it takes 24 hours to dry.

White Glue for Leather
There are polyvinyl acetate white glues made specifically for leather. They have the same characteristics as those described above for white glue, but they are especially formulated to have greater plasticity and flexibility.

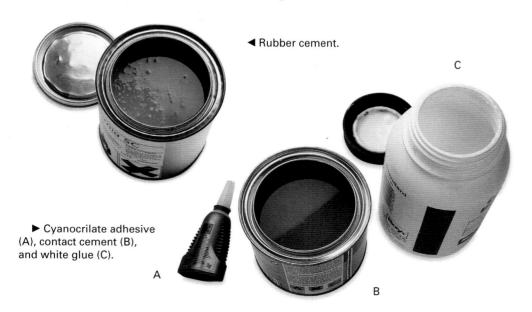

◄ Rubber cement.

► Cyanocrilate adhesive (A), contact cement (B), and white glue (C).

Materials for Finishing

For Patinas and Waxing

Asphaltum

This is a mixture of natural hydrocarbides with a consistency between liquid and solid, soluble in oils and essences. It is sold in cans in dense liquid form, which must be diluted in mineral spirits before use. Asphaltum is used to create an aged patina effect on leather, producing the characteristic dark and warm brown glazes.

Essence of Turpentine

Also called turpentine, although it is somewhat different, essence of turpentine is a liquid (mixture of terpenic hydrocarbides) made from distilling the resin of certain pine trees and other conifers. It is highly volatile, colorless or slightly yellow, and has a characteristic odor. It is insoluble in water but soluble in alcohol. It oxidizes when exposed to sunlight, air, or heat, turning ochre and viscous, at which point it should be discarded. Use of gloves is recommended for handling this product and should be used in well-ventilated areas and away from any heat source.

Mineral spirits is a by-product of distilled petroleum and has properties similar to essence of turpentine.

Wax

Waxes are used for finishing surfaces because they protect the leather and, at the same time, give it a glossy finish. A wide variety of waxes for leather is available, in aerosols, liquids, and solid forms, colorless, with color, or with an aged patina effect, which makes it possible to select the most suitable for any particular need.

Most waxes are mixtures of oils and wax (natural and synthetic) with solvents. The wax most commonly used for finishing leather is carnauba, a natural wax made from the leaves of a South American palm tree that is sold as a liquid in a beige watery emulsion form. The emulsion is thin, easy to apply and spread, and gives the surface of the leather a strong satin gloss. Strong and resistant to wear, the leather must be protected in freezing weather.

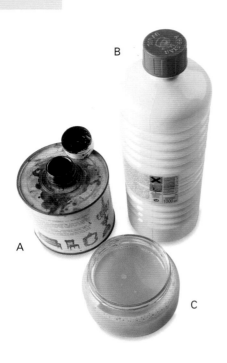

▲ Asphaltum (A); essence of turpentine (B); and carnauba wax (C).

▼ Paints.

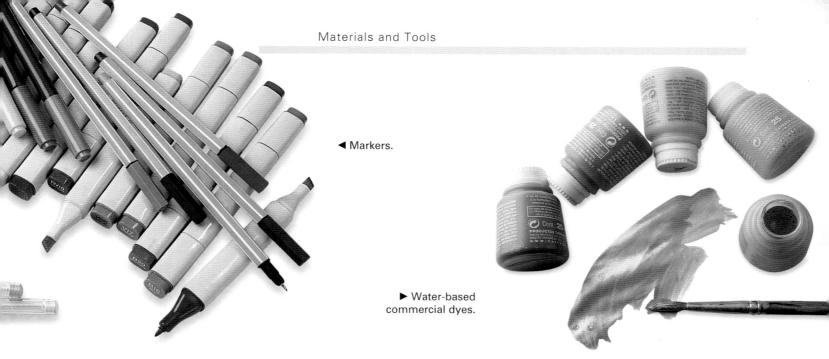

◀ Markers.

▶ Water-based commercial dyes.

For Coloring

Paints

These paints are solid and cover the surface of the leather completely, to the extent that when they dry the grain is completely concealed. A large number of special liquid paints for leather are available on the market, making it easy to choose the most suitable one for any particular job.

The most commonly used paints are water-based acrylics (a mixture of various acrylic and vinyl compounds resulting from the synthesis of plastic materials). These solid colors are easy to apply and dry very fast. They are waterproof when dry, and can in fact be washed with water. Some brands include a protective filter for ultraviolet rays in the formula. There are other water-based or solvent-based paints with metallic compounds. These paints are waterproof and sunproof and come in bright colors.

Dyes

Dyes color the leather without covering the grain. The dye penetrates the leather thanks to a specific solvent that promotes penetration. As with paints, there is a wide range of dyes for leather, some with more covering power than others, so one must choose the most appropriate for each situation.

There are water-based dyes formulated with inorganic or metallic pigments (silver and gold colors, mainly). To apply them, the surface of the leather has to be treated beforehand with a particular product or universal solvent to remove the finish. When the leather dries, the dye is applied and left to dry for 12 to 24 hours, depending on the humidity and temperature. Other dyes are formulated with an alcohol or solvent base, making preliminary preparation of the leather unnecessary, and they can be applied directly.

Markers

Common markers can also be used to color the surface of the leather. They are perfect for outlining and coloring small areas or details.

▼ Dyes.

Tools

For Cutting

Drive Punches

These metal tools consist of a cylindrical body with a handle at one end and a head with a cutting edge at the other used for making holes in leather. Punches can be round, oval, and even geometric in shape (star, semi-circle, triangle, etc.). To make the cuts, the punch is held perpendicular to the surface of the leather and struck on the end with a mallet.

Thonging Chisel

The fork-like metal thonging chisel has a handle and several cutting edges at the other end. It is used like a punch for cutting incisions that will be used for sewing the leather. The tongs can be straight or angled, and there are many different models that can have up to eight or ten prongs. The cuts measure from 3/32 to 5/32 inches (2.4 to 4 mm).

Fid

This instrument has a long and thin metal point with several faces and a wood handle. It is used for making holes and enlarging incisions when sewing.

Cutting Burins

These tools are often homemade, and have a wood handle with a sharpened metal point at each end. The different shaped points have a sharp edge and point that is used for marking and cutting the grain side of the leather.

Swivel Knife

The cylindrical metal handle of this tool holds a blade at one end and a concave piece at the other that swivels on an axis. It is used for making the initial cuts and for final touching up according to the requirements of the design. It is held by placing the first joint of the index finger on the end and holding the handle between the thumb and middle finger of the same hand. Pressure is applied to the blade with the index finger to control the depth of the cut while the other fingers guide and move the blade to make the cuts in the desired shapes.

Swivel knives have replaceable blades of several shapes, sizes, and materials. Among these are straight blades, wide cutting blades, double cutting blades (which are used to cut two parallel lines), blades with several different angles, and even ceramic blades that are ideal for very hard and tough leathers.

Adjustable Gouge

This wood-handled tool has a U or V shaped blade used for cutting shallow grooves in leather. A small mechanism in the shaft, or handle, of the tool is used to adjust the blade to regulate the depth of the grooves.

French Edge Skiving Tool

This is a steel blade with a sharpened chisel-like cutting profile (or mouth) attached to a wood handle. The cutting edge is flat and wide and has vertical sides. It is used for grooving and cutting the surface of the leather.

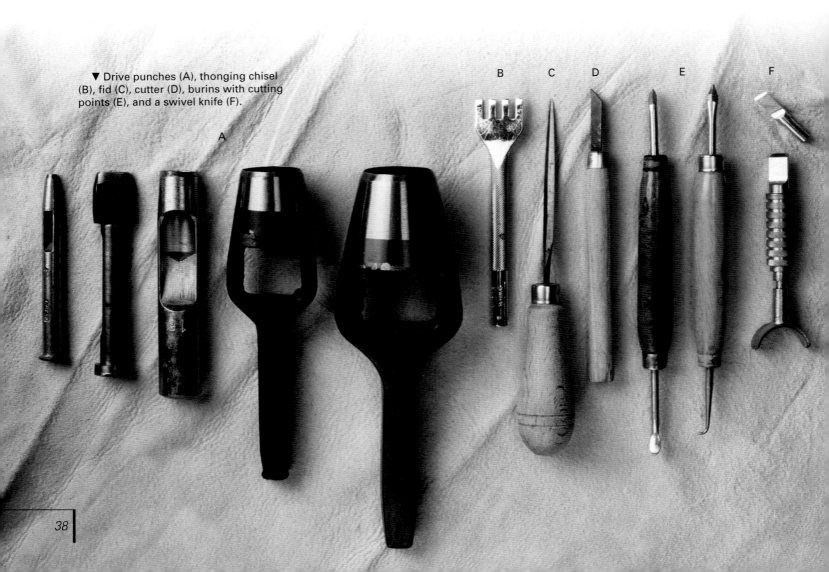

▼ Drive punches (A), thonging chisel (B), fid (C), cutter (D), burins with cutting points (E), and a swivel knife (F).

Edge Bevelers

These chisels have a blade in the shape of a claw that is sharpened on the inside edge. They are used for finishing leather by beveling the edges and for making grooves on the surface of the leather.

Skivers

Skivers are used to reduce the thickness of leather. They consist of a flat blade 1 to 2 inches (3 to 5 cm) wide, sharpened at the slightly rounded end and mounted to a wood handle.

Super Skiver

This is an all-metal tool with replaceable blades that can be used to reduce large areas of the leather.

Chisels

It is also possible to use regular wood carving chisels for making special cuts. They are available with both U and V shaped blades, and are mainly used for finishing edges and making wavy and grooved cuts.

Cutters and Scalpels

Cutters with disposable blades usually have plastic handles that contain a cutting blade inside that can be extended as needed and easily replaced. They are used for cutting leather.

The scalpel is a surgical instrument used for making clean deep cuts. Used for very precise cutting, its steel blade is mounted on a steel handle. There are "fixed" or one-piece scalpels, and scalpel handles that allow the blades to be changed.

Shears

This common tool is made of two pieces of sharpened steel with a point at one end and a hole for holding it with your fingers at the other end. The two parts are connected with a screw or rivet that allows them to rotate. They are used for cutting all types of leather. Serrated shears have a zigzag pattern on the blade that will make a cut with a similar design on the edge.

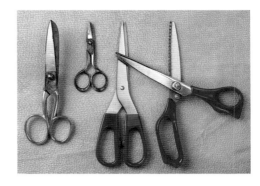

▲ Shears: normal and serrated.

▼ Chisels (A), cutters (B), and scalpel (C).

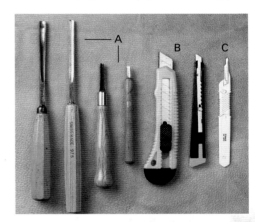

▼ Adjustable gouges (A), edge skiving tool (B), edge bevellers (C), skiving knives (D), super skiver with blades (E).

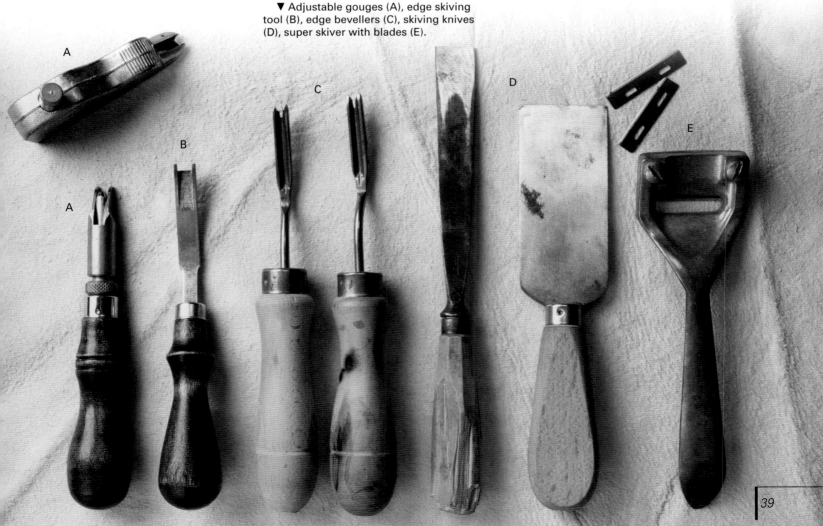

For Die Stamping

Dies

These steel pieces with rectangular and round shafts have a relief design at one end. The design is stamped or imprinted on the leather by holding the stamp perpendicular to the surface of the leather and striking the end with a mallet.

For Embossing and Stamping

Spade Point Modeling Tool

These are modeling tools with a spade point at one end that are used for chiseling deep lines and angles on the grain side of the leather. Tools with a diamond-shape point are used for creating small details and making very sharp lines.

Stylus Modeling Tool

These modelers, with a point on one or both ends, are used for marking the grain by tracing the lines or the shape of the desired design and for making lines in the stamping technique. They are also called tracers.

Curved Stylus Modelers

These modelers, with a curved point on one or both ends, are used for tracing lines in the same way as the previous tools, and for marking small details and areas on the grain side of previously embossed forms.

Spoon Modeling Tool

One end of these tools has a curved, spoon-shaped end, which is used for working on the grain side of the leather, outlining designs that are to be embossed, creating various planes by flattening the surrounding area. These tools are especially useful for creating small details.

Ball Modeling Tool

These are modelers with a ball shape at one or both ends, usually of different sizes. The large balls are used for creating relief with repoussé, from the flesh side. The small ball is for smoothing the grain side of the leather and for accentuating relief work from the flesh side.

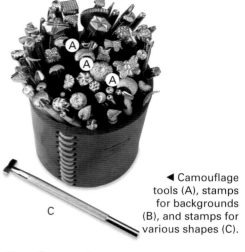

◀ Camouflage tools (A), stamps for backgrounds (B), and stamps for various shapes (C).

For Stamping

Camouflage Tools

These tools have a half-moon shaped surface. They are rounded with a striated pattern, and come in a large number of sizes and different line patterns. They, and all stamping tools, are used like modeling tools to create textures in designs made with the swivel knife. Depending on the desired effect, the motif can be stamped completely, on just one of the sides, or on the bottom part of the half-moon shape.

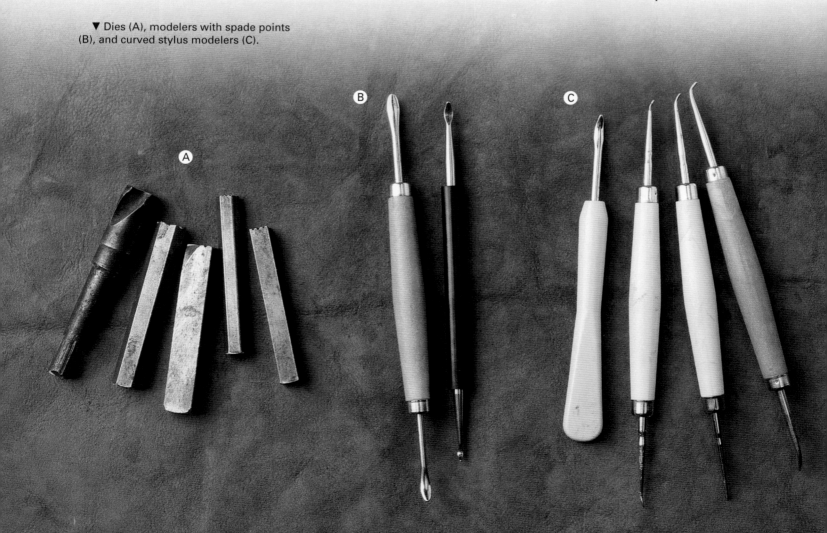

▼ Dies (A), modelers with spade points (B), and curved stylus modelers (C).

Shader Tools

Shaders are stamping tools with a pear, or water-drop shape, that can be smooth, reticulated, or have vertical or horizontal striations. They are used to make the general shape of the design, flattening the surface of the leather to create areas with a slight depression and a darker tone than the surrounding area to create the illusion of shading. This effect is achieved by moving the tool slowly across the leather as it is lightly tapped with the mallet.

Beveler Tools

These are stamps that are beveled or angled with a round or rectangular shape and smooth or reticulated surface. They are used to add volume to the composition by creating a three-dimensional effect. This is done by tracing the outside lines of the design motifs cut with the swivel knife, with the widest part of the bevel in contact with the cut tracings.

Shapes

There are a large number of different shapes that are used to create effects (for example veins of leaves or borders) and for stamping complete motifs (animals, plants and flowers, geometric designs, textures, etc.).

Backgrounds

Flat, rectangular stamps and pear-shaped stamps with reticulated surfaces are used to create backgrounds of worked leather compositions. They lower or depress the surface around the area of the central motif so that it stands out in relief, while adding a texture to the background that contrasts with the design. They are made by working in an orderly way around the composition's background area, tapping lightly with a mallet.

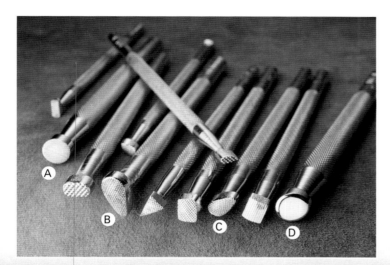

▶ Bevelers (A, D), shaders (B, C) and shapes.

▼ Spoon modelers (D) and ball modelers (E).

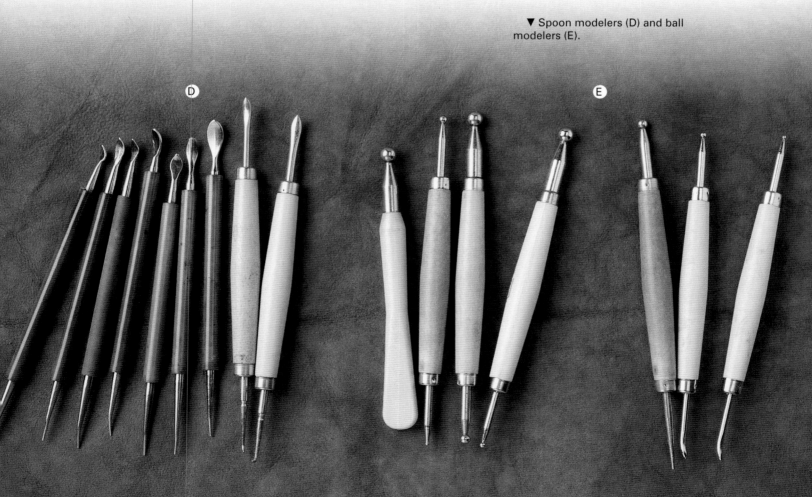

Other Tools

Different Types

Hammers and Mallets

Hammers with steel heads are used for striking stamps and dies in the stamping process to mark the surface of the leather with the desired motif or pattern, and for making holes with the punches. Mallets are used for embossing work and for striking cutting tools like the thonging chisel.

Small Brushes

Many different brands, types of bristles, and shapes of brushes are available for every task. A numbering system indicates the width of the point. Generally, they are used for painting or tinting small details, the best ones for this work being synthetic bristles.

Large Brushes

Like the small brushes, the large ones have a numbering system that indicates the width of the brush. They are made with different materials although their bristles tend to be more stiff and durable. These are used for applying glue and adhesives, and also patinas to the grain.

Wide Brushes

Wide brushes are mainly used for applying adhesives or dye evenly on large surfaces. They are also used for blending and smoothing applications of color and removing brush marks.

Strap Cutters

These are wood tools (although there are aluminum models) with a central body that has a handle at one end and an opening through the other, in which two pieces of wood with a small cutting blade are inserted crosswise. The crosspieces have marks that indicate the distance from the blade. These are firmly attached to the body of the tool with a screw that can be used to adjust the size of the desired cut. The tools are used to cut straps of hard thick leather from 1/8 inch (3 mm) to 4 inches (10 cm).

Sewing Awl

This tool is used for sewing pieces of leather quickly and easily with a very durable stitch.

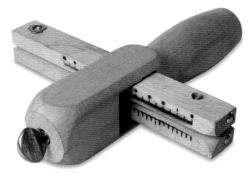

▲ Strap cutter.

▼ Sewing awl.

▼ Hammer (A), plastic mallet (B), nylon mallet (C), small brushes (D), large brushes (E), and a wide brush (F).

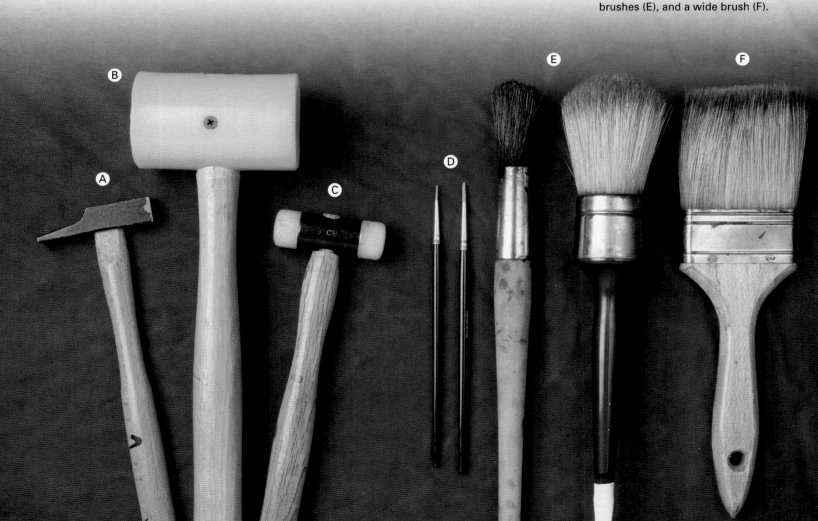

▲ Lace making tool.

► Pyrography machine and styluses.

Lace Maker

This tool is a plastic cylinder with holes of different widths at one end and a cutting blade inside. It is used to make cord and narrow strips of thin, flexible leather.

Pyrography Machine

This electrical tool consists of a transformer that is connected to an electric outlet and a stylus with interchangeable tips. Several brands and models exist, and the best ones have a temperature control. The machine is used for burning designs into the leather.

Rotary Punch

This steel tool has two handles connected by a screw, similar to a pair of pliers. It has a wheel with various punches on one side and a circular base that acts as a footing for the punch on the other side. Used for making small holes, the typical rotary punch has six punches on the wheel for making holes from 5/64 inch (2 mm) to 3/16 inch (4.5 mm). However, there are other models without wheels that have a single interchangeable punch. The best models have wheels with interchangeable punches.

Needles

These are used for hand sewing. Curved needles are used for joining pieces at an angle.

Overstitcher

This tool consists of a wood or plastic handle with a metal shaft. At the end of the shaft is a small rotating toothed disc. The tool is used to mark the placement of the holes that will be made in the leather for sewing. The discs come in various sizes and with numbers of teeth, making it possible to choose the right one for each task.

Creaser

This is a rectangular wood or plastic tool with a center point. It is used to mark the groove that will later be used as a guide for the overstitcher when marking the placement of the holes for stitching.

Roller

A heavy metal cylinder with a wood handle, this tool is used for flattening and smoothing pieces of leather by pressing on them firmly while rolling.

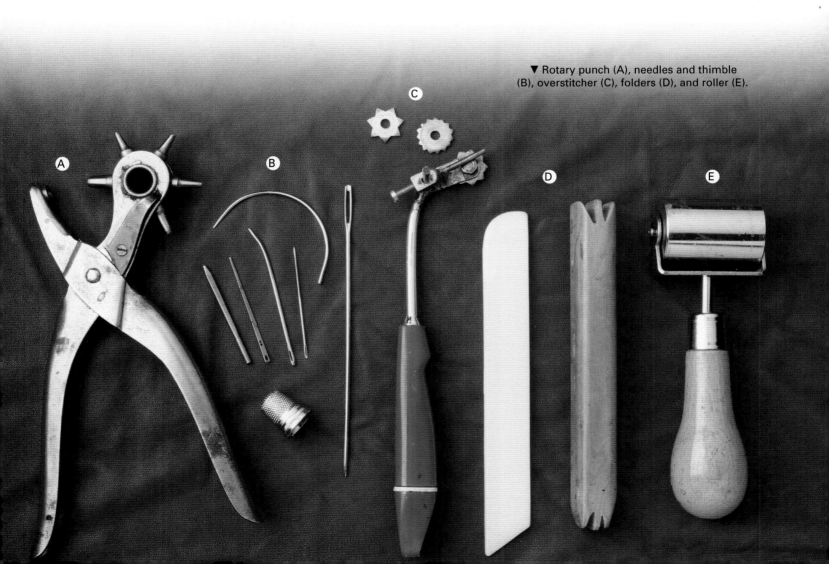

▼ Rotary punch (A), needles and thimble (B), overstitcher (C), folders (D), and roller (E).

Machines

Different Types

Hand Press

This machine, which can be firmly screwed to a work surface, consists of a base holding a stem that is moved by means of a rotating handle. Different kinds of dies can be attached to the stem, which rotates as it is lowered to the footing die below. It is used for processes requiring the use of quick and easy force, like making holes with punches and setting snaps and eyelets.

Sewing Machine

This is an electric machine based on the domestic sewing machine. However, it can be used to efficiently sew thick, tough materials like leather. It allows the stitches to be adjusted and their features changed. It is especially useful for heavy stitching and for pieces that require great precision.

Skiving Machine

An electric-powered tabletop machine that is used to skive pieces of leather. It can be adjusted to cut very precisely.

Strap Machine

Another electric-powered tabletop machine that is used to manufacture leather straps of any width. It has a sharp blade that will make very precise cuts.

▲ Interchangeable dies and bases.

▼ Sewing machine.

◄ Hand press.

Stamping Press

This is a press that will cut leather using cutting dies. It is used to quickly cut a large number of identical pieces. The tool is an electric-powered machine with an adjustable base and cutting board (generally wood on the bottom with a Teflon piece above) and a percussion head. When the pedal at the base of the machine is activated, the head forcibly presses the die against the leather, causing it to cut the piece.

Hot Stamping Machine

This is also an electric-powered machine that is used for hot stamping leather. The stamping takes place when a hot die is pressed on the surface of the leather. The machine has a thermostat and a control to adjust the temperature at all times, depending on the kind of leather, finish, and type of stamping involved. The metal die is attached to a head, and when it has reached the desired temperature, it is pressed against the surface of the leather by pushing a lever.

▲ Skiving machine.

◀ Strap machine.

▼ Stamping press.

▲ Samples of two pieces of skived leather.

▶ Hot stamping press.

Techniques

*I*n this chapter we explain in detail the main techniques for working leather, specifically vegetable-tanned leather. We will begin with basic techniques, starting with cutting, which anyone who wants to learn this discipline must know, and progress to the most elaborate techniques where even those who already know the basics will find useful tips that will help them develop and enrich their work. This chapter also includes options offered by multiple finishes. These technical processes are presented in such a way that they can serve as a guide for any task in the shop. They will also allow the reader to move at his or her own pace and to gradually undertake more complex processes.

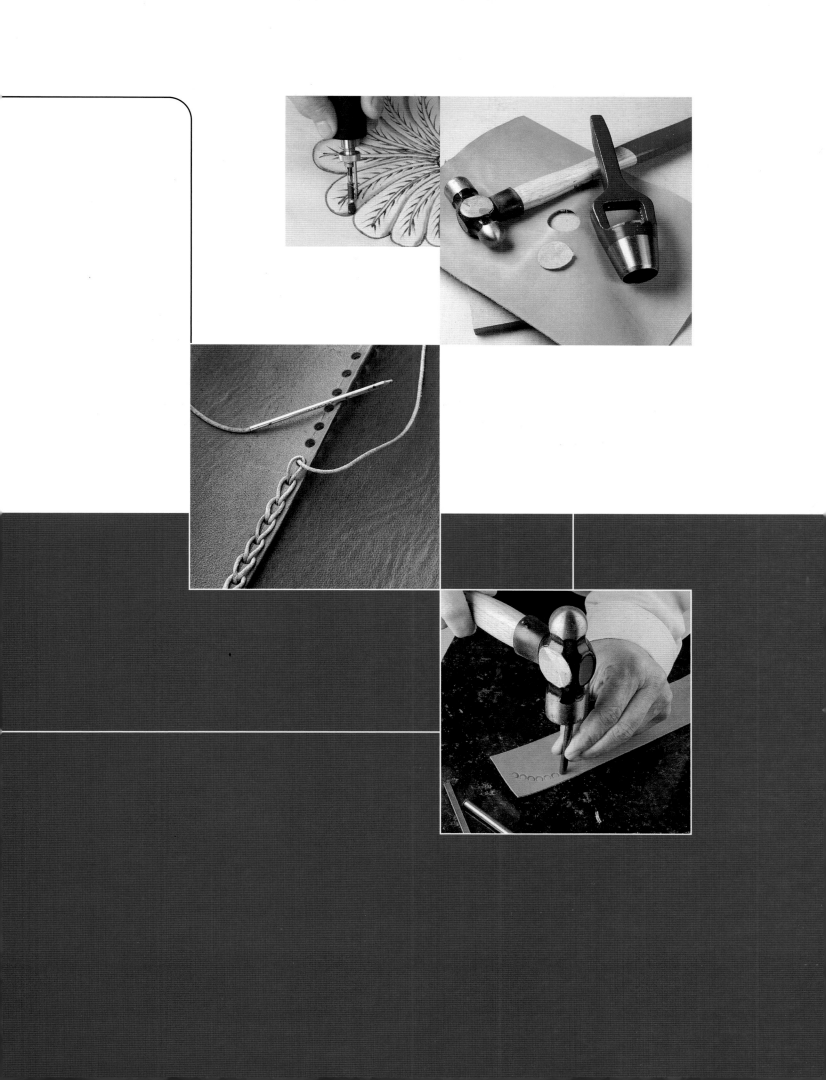

Cutting

▲ Mar Cadarso, *Plan of the Old Section in Vitoria*, 2004. Pierced cowhide in various tanned colors, 31 1/2 × 23 5/8 × 1 3/16 inches (80 × 60 × 3 cm).

Cutting is the first process that must be mastered by anyone who wants to work with leather. It is the first step in the work done in the shop and, though not very difficult, it requires attention. The cut can be made directly, cutting the leather pieces needed for the project in the shop with a drill, or by skiving the leather.

Direct Cut

This step is carried out in the shop to make the pieces of leather based on the chosen design. The operation consists of cutting the pieces themselves, beveling the edges and cutting the lacing.

Cutting Heavy Leather

Due to the characteristics of the material, although the process in essence does not differ from cutting any other variety of leather, such as calfskin for example, cutting vegetable-tanned sole leather requires some attention. These cuts are always made using a square or metal ruler and going over the line several times with the blade or utility knife. Although this is not difficult, it is important to keep in mind that all cuts must be perfectly planned; otherwise some material can be ruined.

PROBLEMS
Cutting sole and other types of leathers requires practice. A common problem when going over a cutting line for the second time is placing the blade slightly outside the first cutting line or straying away from it by accident, as is the case here. Both cases damage the material. To avoid these problems, it is important to hold the square or ruler firmly in place and to cut steadily but slowly, without applying pressure, moving the blade along the line guided by the square or ruler.

◀ **1.** To cut, we place the square or the ruler (as is the case here) at the required place. We press firmly against the sole with one hand while handling the blade with the other. The cut is made from the outside in, towards us.

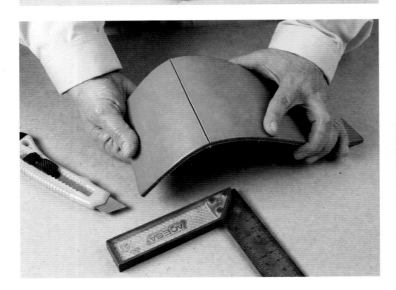

▲ **2.** After making the cut, we separate the cutting line, "opening" it. It is important not to apply too much pressure or the material will tear rather than cut and the leather will be ruined.

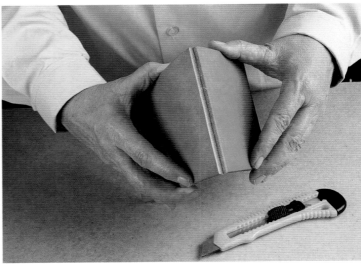

▲ **3.** We pass the blade one more time along the cut line, without straying from it, and we open the line as we did before. This process is repeated until the piece has been cut through completely.

▲ 1. First, we define the cutting area by marking a reference line to cut with the gouge. The leather is held firmly in place with one hand to prevent it from moving. With the other hand, we hold the adjustable creaser perpendicular to the surface of the leather. We slide it from the outer edge towards us, applying pressure. This makes a line or a crease (from which the tool gets its name) that will be used as a cut guide.

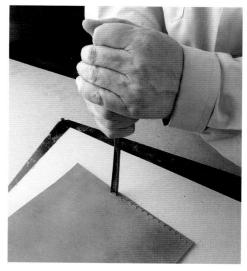

▲ 2. The piece of leather is placed on a hard, resistant surface, in this case marble covered with a piece of heavy cardboard. Following the marked line, we hold the gouge perpendicular to the surface of the leather and we cut it by pressing firmly.

▶ 3. The result is a piece with a wavy border.

Cutting and Outlining Borders

The use of specific tools makes it possible to create pieces that have different borders and finishes. A gouge, which is a type of tool used by other disciplines, particularly wood carving, can create borders with different geometric shapes. To make this cut, we mark the cutting line with an adjustable creaser, defining a line that will serve as a guide and as a border that will be cut with a gouge.

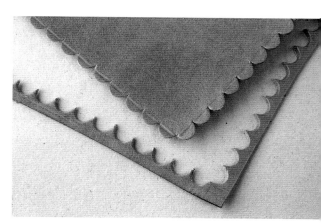

Lace Making Tool

It is very easy to make your own laces and cords in the shop as needed for each project. This impacts directly on the final quality of the piece. Making laces of the same color and material as the leather used in the project, or of a different one that complements it, opens up a wide range of possibilities in terms of form and color. Also, using custom-made lace or cord that fits the project perfectly will enhance the final product. It is important to note that these pieces are readily available when needed without having to buy them in the store.

To make lace and cords, we use thin, flexible leather (as opposed to straps, where the leather is somewhat thicker and stiffer), and we cut it with the lace-making tool. To do this, it is important to make a hole with the punch in the center of the piece of leather chosen, then insert the blade to make the first cut on the edge of the hole and then continue cutting the lace carefully by pulling by the end.

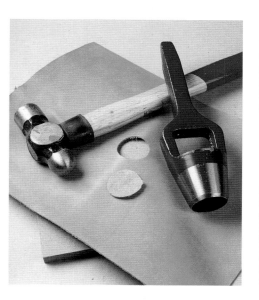

◀ 1. We use the punch to make a hole in the center of the piece of leather. To do this, we place the leather on a hard, resistant surface (in this case a piece of plywood). We hold the punch perpendicular to the leather, holding it firmly with one hand and tapping the handle with the hammer to make the cut.

▶ 2. After making a small incision with scissors, we insert the top of the blade in the hole so the cutting blade makes contact with the edge. Then with a slight movement of the blade, we start the cut in the leather. The lace is pulled firmly from the end to create a length of lace cut to our specific needs. The piece of leather turns around the blade when cutting the lace or cord.

Die Cutting

Die cutting is ideal for projects that require a large number of identical pieces. Only making a sufficient number of pieces from the same design justifies the investment required for manufacturing the cutting die, which must be done by a specialized company, as well as the cutting itself, which must also be carried out by a company with specialized equipment. Therefore, this creative approach (because it does require a specific prototype from which to make the dies) and cutting method require specialized manufacturing which increases the cost of the pieces.

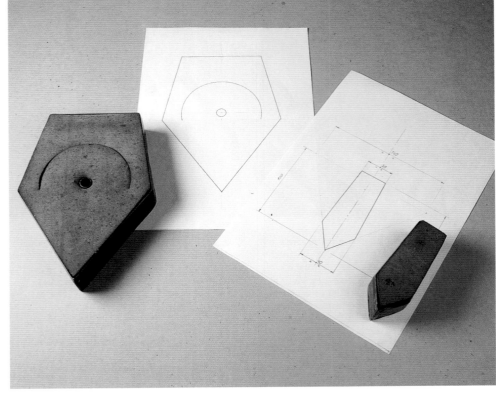

▲ **1.** We create the design to make the dies, which will be made by a company specializing in such products. In this case, there are two pieces involved, which will become part of a clock, the circular dial with the supports and the crosspiece that will hold the parts together. The larger die will be used to create the parts, to cut the dial and to carve out the central hole where the spigot that holds the clock's hands will be inserted.

▲ **2.** We place a piece of sole leather (a variety of leather that we use for this project) on the teflon board of the die cutting machine with the grain side facing up, and we place the die with the cutting side over the leather, as appropriate. We activate the machine and cut out the shape.

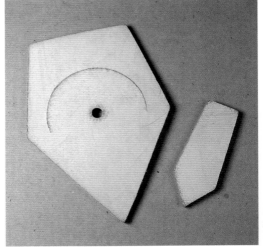

▲ **3.** Here are the two precision-cut pieces based on the design.

▶ **4.** View of the mounted and finished clock.

Gouging

As its name implies, this technique consists of creating a series of designs by making a deep cut on the surface of the leather; in other words, carving out a line on the surface. Therefore, gouging could be considered a technique that belongs to the category of finishes or decorating. However, we use cutting tools because it is included in the section on cutting. To make a deep cut, we use an adjustable "V" gouge, whose blade has been set according to the depth desired. It is important to mention that this technique produces very interesting results if the leather is not painted or dyed all the way through, as is the case here where it has been air brushed, because the lines stand out vividly against the grain.

▲ 1. First, we make a pattern with the motif or design that we wish to create on the leather. In this case, we decided to make a free interpretation of Antonio Gaudí's mosaic art. We cut out a piece of leather (to be used later as an appliqué) of the desired dimensions.

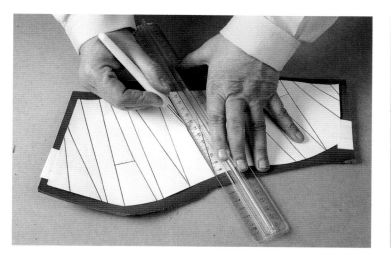

▲ 2. We secure the paper pattern on to the leather with masking tape. We mark the design with the awl, using a ruler to make perfectly straight lines. Then, we remove the pattern.

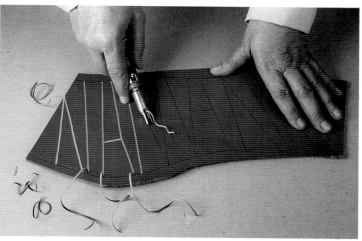

▲ 3. We adjust the gouge's blade according to the desired cutting depth. We make the cuts following exactly the marked lines and staying within.

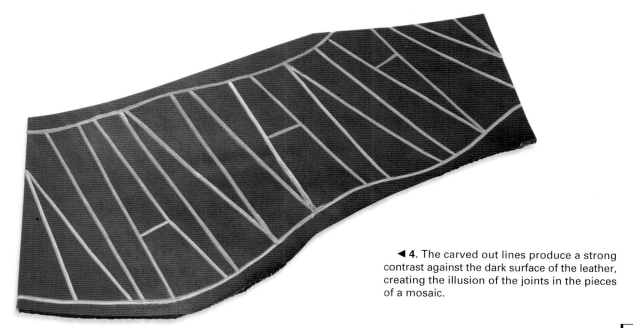

◀ 4. The carved out lines produce a strong contrast against the dark surface of the leather, creating the illusion of the joints in the pieces of a mosaic.

Stamping

The stamping technique consists of working the leather by marking the surface using different methods. The imprint can be created by stamping with dies, or with pyrography, using a die or a hand held tool. All approaches are equally considered stamping, but the methods and the results are very different. While stamping with dies is limited to creating geometric or geometric-like designs, pyrography can be used for any type of design, no matter how complicated it may be.

Die Stamping

Die stamping consists of marking the surface of the leather to create a relief design or effect. To do this, we basically use stamps that can be purchased in the store and that are available in a wide range of designs depicting figures or geometric motifs. However, it is also possible for the artist to make his or her own stamps by altering screws or nails with a small saw for cutting metal until the desired form or shape is achieved.

This type of stamping is always done when the surface of the leather is completely dry, as opposed to another technique, which is often called carving, with which it is sometimes mistaken and that is done on wet leather. Basically, it consists of making an impression of a motif by tapping the end of the punch with a hammer. The leather must be thick enough (more than 5/64 inch or 2 mm thick) to prevent the punch from piercing it through.

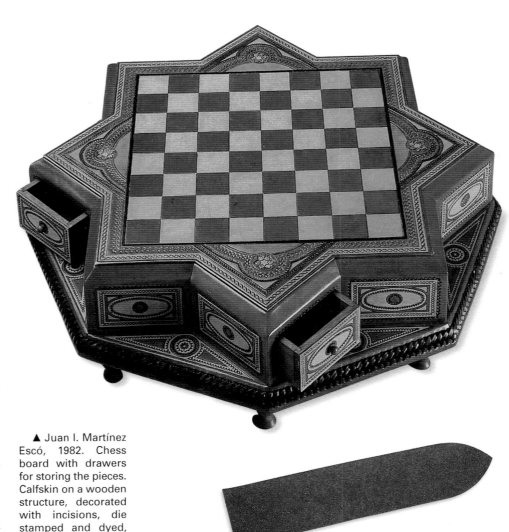

▲ Juan I. Martínez Escó, 1982. Chess board with drawers for storing the pieces. Calfskin on a wooden structure, decorated with incisions, die stamped and dyed, and with an added decorative braided border.

▲ 1. After the leather has been selected, the stamps are chosen. If needed, a pattern of the design can be used, which in this case is made of cardboard. In this example we will make a bookmark with a decoration inspired by a medieval design.

◀ 2. We place the pattern carefully centered on the piece of leather according to our design. We mark the outline (in this case, a traditional Gothic pointed arch) with the awl. The line will serve as a reference for stamping the selected designs.

▶ **3.** Using a metal ruler we make eight cuts on one end of the bookmark, creating a fringe with nine strips as a decorative trim.

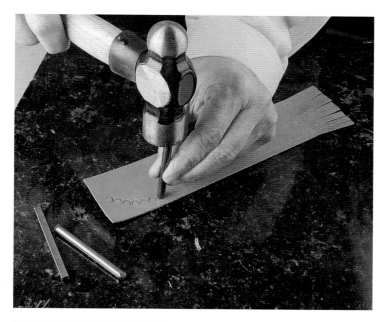

◀ **4.** Then, we proceed with the stamping. To do this, we place the bookmark on a hard and resistant surface (a piece of marble in this case) and we stamp the half-moon motifs below the design line first, as a border. We position the stamp where required, perpendicular to the surface of the leather, and we tap on it with a hammer. Each design will be made with a single strike, always tapping with the same force if possible, to avoid uneven depths and differences in tones.

◀ **5.** We do the same with the punch that has a floral tip with four petals, alternatively marking the outer side of the half moons including all the ones that form the arch and the lower part of the composition. Then we mark the empty spaces with a stamp that has a diamond shaped motif.

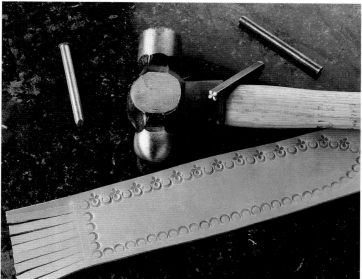

◀ **6.** View of the finished bookmark.

Pyrography

As its name indicates, pyrography is a method that makes the impression of the design on the leather by burning it with heat. The two systems used are plates made by photoengraving for hot stamping and pyrography. Both techniques provide a wide range of possibilities for creating elaborate designs, without other limitations than those stipulated by the design itself. But while the hot stamping is limited by the machine, that is, by the dimensions of the plate, pyrography can be applied over the entire surface of the leather creating solutions of great artistic value.

Photoengraving

This method, like the one using stamps, is ideal for projects in which the same design is to be engraved on a series of pieces. This is the only case that would justify ordering a plate, which would have to be made by a company specializing in photoengraving, and stamping or engraving with heat by a specialized shop with the specific equipment. The plates are made of metal on which the desired design can be reproduced in relief with the photoengraving method. The plates are mounted on a hot stamping machine, and when the required temperature is reached, the impression is transferred to the leather by applying pressure. Any design can be reproduced cleanly and accurately using this method.

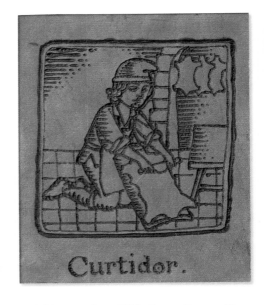

▲ Tanner, circa 1970. Decorative motif on an album with illustrations of the tanning process, modern reproduction of a Catalonian tile depicting 19th century trades. Pyrography on sheepskin. Museu de la Pell d'Igualada i Comarcal de l'Anoia (Barcelona, Spain). 3 3/4 × 3 1/8 inches (9.5 × 7.9 cm).

▲ 1. First, we make the design. In this case, a floral motif and a butterfly.

◀ 2. The plates with the motifs are made by a specialized company; in this case they are made of magnesium 1/4 inch (7 mm) thick.

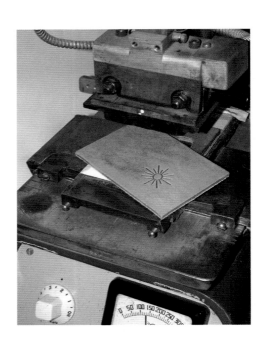

◀ 3. The imprint is made with specialized equipment. After the working temperature of the machine has been adjusted according to the type of leather, the motif is stamped by pressing for a few seconds on the grain side. The result is a very clear and precise image, no matter how small the design may be.

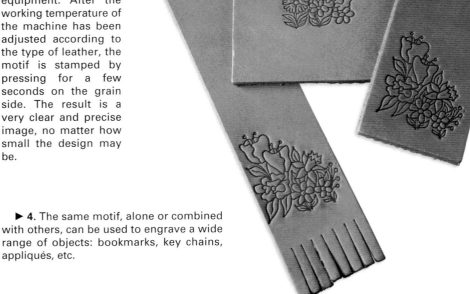

▶ 4. The same motif, alone or combined with others, can be used to engrave a wide range of objects: bookmarks, key chains, appliqués, etc.

Pyrography

Pyrography consists of marking the surface of the leather by applying heat, burning it to make the desired designs. This technique can be used to create art-quality forms and shapes because the tips are interchangeable and the temperature can be adjusted. It can only be used on untreated vegetable or chrome-tanned hides, because other finishes could make moving the tip on the surface difficult or produce unwanted effects. It is very important to control the working temperature since the marks cannot be corrected; therefore, it is always a good idea to run a few tests before beginning any project.

This time, we have chosen a palm tree design from a relief at the Palace of Assurbanipal in Nineveh (ancient capital city of Assyria) that dates back to 668–626 B.C.E.

▲ **1.** We trace the motif on vegetable paper from an enlarged photocopy. We transfer it to the leather (in this case we use unfinished sheepskin), previously wetted, tracing it with the stylus. In our case, we have made the stylus using a pen shaft and a very thin crocheting needle.

▶ **2.** With the burner set at medium hot, we mark the lines of the design using a medium rounded tip. If the temperature were high, the leather would burn too much and the lines would be too wide, deeper and darker than needed.

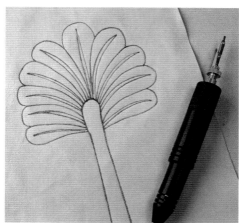

▶ **3.** We mark the leaf veins extending them from the central nerve out with a beveled tip and with the thermostat set at medium temperature.

◀ Half round point with a double-bevel tip.

◀ **4.** To make the trunk of the palm tree we mark the place where the dead leaves formerly grew on the trunk with the round tip and the temperature set at medium hot as well. The marks are made with a horizontal overlapping configuration.

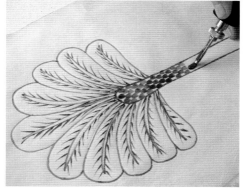

◀ Round spatula style tip.

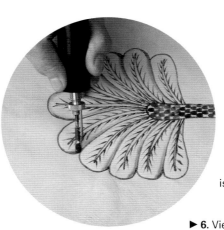

◀ **5.** Finally, we do the shading of the leaves with the same round tip, this time set at low temperature. We go over the inside lines as many times as needed until the desired tonality is achieved.

▶ **6.** View of the finished pyrography work.

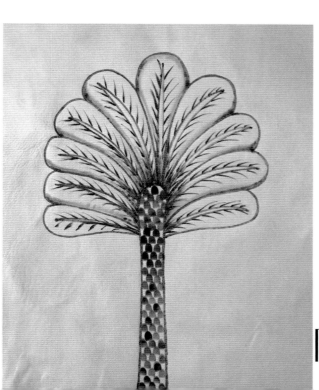

Repoussé and Embossing

The repoussé and embossing techniques are based on the same principle, the creation of relief motifs on the leather. Even though the techniques used are different (in fact they are almost opposite to each other and yield completely different results), they are often confused. So, while repoussé consists of making relief motifs by working the leather from both sides, embossing consists of making small incisions on the surface and then creating relief motifs by working the leather on the grain side.

Repoussé

Repoussé is a decorative technique that consists of making a relief design on the leather, creating one or several motifs and giving them a three-dimensional appearance. Unlike carving and embossing, in repoussé the leather is worked mainly from the flesh side, pressing it to raise the leather to form relief. However, it is also worked from the grain side. It is a process that combines working on both sides: from the flesh side to give it volume and from the grain side to outline and to define areas.

Repoussé is done on vegetable-tanned leather. The most suitable type is calfskin, especially 3/64 and 1/16 inch (1.2 and 1.5 mm) thick pieces, although some artists prefer thicknesses greater than 5/64 inch (2 mm). The leather is dampened slightly and the design is transferred to the grain side, then the motif is outlined with the appropriate modelers. Next, the leather is worked from the flesh side to give it volume. The process continues by working both sides of the leather alternatively, using different awls until the desired figures are achieved. To get good results with this technique, the leather must be somewhat flexible; therefore it may have to be dampened several times during the process.

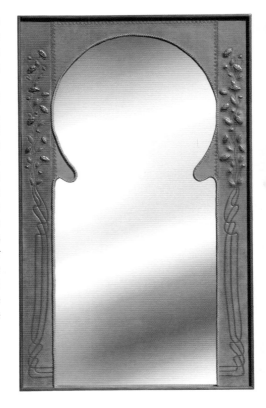

▲ María Teresa Lladó, *Mirror,* 1998. Repoussé on calfskin with incisions, engraved and dyed, decorative braiding, wood support, 50 × 30 × 1 3/4 inches (127 × 77 × 4.3 cm).

▼ **1.** The design is drawn on paper; in this case we have selected a marine design, a sea shell, with repoussé.

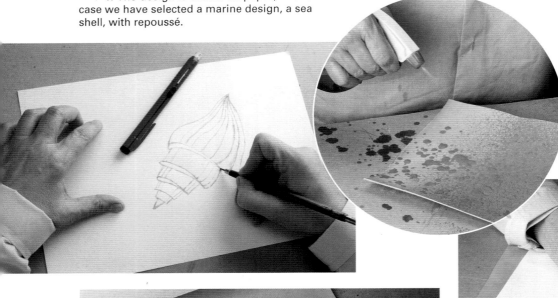

◄ **2.** We use calfskin measuring between 3/64 and 1/16 inch (1.2 and 1.5 mm) in thickness. We wet the surface of the leather evenly (grain side) with a spray bottle full of cold water.

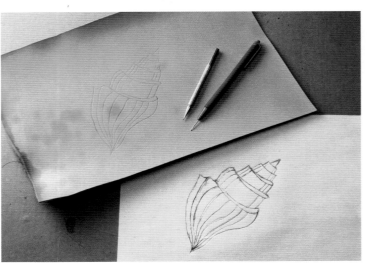

▲ **3.** We place the design on the calfskin and we secure it firmly with clothespins to prevent it from moving. We go over the lines with the tracer applying pressure to make an imprint on the leather.

◄ **4.** The design appears printed on the grain side of the calfskin.

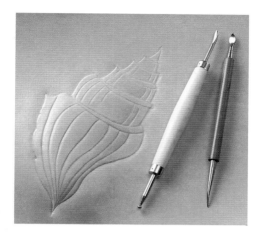

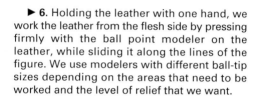

▲ 5. We trace around the design with a deer foot or curved point modeler. Next, with the small ball modeler we go over the inside lines of the seashell.

► 6. Holding the leather with one hand, we work the leather from the flesh side by pressing firmly with the ball point modeler on the leather, while sliding it along the lines of the figure. We use modelers with different ball-tip sizes depending on the areas that need to be worked and the level of relief that we want.

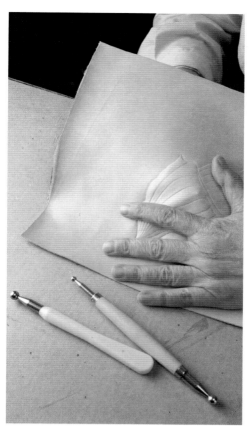

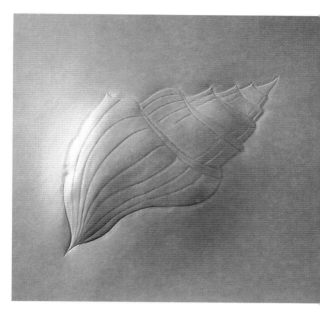

▲ 7. A view of the figure in relief. It contrasts with the rest of the leather, but it still does not have the proper relief of a seashell.

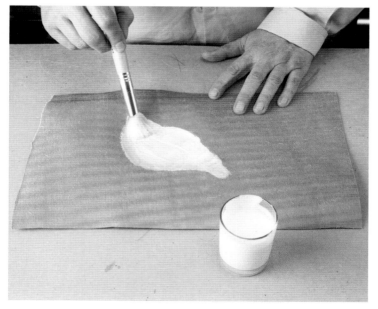

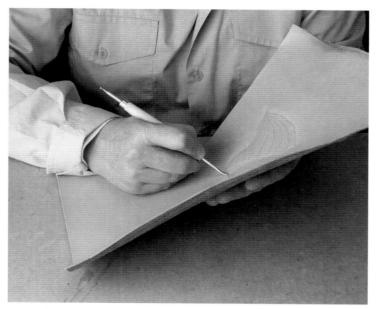

▲ 8. Once we achieve the desired volume, we apply white glue on the reverse of the figure (flesh side) to harden the leather and to make it hold the shape. We let it dry for about 12 hours. When the glue is dry it turns into a resistant and flexible film that helps maintain the shape and makes it easier to continue working on it.

▲ 9. We mark the lines of the shell with a spoon end modeler. We press gently on the grain side, modeling the lower part of each section, just above the line that marks the joints of the valve's spiral forms, and we outline the body. To do this, we use a modeler with a very narrow spoon end with a slight curve.

◄ Modeler with a very narrow spoon end.

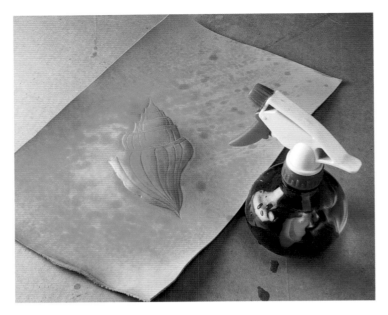

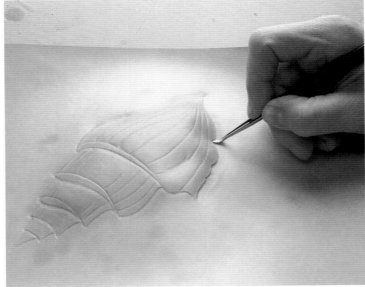

▲ **10.** We moisten the surface of the leather evenly with a spray bottle to make sure that the leather stays flexible and able to be worked.

▲ **11.** We mark the small spaces and small details of the seashell on the grain side, using the narrow point spade-end modeler and pressing firmly over the areas with very narrow spaces.

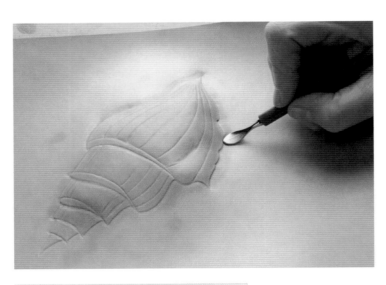

▲ Diamond point spade-end modeler.

◀ **12.** The rest of the seashell's outer contour is marked from the grain side, following the outlines of the wavy sections and flattening, at the same time, the surface of the leather that surrounds the figure. To do this, we use the spoon-end modeler with a medium round tip.

◀ Spoon-end modeler with a medium round tip.

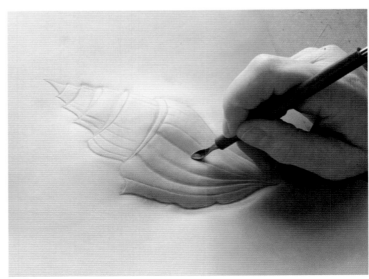

▶ **13.** We mark the depressions of the shell, outlining them with a spoon-end modeler to give it volume. The central depression of the design is deeply marked, while the depressions located to its sides are modeled from the inside out. This is how we give the figure a feeling of volume.

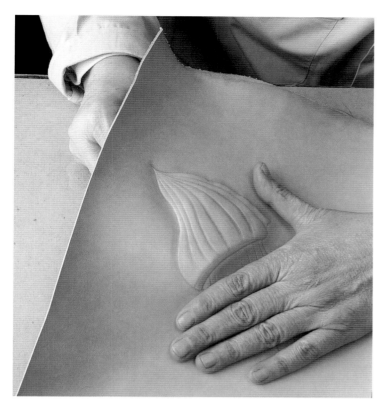

▶ 15. We outline the curve with a round spoon-end modeler, pressing firmly on the grain side over the area located immediately next to the line that marks the end of the curve.

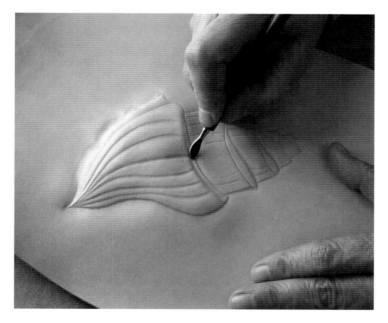

▲ 16. We go over again with the same modeler, flattening the area between the two curved lines. We continue with this process for the remainder of the design.

▶ 17. View of the seashell with the finished repoussé.

◀ 14. Now, we continue working the repoussé from the flesh side. We work on each of the areas between the depressions separately, following the design in such a way that the central section will have the highest relief, while its sides will have less, decreasing toward the outside. The work always follows the sinuous shape of the design. We use a modeler with a small ball point.

◀ Modeler with a small ball point.

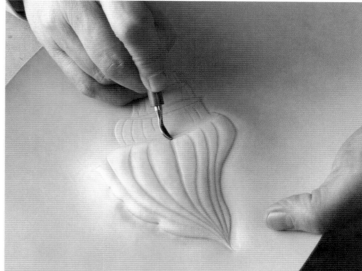

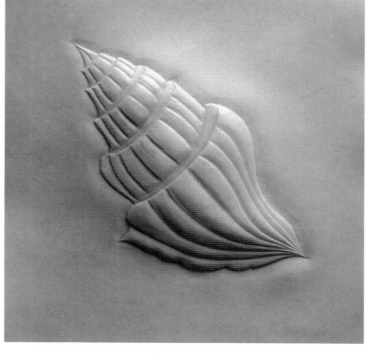

Embossing

This technique is essentially based on the process of cutting the surface of the leather to create the desired motif, and later making depressions in certain areas to create different levels and to give the composition the appearance of relief. When the design has been traced on to the leather, which should be wetted beforehand, we make a few incisions on the surface on the grain side with a swivel cutter following the lines of the design. Then, using different stamps we apply texture, make creases to create shadows, create volume, and make the background or apply details.

This technique has been used traditionally to create figurative work, although it is suitable for any type of design if the stamps are used in creative ways and according to the needs of the project rather than limiting ourselves to traditional designs.

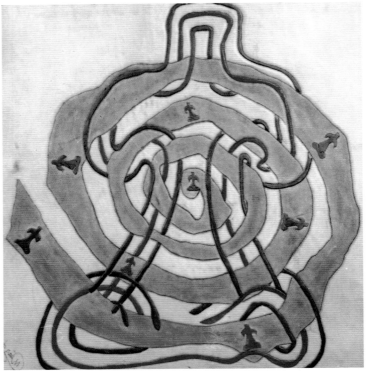

▲ Miguel Díaz de Castro, *Maternity*, 2002. Stamped and dyed leather, 19 × 19 inches (50 × 50 cm).

◄ **1.** The stamping is done on a piece of vegetable-tanned, natural color untreated cowhide, 1/16 to 1/8 inch (2 to 3 mm) thick; for this project we have selected leather from the shoulder area. First, we moisten the leather on both sides with a generous amount of water.

▶ **2.** We place the drawing done on tracing paper on the leather, with the marked side facing up and press over the lines with the tracer. Both sides are held in place firmly, in this case with clothespins.

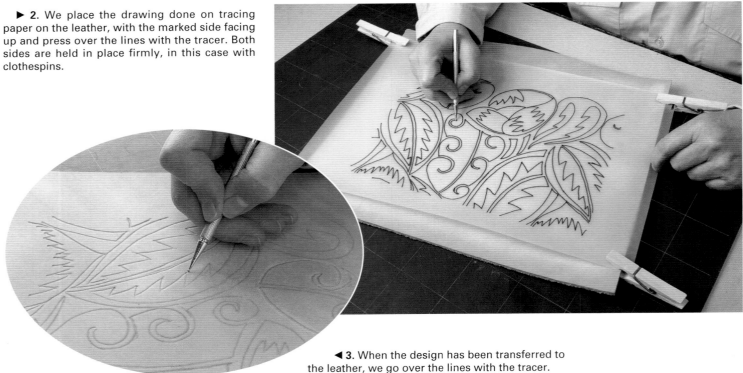

◄ **3.** When the design has been transferred to the leather, we go over the lines with the tracer.

The swivel knife is used by placing the first joint of the index finger on the upper handle and holding the swivel shaft between the thumb and middle finger of the same hand. Pressure is applied on the knife with the index finger while the rest of the fingers are used to direct the blade in the right direction and to maneuver it to make the desired cut. The blade is held at an angle when making a cut, always moving it from front to back, that is, towards the person making the cut.

▲ **4.** The lines are cut with a swivel knife. It is important to be very careful not to stray off the lines or not to make two cuts over the same line.

◄ **5.** The centers of the leaf motifs will have depressions. The points are marked with punches that have design tips, by holding them vertically against the surface of the leather and making the impressions by tapping with the mallet only once.

To do this, here we have used two different design tips depending on the motif's size and placement. All the motifs shown in this section are enlarged 35% to better appreciate them.

► **6.** The inner contours of the motif are outlined with the beveled punch. We make a depression around the perimeter of the design, which will create the relief.

In this case, we have used two beveled punches of different sizes that fit the motif's designs.

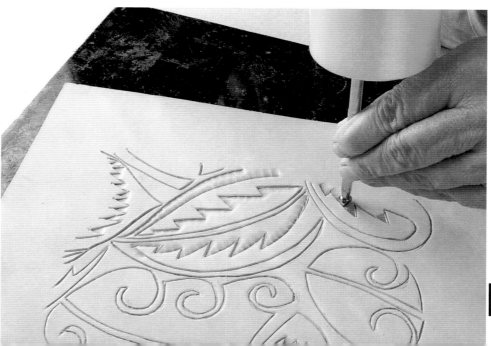

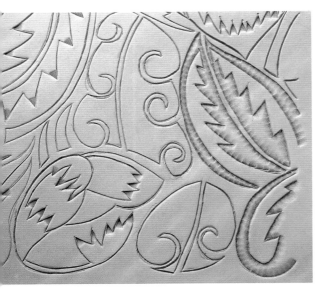

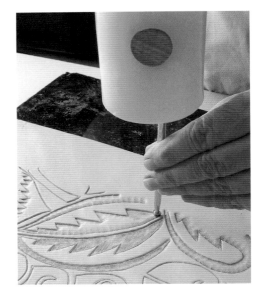

◄ **7.** View of the beveled designs. The design appears in relief, contrasting with the background areas.

◄ **8.** The inside is worked by making depressions over the entire area. We keep moving the punch to apply texture evenly over the entire figure.

To do this, we use shading tools, in this case a pear shader with a grid texture on the surface.

◄ **9.** View of the finished figures. Notice that some designs have been left with their beveled outlines, thus creating a three-dimensional effect.

▼ **10.** The figures with wavy contours have been created differently than the rest of the composition, and we have created effects by using different punches, for example, shaders (A), round beveler (B), and background tools (C).

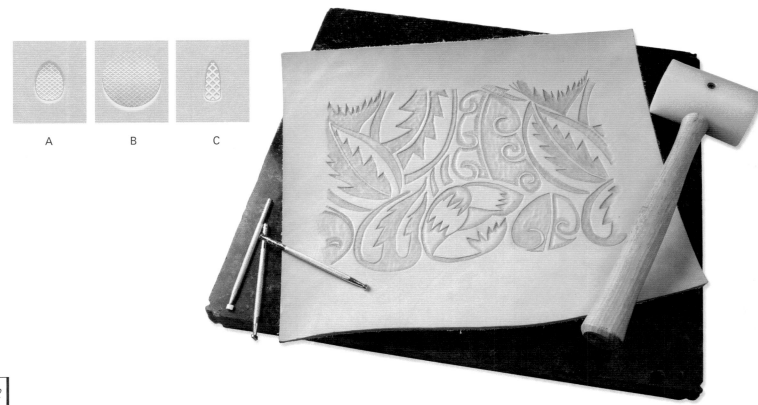

A B C

The molding technique is based on shaping leather into different forms through the use of molds. This can only be done with vegetable-tanned leather. The thinner the leather the easier it will be to mold. Extremely versatile, this technique can be used to create any type of form. The technique can be used with different molds (open or a two-part, positive or negative) and working on a base or by manipulating the leather. This method opens up an interesting array of formal and expressive possibilities where there are no limits other than those imposed by the artist.

▶ Ana Serra García, *Cuncas,* 2000. Molded leather, imprinted and dyed, 3 3/4 inches (9.5 cm) in diameter. Photograph by Manual Suárez Barreiro.

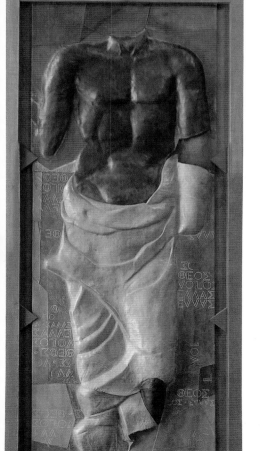

A Mold

A mold can be any object whose shape can be transferred to the previously dampened leather. In this sense, there are many possibilities for experimentation. It is possible to make a wide variety of objects, from plates and bowls to more complicated shapes. However, most of the time the artist makes his or her own molds. The range of possibilities in terms of shapes, materials, and techniques for making molds is endless. This is why we will only show a few of the possible resources here.

Molds can be made of any material. The most common ones are made of wood and clay, although plaster and several resins are also suitable.

▲ Clay is an ideal material for creating open molds. Since the leather is placed wet over the mold, it is very important to use molds whose surfaces are waterproofed with an outdoor quality varnish that is water resistant, as we did with the sun and moon molds, or else with fired clay.

▲ Maria Teresa Lladó, *Sun and Moon,* 1990. Molded calfskin, colored with dyes and markers, and waxed, 13 × 17 1/4 inches (33 × 44 cm).

◀ Juan J. García Olmedo. ΕΛΛΑΣ Ι, 1994. Sheepskin with repoussé, molded in high relief and colored with mixed technique and oils, 84 × 35 1/2 inches (213.5 × 90 cm). Photograph by Calixto Hidalgo.

◄ **1.** We use a mold made of fired clay (terracotta) to make this mask.

► **2.** To mold the mask with Asian features we use a 3/64 to 1/16 inch (1.2 to 1.5 mm) thick piece of calfskin, which has only been tanned and dried without any other type of treatment (stretching, etc.) or finish. The piece of leather is submerged in a container of water and is left to soak until no bubbles are seen coming out of it; this indicates that the leather is completely soaked.

► **3.** We wring the leather and place it over the terracotta mold. We press it gently so it molds around the different shapes. Then it is set aside for between 12 and 18 hours.

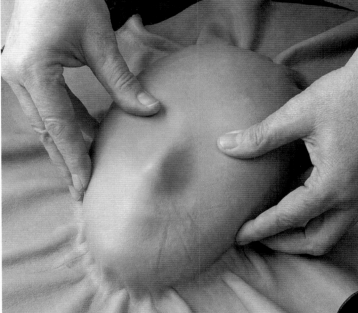

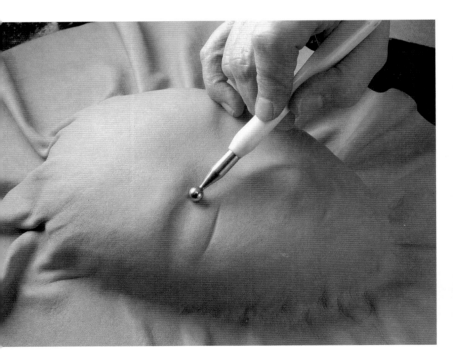

▲ **4.** Since this is an open mold with slight volumes and small details, it will be very important to use tools to create the desired form. Using the ball-end modeler we create the shape located between the eye and the eyebrow.

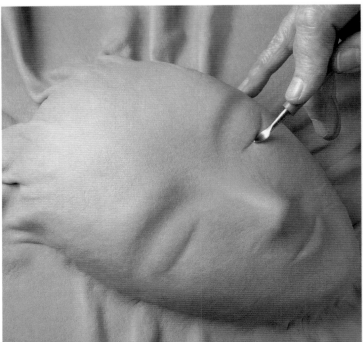

► **5.** The shape of the eyes is achieved by pressing the leather against the mold with a spade-tip modeler with a pointed end. The shape of the mouth is done the same way.

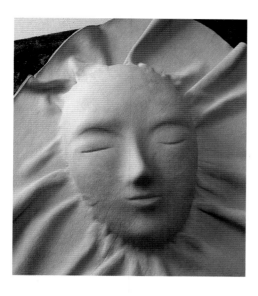

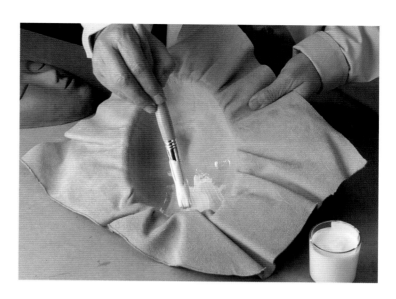

◄ **6.** We let the calfskin dry on the mold.

► **7.** Then, we remove the mold and we apply a coat of white glue (PVA) underneath to make the piece of calfskin stiff so it can hold the molded form. It is left to dry.

OTHER METHODS FOR MOLDING

Open and nailed mold		A molding system similar to the one explained consists of placing the piece of leather on a wooden open mold.
		Once the form has been molded by pressing with the hands, the lower edge of the leather piece is held by nailing it to the wood. The leather is left to dry.
		When it dries, the leather will have acquired the shape of the mold. The nails are removed and the leather is cut out above the holes left by the nails.
With a two-part mold		Molds with two matched parts can also be used to mold leather. This method, however, always requires using pieces of leather that have the same thickness, which is not always easy to find. This example is shown with a section view of the mold.
Two-part sand mold		A method for dealing with the problem of the leather's uneven thickness is to use sand for making the top mold. We place the leather over an open mold, which in turn will be placed inside another container that is large enough to hold it. We cover it with a sheet of plastic and then we cover the entire piece with sand. We put a wood board over the sand, as if it were the cover for the container and a few weights on top of it. The sand exerts pressure in every direction pressing the leather on the mold, in other words, acting as an upper mold piece. This example is shown with a section view of the mold to show how the materials are laid out.

▼ ► **8.** We continue outlining the details for the mouth and the eyebrows with different modelers.

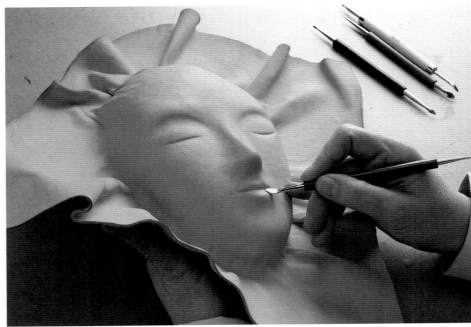

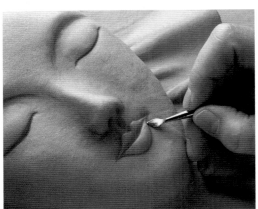

◄ **9.** We shape the mouth with a spade-end modeler and the eyebrows with a round tip spoon-end modeler.

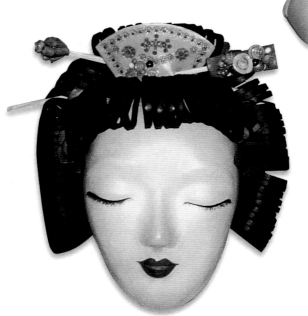

▲ **10.** View of the finished mask.

◄ 11. The excess calfskin has been trimmed off, the mask has been painted, and hair, flowers, and accessories made out of leather with different techniques have been added.

On a Support

One of the variations of the molding technique is based on shaping the leather by using a frame. Basically this consists of giving relief to the leather by creating forms on the support over which it is placed. This technique differs from molding done with molds in that it always requires the use of a support, which becomes part of the final piece. On the other hand, using molds makes it possible to create forms that do not require any support. But the use of a frame or support opens up interesting opportunities for experimenting with forms, while allowing very detailed relief work (almost high relief) that would be very labor intensive if done using any other method.

◄ Maria Teresa Lladó, 2004. Frame for a mirror made with dyed pinewood and molded calfskin over a leather cord, 10 × 10 × 1 3/16 inches (25.5 × 25.5 × 3 cm).

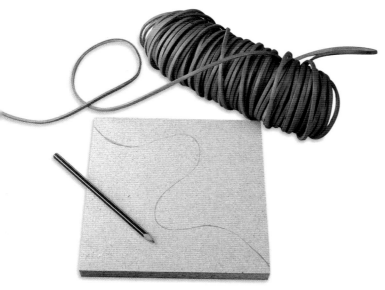

▲ 1. Wood is one of the most commonly used supports for making pieces on a frame. In this case, we have decided to make a relief on a piece of fiberboard with a leather cord. We place the cord on the wood in the desired configuration and mark it with a pencil.

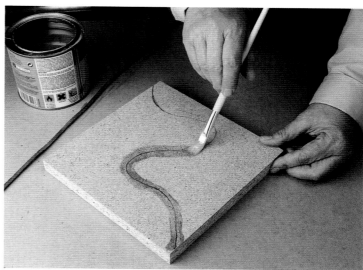

▲ 2. To attach it we use contact cement, which is applied to the cord and to the area of the wood marked with the pencil line.

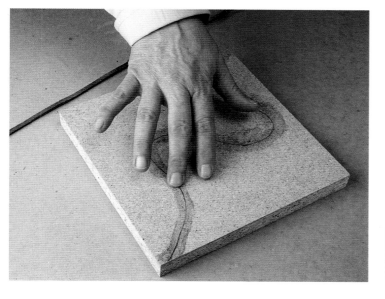

▲ 3. We let it dry until it is no longer tacky.

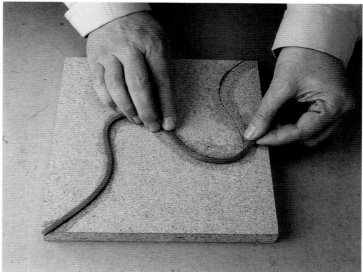

▲ 4. Next, we arrange the cord over the mark. This operation requires some attention because it adheres instantly and it does not allow for corrections.

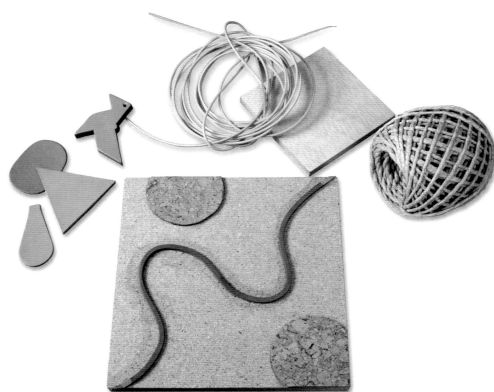

▲ **5.** We trim the ends of the cord with the skiving knife to make them flush with the support. By doing this we depress the relief in the area over which the leather will be folded to cover the support, making its placement and gluing easier.

▲ **6.** Any material can be used for making a support: leather lace and cords, pieces of wood, cork, and leather of various shapes, twine, or vegetable fibers, etc.

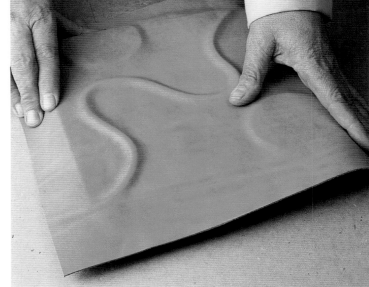

▲ **7.** The composition is complemented with two geometric figures made of corkboard. We cut a piece between 3/64 and 1/16 inch (1.2 and 1.5 cm) thick unfinished calfskin, a little larger in size than the support. Unlike the previous one, this technique is done dry.

▶ **8.** We attach the leather to the support with rubber cement by applying one coat on the flesh side of the calfskin and another coat over the support. We place the leather perfectly centered and we attach it to the support by applying pressure over the entire surface until the relief motifs are visible.

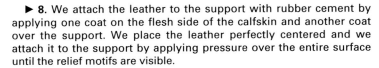

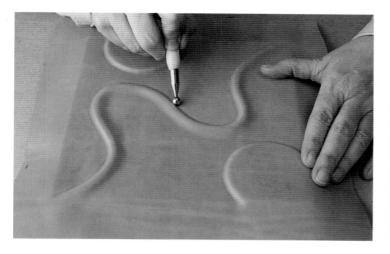

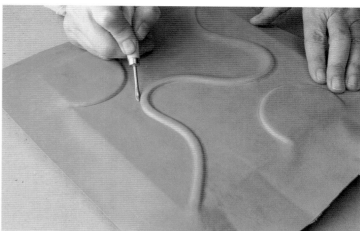

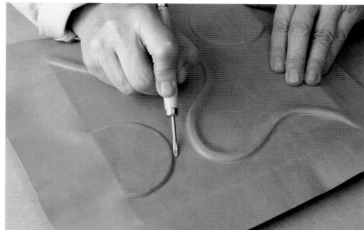

▲ ▶ ▶ **9.** To finish outlining the forms and to achieve the permanent relief we must use several modelers. The ball-tips are used to smooth out the areas around the curved design. To outline the curves we use the narrow, spade-end modelers with pointed tips. The adhesive is left to dry for 24 hours.

▲ **10.** We cut out the corners of the calfskin leather at perfect right angles and the leather is glued to the sides of the support with rubber cement.

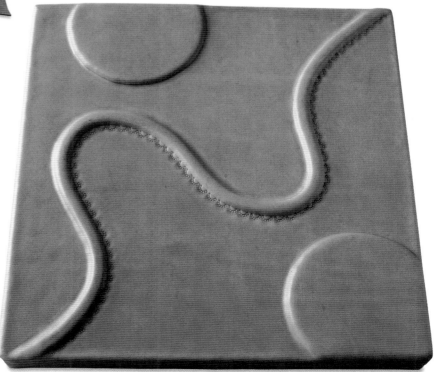

▶ **11.** View of the finished relief. The wavy motif in the middle has been highlighted with stamped designs made with a punch with a half moon tip.

Sewing and Braiding

Although sewing and braiding are not considered techniques in their own right, they offer interesting alternatives for creating pieces. Their main function is to hold the pieces together by making strong joints and a solid final piece, which usually has practical uses. Its decorative purpose is also important. Therefore, the sewing and the braiding techniques share a double purpose, a functional one and a decorative one. There is a great variety of stitches and a wide range of braiding approaches, and each would require a separate book. In the following pages, we will show the most common ones, so each person can adapt them as needed for his or her work, for construction purposes or to make decorative motifs.

All the sewing and braiding techniques, regardless of how easy they may appear, require skill, and this is only achieved through practice. It is a good idea to begin with the simplest ones and to progress gradually to more complicated forms.

Joints

A wide variety of stitches can be used to make joints, depending on the type of leather and the thickness of the pieces that need to be joined, as well as the final characteristics of the piece and its later use. In this section we will show in detail how to work the most common stitches, which are presented by way of a guide. Not all are suitable for the same type of joints and some of them are used strictly for decorative purposes.

Double stitch

This stitch is also called two needle backstitch or saddle stitch because this type of stitch is used traditionally for sewing harnesses (the straps and other gear that are mounted on the horses to attach them to carts or to ride them), as well as to make certain leather objects. To do this stitch we use two needles, which produce parallel stitches lengthwise and that are inserted through the same hole in opposite directions. This produces a pattern with similar and continuous stitches that have no gaps between them, have a line-like appearance and are very resistant. This stitch is most suitable for joining pieces vertical to each other.

Next, we will demonstrate how to do this stitch. First, the preliminary steps of the process itself will be explained, that is, how to make the holes for sewing.

◄ Juan I. Martínez Escó, *Trunk,* 1982. Calfskin decorated with designs made with incisions and dyes, decorative braided finishes, wood structure.

▼ **1.** First, we mark the lines that will be used as guides for the overstitch spacer and that mark the distance between the sewn part and the edge of the piece. We hold the creaser perpendicular to the surface and lined up with the border of the leather, and we mark the line pressing on it as we slide it towards us.

▼ **2.** We select the most appropriate roller according to the size and number of stitches that will be required for our piece and we mount it on the spacer. We go over the line with the spacer moving it from us towards the outer edge to mark the points where the holes will be made.

► **3.** Then, we secure the piece to a durable cardboard base (in this case we have used clothespins) and we make the holes with a hand press, following the marks made by the spacer. We choose the size of the drill bit according to the mark and the material used to do the sewing; in this case, we use a bit that measures 1/16 inch (1.5 mm) in diameter and wax twine.

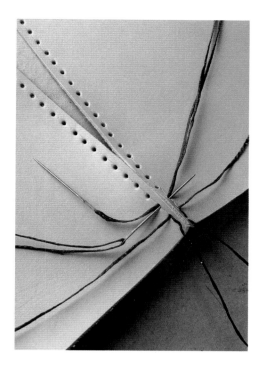

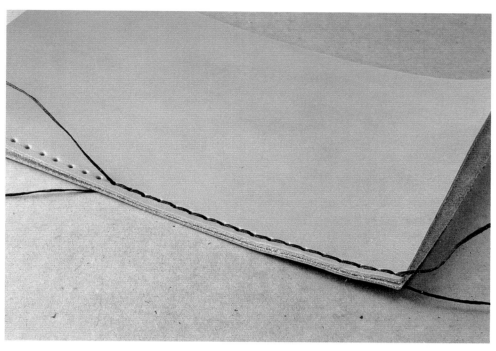

▲ **4.** The double stitch is made by sewing every stitch with two needles, inserting it through the same hole in opposite directions.

▲ **5.** The result looks like a line with straight stitches that is very resistant. To sew large pieces, a special saddle maker sewing board can be used.

Single stitch

The single stitch consists of making continuous stitches by taking the needle back after each stitch, that is, the first stitch goes through the first and third holes, leaving the second one in between empty; then the needle is inserted from below through the empty hole.

This results in regular and continuous stitches that alternate and have a wavy appearance. It is ideal for sewing pieces lying side-by-side.

In this case, the sewing is done with 1/16 inch (1.5 mm) thick leather cord and holes made with a 1/8 inch (3 mm) diameter punch.

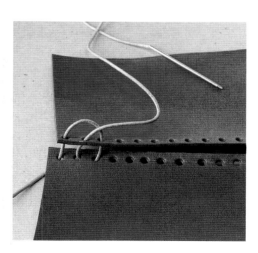

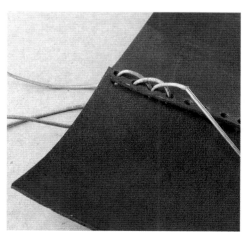

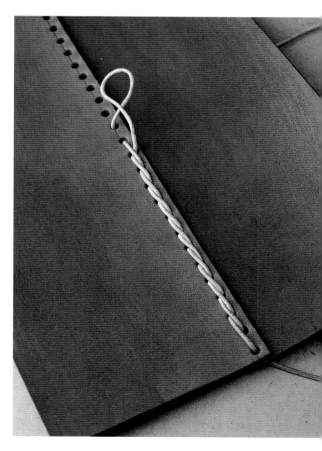

▲ **1.** The needle is inserted from behind the pieces through the first hole and passed in front to the third. Then we insert it through this hole, pass it behind the leather pieces and come out through the empty hole, between the first and the third.

▲ **2.** We continue sewing through the next open hole going back from behind and coming out through the previous hole.

▲ **3.** This stitch creates a line-like pattern with continuous and even stitches.

Chain stitch

The chain stitch, as its name indicates, consists of sewing with interlocking stitches that seen together look like chain links. This type of stitch, which is ideal for sewing side-by-side pieces, consists of making a first stitch from below and coming out of the front to go back in through the same hole to make a loop within reach of the next hole. The second stitch, which is done exactly the same way, comes out of the next hole and loops through the previous stitch. We use a thread similar to the one used previously; therefore the holes will also be punched the same way.

◄ Ana Serra, *Round Purse,* 1999. Cow hide with incised and dyed design, overlapped hand-made seam, 13 inches (33 cm) in diameter and 3 3/16 inches (8 cm) wide.

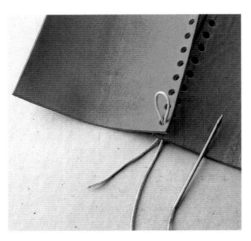

▲ **1.** The first stitch is made from below. The needle is pulled from the front through the first hole making a loop and inserting it again through the same hole.

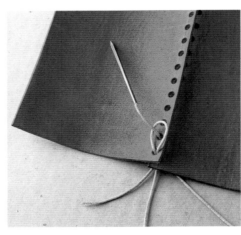

▲ **2.** The needle is passed through again, from the next hole and is pulled out through the previous loop.

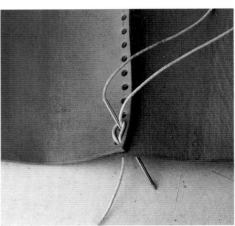

▲ **3.** The process is repeated, inserting the needle again through the same hole from which it came out; this way, we create a second loop that interlocks with the first one. Each loop should be pulled tightly.

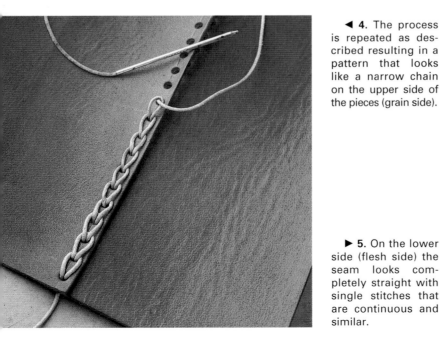

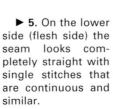

◄ **4.** The process is repeated as described resulting in a pattern that looks like a narrow chain on the upper side of the pieces (grain side).

▶ **5.** On the lower side (flesh side) the seam looks completely straight with single stitches that are continuous and similar.

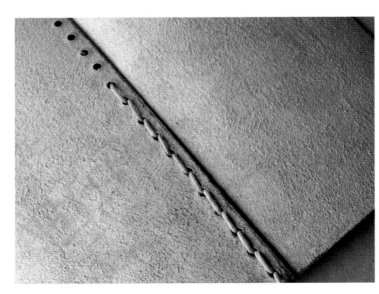

Cross-stitch

This stitch is ideal for vertical joints and it is used for its durability and for its decorative characteristics. Besides sewing or joining two pieces together, it can be used as a decorative motif on edges; in this sense, it offers multiple possibilities. It is a type of sewing that has volume, suitable for joining thick pieces of leather.

It consists of sewing over several times to create double loops that result in a rounded seam with stitches that look like a stalk of wheat. The stitches are created by sewing from the same side, always leaving the last stitch a little bit loose and tightening the previous ones. In this example we have used a 1/8 inch (3 mm) wide leather lace with 3/16 inch (4 mm) diameter holes.

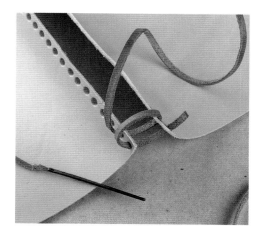

▶ **2.** The stitch is set firmly by pulling. Then the needle is inserted inside the previous stitch or loop from the other side; that is, the same one through which the first stitch was inserted, passing over the seam between the pieces.

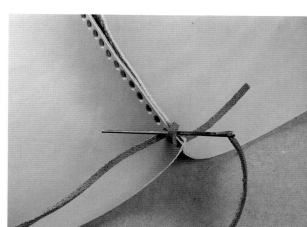

◀ **1.** We insert the needle through the same holes, crossing over the seam of the pieces and passing through the second hole.

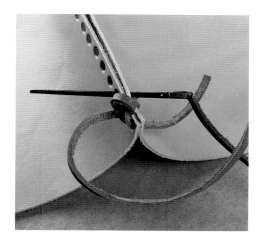

▲ **3.** When the leather lace has been passed through and the loop is made, the needle is inserted from the other side through the next hole.

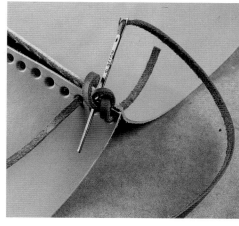

▲ **4.** We go back, inserting the needle through the opposite side between the first cross-stitch and this second loop, just below them, between the lace and the leather pieces.

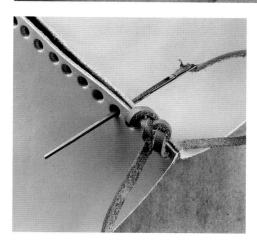

▲ **5.** When the cross-stitch is completed, the needle is moved to the other side and inserted through the next hole. Notice how the needle goes through a new hole or between cross-stitches, always beginning on the same side and going in the same direction.

▼ **6.** The result is a second loop that is next to the previous ones and that provides the stitch pattern that resembles a stalk of wheat.

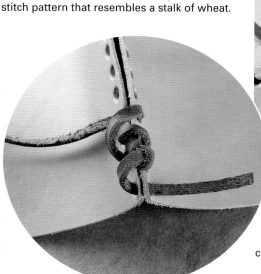

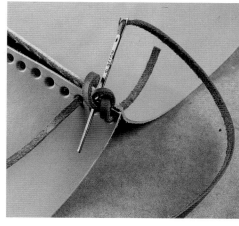

▲ **7.** We repeat the procedure in step four; that is, we go back to inserting the needle between the loop and the previous cross-stitch, under the lace.

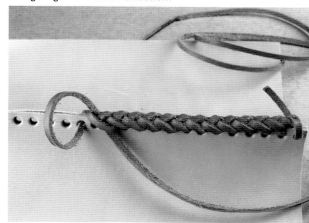

▲ **8.** We continue the process of making loops and going back to make cross-stitches. The resulting pattern has a rounded outline with the lace laid out in the shape of a stalk of wheat.

Double cross-stitch seam

A very important aspect of the sewing patterns that include decorative components is the ability to make seams by joining together sequential stitches that look like continuous sewing. This is especially interesting when sewing the perimeters of the pieces and in the decoration of continuous edges. The joints are created by interlocking the stitches with a particular method that insures holding the pieces together properly while giving it a continuous look. In this example, we have used leather lace the same size as the previous exercise; therefore the holes will be identical as well.

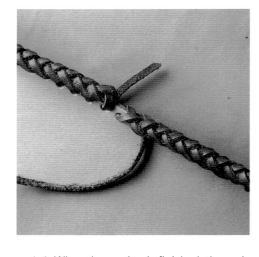

▲ **1.** When the sewing is finished, the ends are joined together so it looks like continuous sewing.

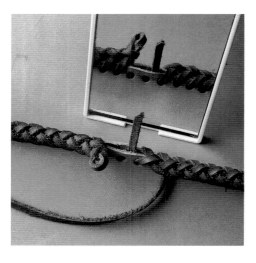

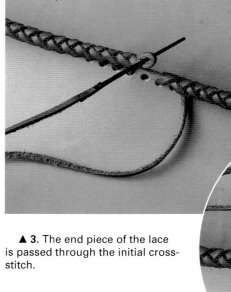

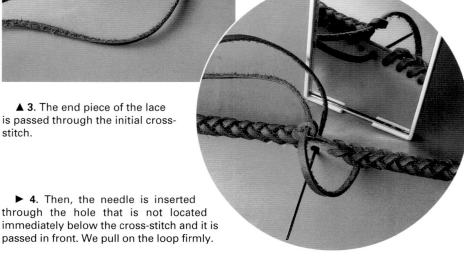

▲ **2.** To join the stitches together properly, we pull the first stitch out of the sewn piece, the one located at the beginning. That is, we take the initial stitch out by pulling the lace out of its hole and placing it inside the sewn part. By doing this, the first stitches end in a bow, with two empty holes on one side and one on the other.

▲ **3.** The end piece of the lace is passed through the initial cross-stitch.

▶ **4.** Then, the needle is inserted through the hole that is not located immediately below the cross-stitch and it is passed in front. We pull on the loop firmly.

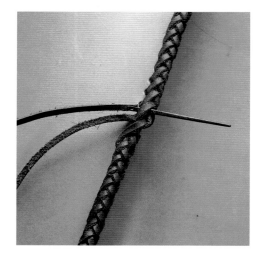

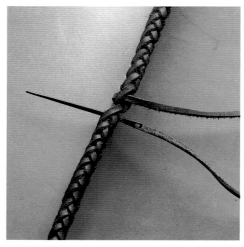

▲ **5.** The needle is passed towards the upper part of the stitches, underneath the next cross-stitch pulling it out through its center.

▲ **6.** To make the last stitch, the needle crosses over the lower part of the cross stitch that corresponds to the last one of the sewn part.

▲ **7.** Then, the other side is passed through inside the next cross-stitch, which will be the joint for the sewing.

8. Then, the needle is passed from the other side through the hole and tucked inside, that is, between the two pieces that have been joined together.

▶ **9.** Finally, the end of the lace is trimmed off and glued inside the stitches, between the two pieces, with a small drop of cyanocrilate glue.

Simple Cross-stitch: Edging

This type of stitch is used for joining together thin pieces of leather that are not too heavy, as well as for decorating unique pieces. It is simple and quick to make, so it does not require too much skill. It does not result in a strong sewing pattern, unlike the previous double cross stitch, so it is not appropriate for sewing heavy joints. Next, we will show how to make this stitch, as well as the stitches for sewing the corners of any piece. In this example we have used 1/8 inch (3 mm) wide leather lace; therefore we have made 1/8 inch (3 mm) diameter holes as well.

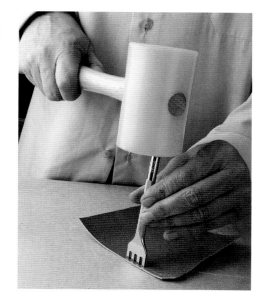

◀ **1.** We mark the location of the holes with the creaser as was explained in the section about the double stitch (see page 70). The placement of the holes is marked with a thonging chisel with 1/8 inch (3 mm) wide prongs placed on the piece of leather and held perfectly vertical. The incisions are made by tapping with the mallet. Another incision is made at the corner of the piece at a right angle with the others.

▼ **2.** The holes are widened with a fid, inserting it through each hole.

▼ **3.** The first stitch is sewn by inserting the needle from behind the piece through a hole at the center of one side, pulling it back to create a loop. Then, the needle is inserted from behind through the next hole.

▼ **4.** We pass the needle back through the loop from in front of the first stitch backwards.

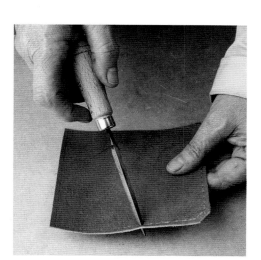

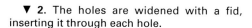

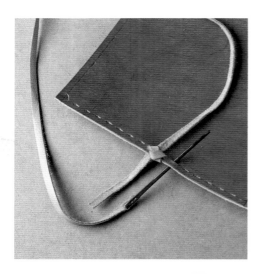

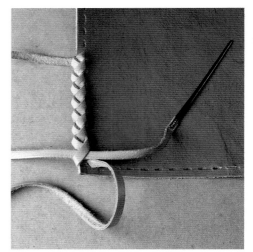

◀ **5.** Then, the lace is pulled firmly to set the stitch in place and it is inserted through the next hole. We repeat the procedure described to make the next stitches.

▶ **6.** Now we make the last stitch along the side and the needle is passed from the back to the front through the hole in the corner. We pull out the needle, and we pass it back through the previous cross-stitch. We pull it firmly.

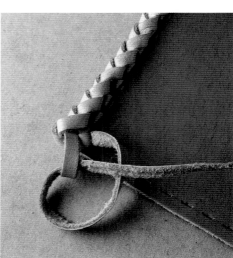

◀ **7.** We repeat the process; in other words, we pass the needle through the back of the piece and then we pull it out through the hole in the corner. Then, we pass the needle back through the previous stitch making a larger loop than the previous ones. Thus, we make two stitches.

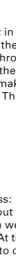

▶ **8.** We repeat the process: we pass the needle back and we pull it out through the hole in the corner, after which we pass inside the cross-stitch from behind. At this point, we have sewn the three stitches to complete the corner.

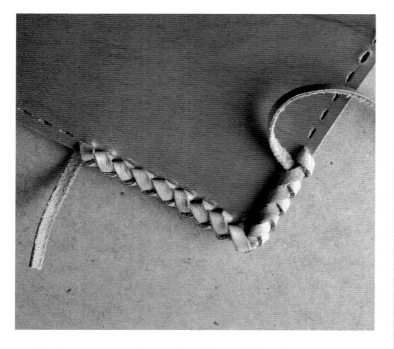

▲ **9.** Next, we pass the needle to the backside of the leather, flesh side, to continue sewing following the steps already described.

MAKING HOLES

Making holes to join pieces together by sewing or lacing is not an especially difficult task, although some basic points must be kept in mind.

The leather pieces are worked individually, in other words, making holes in each piece one at a time.

Holes should never be bored in two pieces at the same time by placing one over the other because the holes would not be the same. The tip of the punch in the hand press or the rotary punch has a conical bevel, so the holes made on the upper piece will always be larger than the lower ones.

If holes need to be made in two pieces, they should line up with each other and placed in identical locations. To do this, we use a piece that already has holes as a guide and copy the exact placement of the holes in the other. The pieces are placed face to face, either on the flesh side (that is, flesh against flesh) or on the grain side (grain touching grain), and the locations of the holes are marked on the piece to be bored.

In either case the holes should be made according to the marks, either by following the method explained here or the one shown at the beginning of this section (see page 70). Before joining any pieces together, it is important to check the holes in the pieces and to make sure that there are the same number of holes and that they are located symmetrically.

Decorations

To make decorations a wide variety of stitches, braiding patterns, and fabric can be used depending on the type of decoration and the characteristics of the piece. Therefore, some decorations can have a purely esthetic purpose, creating finishes with bows and stitches, or made to be used as appliqués. Others, however, can be used for structural purposes, that is, to join the pieces together. In this section we will show examples of how to make a stitch and a knot, explaining in detail the specific steps. There are many more techniques, but here we will cover the two most interesting ones as a starting point for those who wish to explore this discipline further.

Cross-stitch

This consists of crossing a leather lace forward and backward through the holes made in the piece. It can be used for purely decorative purposes, as a chevron to adorn or to decorate any piece, and it can also be used for strong horizontal stitches. To make this stitch, the space between the holes and the separation between the rows of holes must be in proportion to each other. In this case, the stitch is done with a 1/8 inch (3 mm) wide leather lace in holes 3/16 (4 mm) in diameter, with a 1/4 inch (7 mm) separation between them and placed in two rows, 1/2 inch (1.2 cm) apart. In this example we have used the stitch for making a joint, although the technique is the same for decorative purposes.

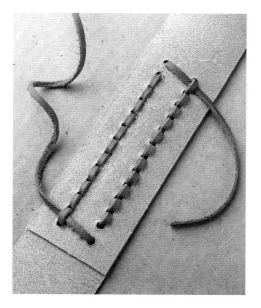

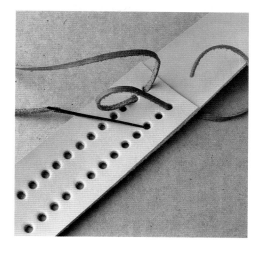

◄ **1.** We begin by inserting the needle from the bottom of the piece through the first hole of the row on the right, leaving part of the lace hanging loose. The lace is crossed over to the second hole in the other row (the one to the left), through which it goes in, and then it comes out of the first hole from behind.

▼ **2.** The lace is crossed over again on to the opposite row, the right one, entering through the third hole and coming out of the second one from behind.

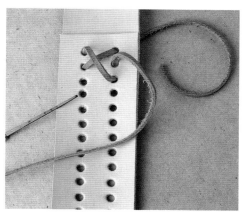

▼ **3.** It is crossed over to the opposite row again, introducing the needle through the third hole and pulling it out through the second one from behind.

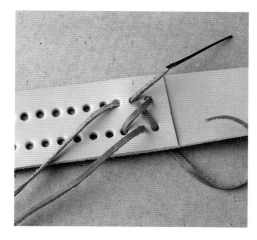

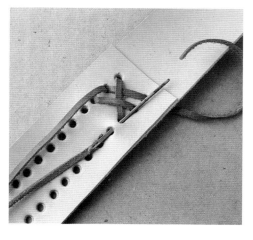

► **4.** It is crossed over again to the opposite row, on the right, and the needle inserted through the fourth hole, coming out of the third from behind. This process is repeated, crossing over to the opposite row and inserting through the empty hole located below each stitch from the front and coming out of the back through the upper hole where the previous stitch is located.

◄ **5.** When the cross-stitch is finished, two rows of long, similar, and symmetrical stitches can be seen on the lower part (flesh side). The ends of the lace are secured as shown here, passing them through the first and last stitches. The excess lace is trimmed off and each end glued on to the leather piece with a drop of cyanocrilate adhesive.

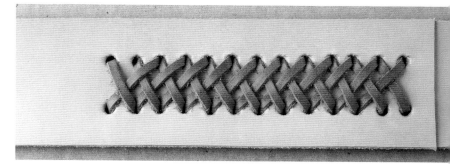

► **6.** View of the piece joined together with cross-stitching.

Flat five-sided knot

This knot can be used to finish off an area of sewing or stitching, or as a decorative element to adorn a piece. Using leather cord we make five identical loops that are placed symmetrically, passing the cord over one of the sides and below the other one from each loop, respectively. Once the first round is finished, we repeat the process as many times as needed to create the knot, pulling tight after each section so the knot is firm and compact. It is a good idea to use a pattern, although experienced individuals can make the knot without it. In this case, we use 3/32 inch (2.5 mm) diameter cord making five bows with five loops.

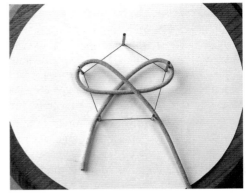

◄ **1.** First, we make a pattern by drawing on a piece of paper a regular pentagon with 1 3/16 inch (3 cm) sides. We place the pattern on a wood support pinning it down with headless needles at each corner of the pentagon.

▶ **2.** To start the knot, we pass the cord outside the left needle at the pentagon's base making a bow around the right corner of the pentagon. Then, we pass the cord above the first needle and we make a second bow in the opposite corner (left).

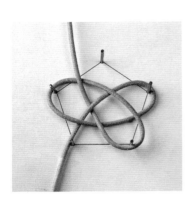

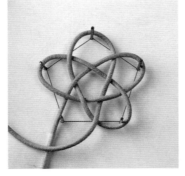

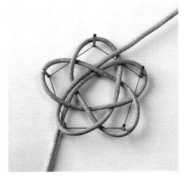

▲ **3.** We pass it over the cord of the first loop making a new loop around the needle to the right of the pentagon's base. We pass the end of the cord below the end of the first bow and above the loop of the second one.

▲ **4.** We make a fourth pass around the needle on the upper corner of the pentagon passing above the second loop on the way up and below the going cord of the first loop, then over the going one of the third loop, below the returning one of the first loop and finally above the return of the third.

▲ **5.** To finish, we make the fifth loop around the first needle, the one located on the left side of the base, passing the cord under the going loop of the second bow. Then, we continue passing the cord following the previous pattern, pulling them tight.

▲ **6.** The cord is passed alternatively above and below each bow. We make as many loops as needed until the space is full in such way that the cord will be completely tight.

◄ **7.** When the knot is finished, we remove the pattern carefully. If we wished to make a new motif for an appliqué, we cut out the remaining cord and the ends are glued behind the knot with a drop of cyanocrilate adhesive. If we wished to make a hanging decoration, only the initial end of the cord would be glued.

▶ **8.** View of the finished five-sided flat knot to be used as an appliqué to decorate any piece.

Decorations are the elements used to adorn the leather or a finished work. However, decorations are not limited to ornamental motifs but, as explained in previous chapters, the leather-working techniques themselves can also be considered decoration. Therefore, there exist a wide range of options in terms of form and techniques where anyone can find a means of expression.

The finishes include all the processes that are used in completing work on a piece, giving the surface of the leather a different look or adding new elements. There is a wide variety of finishes that can be used to make the piece glossy, to shade the leather, or to apply an overall layer to simulate aged leather; it is also possible to add other specific ornamental elements and use pyrography. In this area, there is ample room for experimentation based on the creative mood of each person.

Outlining

The outlining technique consists of highlighting the repoussé motifs, making their color stand out against the background. It is done by going over the contours of all the elements of the design with the cutting modeler, making a light incision on the surface to cut the leather's grain. Then, a layer of very diluted dye is applied that penetrates the incisions and makes them look darker than the rest of the design and stand out. The cutting tool is a conventional utensil that has been modified in the shop; it has been sharpened to make a cutting tip. Each artist can make his or her own according to need and in the most suitable way for the particular project.

Outlining is not considered exactly a decorative method but a preliminary step to coloring, although as the latter, it forms part of the leather decorating techniques.

► Juan Antonio Fernández Argenta, cover for the book entitled *Mortal y rosa* by Francisco Umbral, 2001. Binding in full grain cow hide with painted incisions and sign with movable typography in bronze, 9 1/2 x 12 5/8 inches (25 x 32 cm).

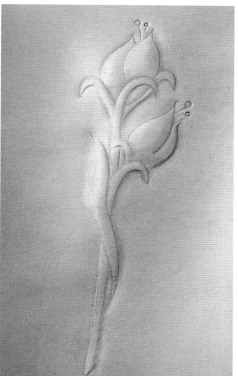

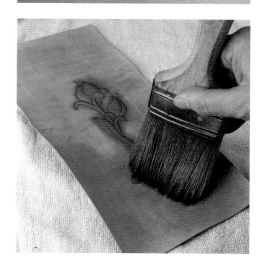

◄ 1. We outline a floral repoussé motif in 3/64 inch (1.2 mm) thick calfskin (see section on "Repoussé", beginning on page 56).

▼ 2. First, a layer of carnauba wax dissolved in water is applied evenly (1 part wax to 3 parts water) over the entire surface of the leather.

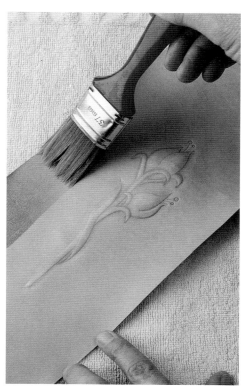

◄ 3. The surface is evened out by tapping gently with a wide, soft bristle brush. This step should be carried out fast and with small evenly applied taps to avoid creating marks on the leather. It is left to dry.

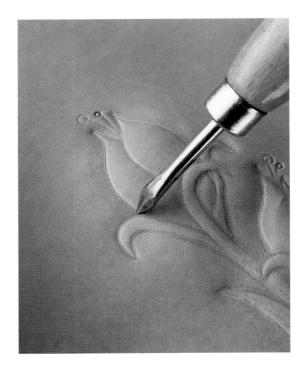

▲ **4.** We go over every contour with the cutting modeler, outlining each with the cutting edge.

▼ Luces Montoya, *El castillo encendido* (The Lighted Castle), 2003. Cow hide with pyrography and oxidized nails on a wood frame, 9 1/2 x 10 1/4 x 7 1/8 inches (24 x 26 x 18 cm), series of 3.

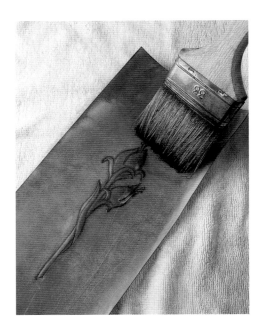

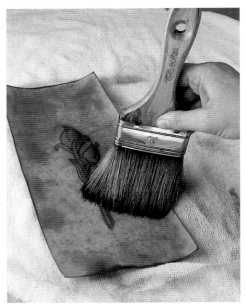

▲ **5.** We apply an even layer of very diluted dye with a wide brush. Its concentration will depend on the color we wish to give the leather background. Therefore, it is important to test it on pieces of scrap leather like the one used in the project, checking the final color before we apply it to the motif.

▲ **6.** The surface is evened out by tapping softly and repeatedly with a wide brush. This step must be done quickly.

▶ **7.** The floral repoussé and outlining motif contrast with the background.

Polychrome

One of the decorations that offers the most possibilities is multicolor painting. The use of dyes, paints, and markers (and other products, such as natural pigments, for example) opens up a wide range of limitless creative possibilities. For this purpose we can use the same methods used in decorative painting such as stamping, resists, glazing, to mention just a few.

Here, we are going to show the results obtained using dyes and paints. In a table shown at the end we offer a small sample of the wide range of possibilities offered by polychrome. Other materials like henna can be used or the color of the leather can be lightened by exposing it to the sun.

Dyes

Dyes are coloring agents that penetrate the material. Dyes color the leather without concealing the grain, which is why they are very appropriate for creating decorative applications where the quality of the leather itself is part of the design. Dyes are very suitable for modifying the color of the leather's background (see "Box with Repoussé" in the step by step procedure beginning on page 128) and for creating special effects, glazing among them. They are also used for coloring the background of stamped leather.

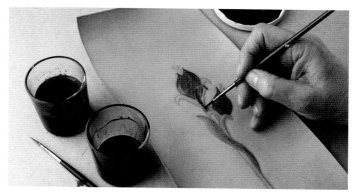

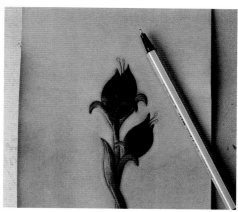

▲ **2.** For the small details (the stamens of the flowers) we use a marker with a very fine tip, since it would not be possible to color them with dyes.

▶ **3.** View of the multicolor motif with dyes. The colors hide the original tone of the leather.

◀ **1.** Once the design has been outlined (see pages 79 and 80) and the background painted, we apply the dye with a thin, round brush with a soft bristle.

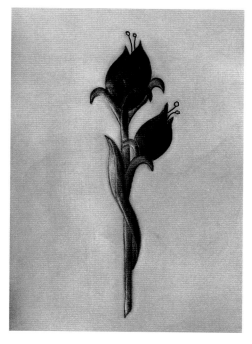

▲ **1.** The chosen colors are mixed until the desired tone is achieved. They are applied like the dyes, with a soft, round bristle brush.

▶ **2.** View of the multicolor repoussé design, the layer of paint covers the leather.

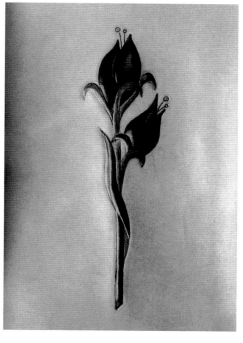

Paints

Paints are covering pastes used in art that color the leather's surface creating a film that covers the grain and, with it, the normal qualities of the leather. They come in a wide range of bright and very resistant colors, a quality that makes them ideal for creating very showy decorations where color is the main element. The paints can be mixed on the palette (or on a similar support) to achieve the desired tones. In the case of dyes, it is possible to achieve different combinations by mixing the liquid dyes in a container, but the task is more difficult. As in the previous case, paints are applied once the design has been outlined and the background color has been applied.

SEVERAL POLYCHROME TECHNIQUES

Dripping

Dripping is one of the many possibilities offered by dyes. Basically, dripping consists of coloring the leather by dripping directly on it, which can create a great variety of tones since drops can penetrate and drip on the leather in different configurations.
In this example, we are going to create a surface with drops by making resists with gum Arabic. First, we make the resist areas by dripping gum Arabic from the bottle. We let it dry completely.

The dyes are applied with a drop dispenser. First, we apply red drops. They are left to dry.

Then, we begin dripping with a light green dye, and when this dries we continue with a third dripping application using brown dye.

Effects with paper

To create effects on the surface of a piece or on the background of a composition or design, we can use a great variety of materials, like paper. This produces an uneven mottled effect of great esthetic value.
The green dye is poured into a wide container. Then, we make a finishing pad by crumpling brown wrapping paper and dip it into the ink. The excess dye is wiped off on a piece of blotting paper and the ink is applied by tapping gently on the leather with the pad. It is left to dry.

We repeat the process with the red dye, applying it as evenly as possible. It is left to dry.

Effects with twine

Other materials that offer many possibilities for creating effects are cord and twine. They are used the same way as paper, and the result is an effect based on their form and texture. In this case, we have used a very thin cord that creates a soft striped texture.

Stamping

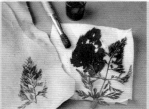

Another interesting approach for finishing and decorating leather is stamping. It consists of marking a motif on the surface by using a pattern or a stamp charged with paint or dye. Stamps can be purchased in specialized stores or made in the shop as needed. There is a wide range of materials that are suitable for stamping.
Here, we use a natural motif to stamp color designs on a piece of sheepskin.

Wax glazes

It is also possible to create glazing effects on leather (in this case sheepskin) by applying dyes with light brush touches; this produces very diffused colors. Here we apply a light red dye on sheepskin with light touches done with a round brush. It is left to dry. Then, we apply a light green tone the same way. When everything is dry, we apply carnauba wax by touching up briefly with the brush as well. The resulting effect is a very soft glazing that is combined with shiny areas due to the effect of the wax.

Patina

Patina is the natural color and appearance acquired by the surface of certain materials due to the effect of time. One of the most common finishes in leather pieces is aged patina, which gives the leather an old or aged look. Basically, it consists of altering the existing color by applying certain products that provide the characteristic color of aging. It can be used to age multicolor pieces, created either with paint or dye and even over decorations. It can also be used to highlight or emphasize the forms and the values of some pieces imprinted with awls, creating contrast between the areas with the patina and the ones that have been left untreated.

This patina is achieved by treating the surface of the leather with asphaltum previously dissolved in mineral spirits. The proportion of the solution will vary depending on the original concentration of the asphaltum, which differs according to the brand, the time elapsed since the can was opened, because it tends to become more concentrated as the solvents contained in it evaporate, and the final result desired, which depends on the tone we wish to create. Therefore, it is very important to conduct several tests with different concentrations on leather scraps before applying the patina paste to the permanent piece.

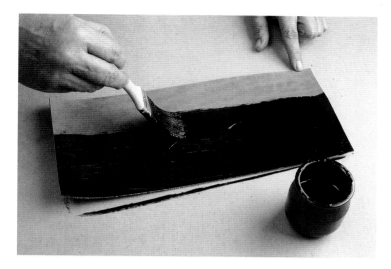

◄ **1.** Once the design has been outlined and the background treated, we apply an even coat of asphaltum dissolved in mineral spirits on the leather with a medium hair, medium size wide brush.

▼ **2.** The excess patina paste is eliminated by rubbing the surface with a cotton rag soaked in mineral spirits.

▼ **3.** The overall tone of the leather looks darker and deeper. The patina emphasizes the repoussé design.

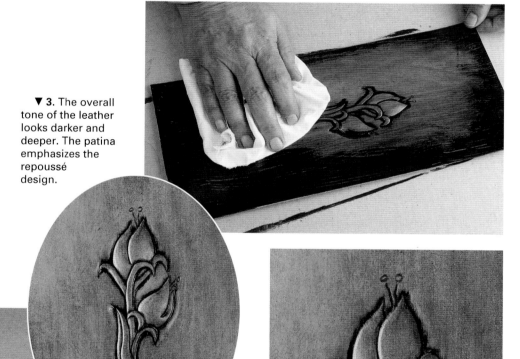

◄ **4.** Before it dries out completely, we apply a small amount of talcum powder to the leather and we rub it with a cotton rag.

► **5.** View of the repoussé motif with an aged patina finish.

*I*n this final chapter, we present the step-by-step process for creating a series of pieces. These are eight original projects where we explain the complete process for completing the work, from the starting point to the finished piece. These exercises have been organized according to the degree of difficulty so that each person can progress gradually by making them one at a time from the first one to the last. Most of the projects use several different technical processes that are taught in the book. These step-by-step exercises are presented so the reader can learn from them, and with that in mind, we have introduced various technical and formal approaches. Therefore, the idea is not to copy them, but to use them as a guide to develop your own work and as a source of inspiration.

Step by
Step

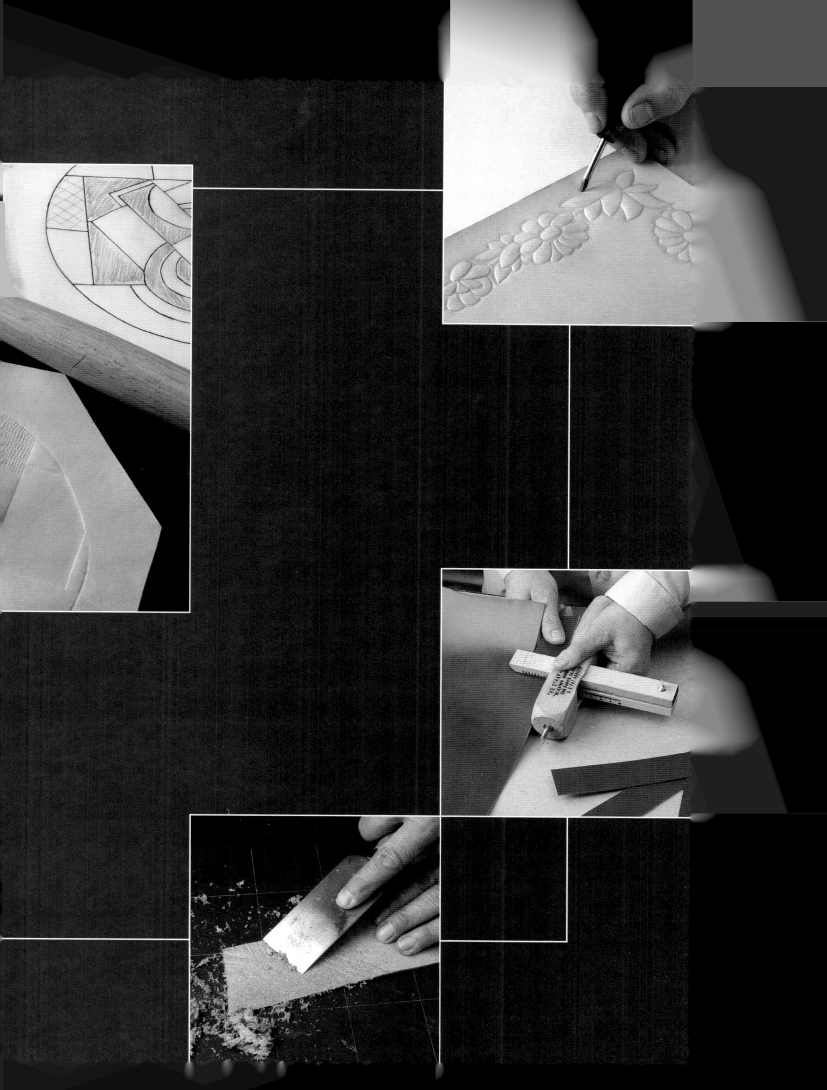

Woven Basket

*I*n the first step-by-step exercise, we offer a detailed explanation of how to make a woven leather basket. First, we make a square basket with flat woven sides, finished at the top with a decorative sewn piece, which at the same time holds the sides together and makes the piece sturdy. To make this basket, we used a 1/16-inch (1.5 mm) thick piece of shoulder cowhide with a grain finish, tanned with vegetable wattle and quebracho extract, and colored with semi-aniline dye.

◀ **1.** The first step is to make a prototype to work out the steps that we need to follow to make the piece, as well as to assess the most appropriate type of leather and how much of it we will need to buy. We begin by making a square flat cross-shaped piece, folding the sides upwards and weaving the strips of leather through all of them. The prototype is made out of pattern paper (a special heavy paper that is used to make patterns for clothes), although any other paper that is heavy enough would work as well.

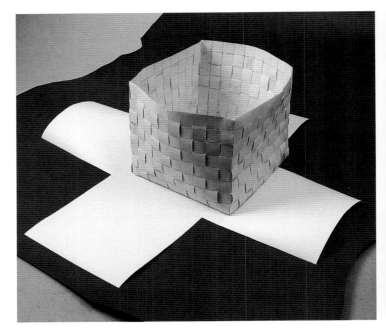

▶ **2.** Using the prototype as a guide, we make the pattern of the main piece for the basket, which will become the base and the sides. A cross-shape with 9 1/2 inch (24 cm) sides is cut out of paper (the five sides of the basket's cubic shape), that is, 9 1/2 × 9 1/2 inches (24 × 24 cm) including the central part and each of its arms, with total dimensions of 28 1/2 inches (72 cm) long and 28 1/2 inches (72 cm) wide.

◀ **3.** The pattern is placed on the leather and we cut out the shape with a craft knife, using a metal ruler, making sure that the sides are perfectly square.

▶ **5.** We make the cuts with a craft knife, paying special attention not to cut beyond the edges of the lines. We have attached a piece of masking tape to the metal rule, which will serve as a sort of guide for marking the cut lines.

◀ **4.** We place the piece with the grain side down for marking and making the cuts on the flesh side. We use an awl to mark a line 1 1/8 inches (3 cm) from the outer edge of each arm, which will later become the upper part of the basket. The perimeter of the base, the line that connects with the sides where we will later make the folds, is also marked. To finish, we mark the lines for the strips that will be woven together. There will be eight 1 1/8 inch (3 cm) wide strips, between the top and bottom lines, 8 1/4 inches (21 cm) long.

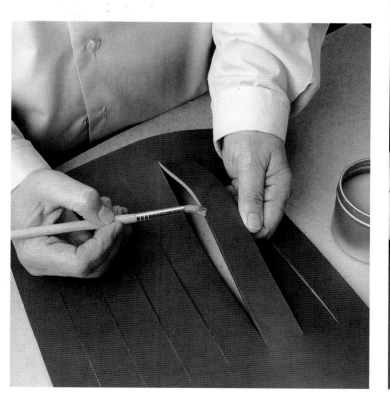

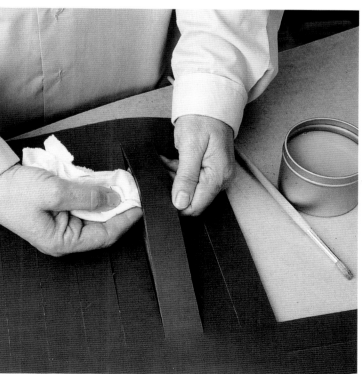

▲ **6.** With a medium round brush, we apply carnauba wax to the edges of the strips to create a smooth and soft surface.

▲ **7.** The excess wax is wiped off quickly with a clean cotton rag to avoid staining the leather's grain.

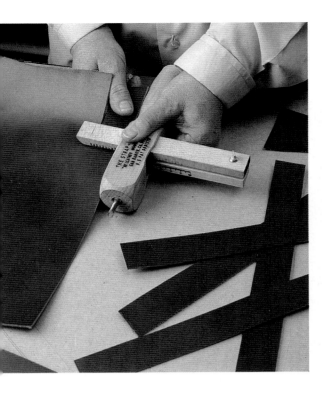

◄ 8. We cut eight strips measuring approximately 1 1/8 inches (3 cm) wide and 10 5/8 inches (27 cm) long with a strap cutter. These will be used to finish off the upper part of the basket on the inside and on the outside.

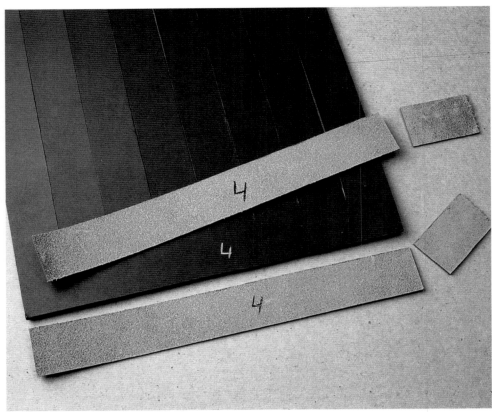

► 9. The strips are cut to size and placed back to back; one will become the outer part (grain side) and the other the inner part (flesh side). We mark these strips with numbers on each side, as well as on the corresponding part of the basket.

► 10. With the creaser placed perfectly vertical, we mark the line where we will make the holes, which in this case is set 1/5 inch (0.5 cm) from the edge on all the pieces.

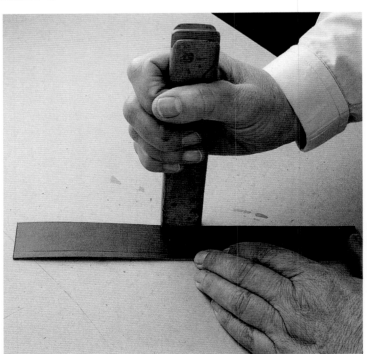

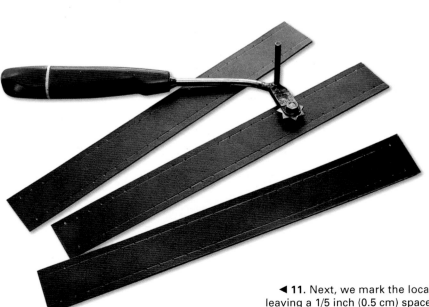

◄ 11. Next, we mark the location of the holes with an overstitcher, leaving a 1/5 inch (0.5 cm) space on each side of the piece. In this case they will be 1/3 inch (0.8 cm) apart.

▲ 12. Following the previous marks, we make the holes on the piece that will be placed on the outer part of the basket, the one that corresponds to the leather's grain. The holes are made with the hand press fitted with a tip measuring 1/8 inch (3 mm) in diameter.

▲ 13. The holes of the outer piece are copied onto the inner piece; to do this, the strips are placed grain to grain marking the placement of each of the 27 holes on the inner piece. Then the holes are punched through the same way.

▲ 14. Each strip is numbered on the flesh side. These pieces will be used to finish off the upper part of the basket. This way, we make sure that the pieces fit perfectly together, thus avoiding any misalignments that may occur if one of them moves accidentally.

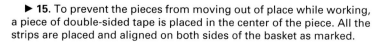

▶ 15. To prevent the pieces from moving out of place while working, a piece of double-sided tape is placed in the center of the piece. All the strips are placed and aligned on both sides of the basket as marked.

▼ **16.** To sew the piece together, we will need to punch holes on the main piece of leather following the placement of the existing holes. The piece is placed on a hard surface (we use a piece of wood in this case) and the holes are made with a nail that is a bit smaller than the existing holes, tapping gently with a hammer.

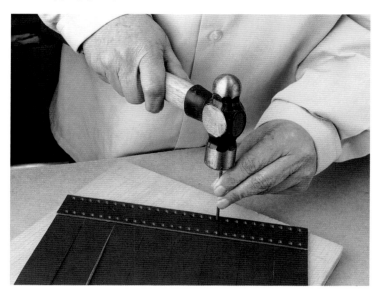

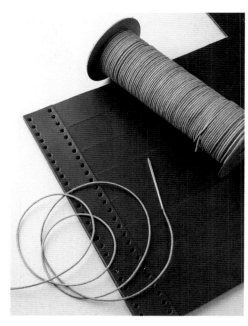

◄ **17.** Natural-color leather lace 1/16 inch (1.5 mm) in diameter is used for sewing.

► **18.** A simple, running stitch is used by pulling the needle out backwards after each stitch (see page 71).

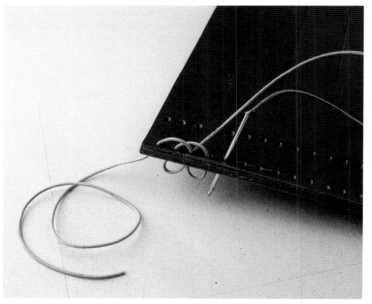

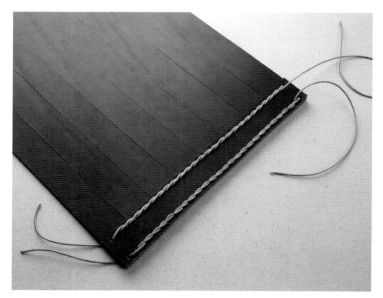

▲ **19.** The sewing is done from left to right on the upper edge of the strip and from right to left on the lower edge, so both look completely symmetrical.

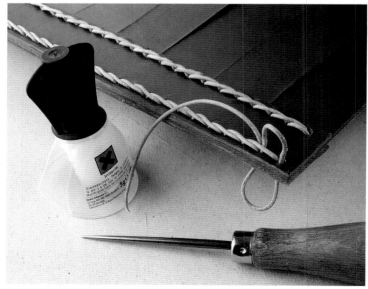

► **20.** One end of the basket's sewn line is finished off (in this case the one on the right) by inserting the lace with an awl, if needed, through the last hole and going back to pull it out of the previous hole. The end of the lace is held in place with cyanocrilate glue and the excess is cut off.

▶ **21.** To make the woven part of the basket, we cut out six 1 inch (2.4 cm) wide and 39 inch (100 cm) long strips of leather. A metal ruler that is used as a guide is held in place on the cutting surface with a clamp.

▼ **22.** The ends of each strip of leather are skived with a skiving knife on the grain side and on the flesh side, reducing it by approximately a width of 5/8 inch (1.5 cm).

▲ **23.** Now, we begin putting the basket together. Each strip of leather is woven through all four sides, passing it over and under the vertical strips all around the basket, and weaving the adjacent strip around the vertical strips under and over. During the assembly, the strips are held in place with clothespins to prevent them from moving.

◀ **24.** Once all the leather strips are assembled, the ends of each one are glued on the skived area with contact cement.

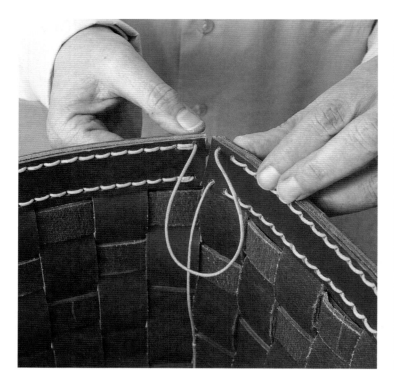

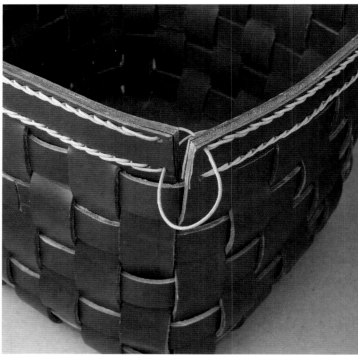

▲ **25.** The joints of the basket's upper part are finished off with leather lace. The upper extension of lace at each corner of the basket is inserted through the first upper hole of the adjacent side (which is at an angle).

▲ **26.** This lace is crossed over in front and inserted through the lower hole on the adjacent side, that is, the side the lace had come out of. We pull firmly to tighten the joint.

◄ **27.** We take the lower lace and insert it from behind through the previous sewing hole coming out through the front.

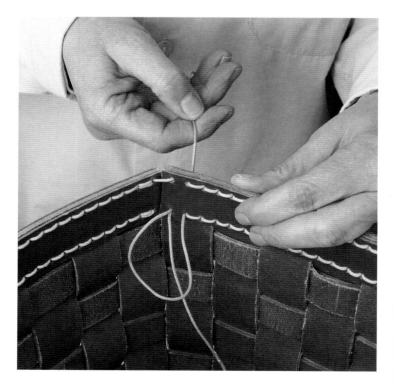

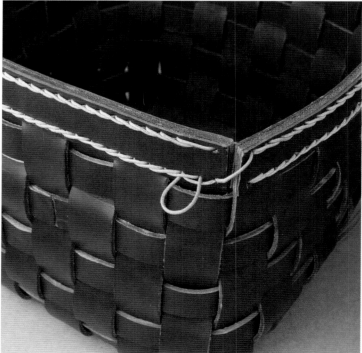

► **28.** Then, it is pulled to the back again through the other previous hole, the next to last.

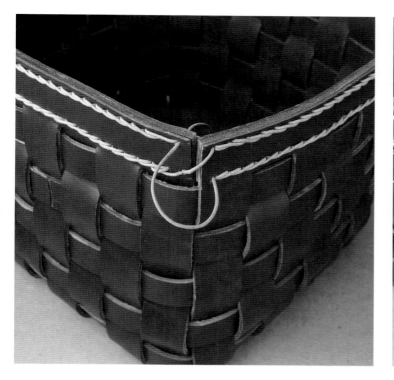

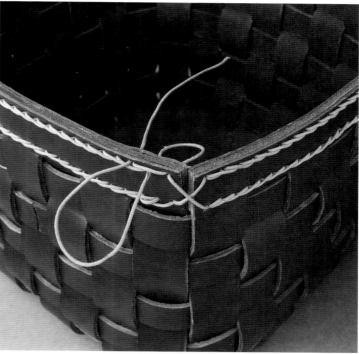

▲ **29.** The same procedure in making the first part of the joint is repeated: we pull it through the first hole on the other side and we cross it in front to the first hole of the upper sewn line.

▲ **30.** The ends of all the joints are finished off the same way: the lace is passed to the front from the back through the previous hole and is inserted through the second to last hole, pulling the lace taut.

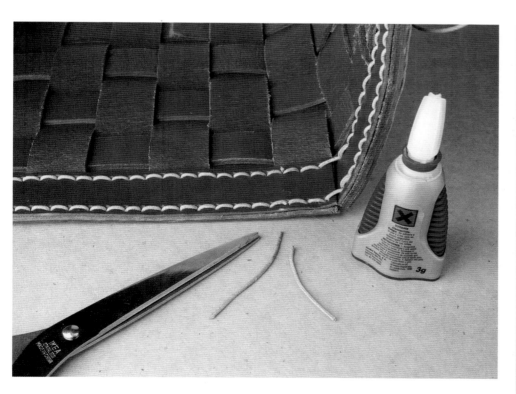

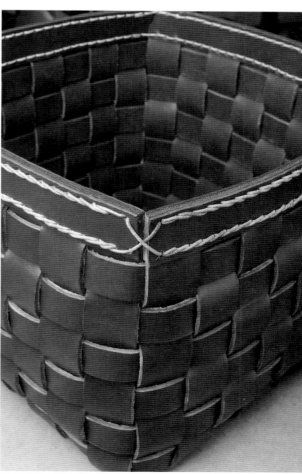

▲ **31.** The excess lace is cut off and the end held in place with a drop of cyanocrilate.

▶ **32.** The joints are strong and perfectly concealed on the inside of the basket where they are hard to tell apart.

▶ **33.** To finish, a 9 3/8 inch (23.7 cm) square piece of leather is cut out for the base inside and is glued to the bottom on the flesh side with contact adhesive.

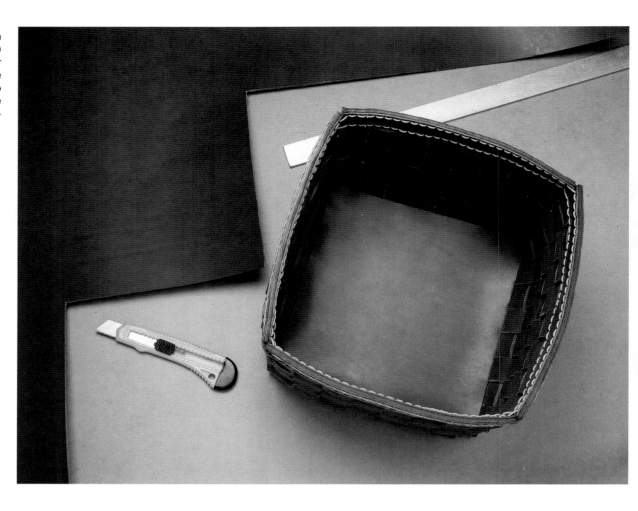

▼ **34.** To protect the leather lace, a layer of carnauba wax is applied with a medium-hair, medium-round brush.

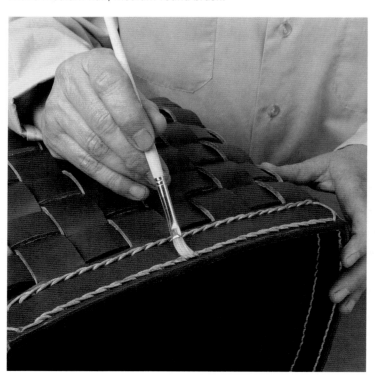

▼ **35.** The excess wax is wiped off immediately to avoid staining the leather.

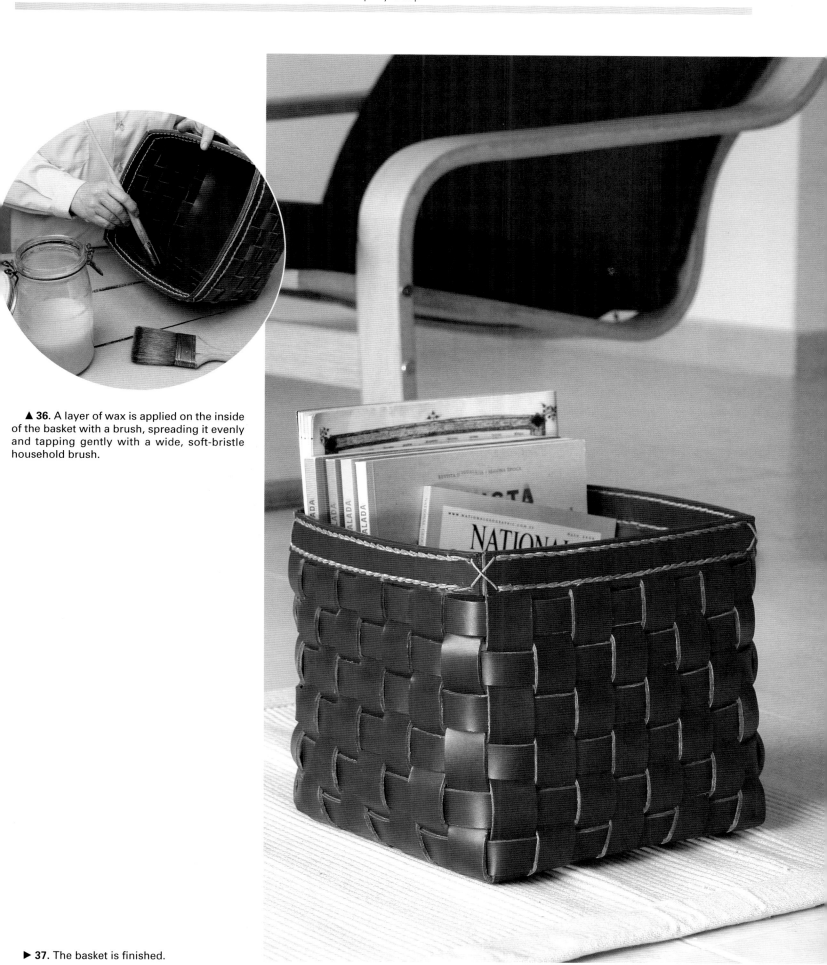

▲ **36.** A layer of wax is applied on the inside of the basket with a brush, spreading it evenly and tapping gently with a wide, soft-bristle household brush.

▶ **37.** The basket is finished.

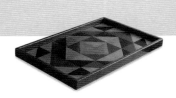

Tray with Mosaic

In this exercise we will show how to make a tray with mosaic. Taking a pre-made plywood tray as a base, the central design that will decorate the board is created using the mosaic technique, and then, the rest of the tray is covered with leather. For this project we have used one piece of natural-color calfskin and another one dyed in tan color, both vegetable tanned, as well as a piece of brown pigskin, all of them 5/64 inch (2 mm) thick.

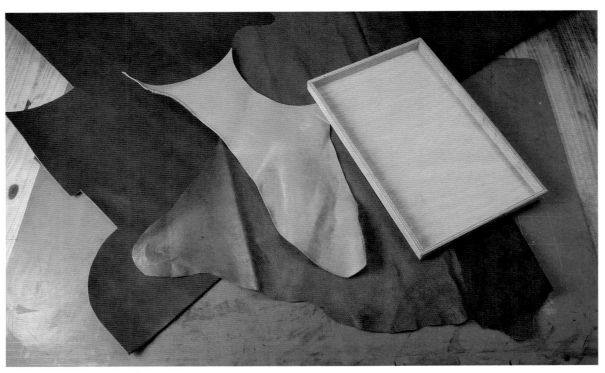

◄ 1. We purchase an inexpensive wood tray measuring 15 × 9 1/2 × 1 inches (37.8 × 23.8 × 2.5 cm), and we select the calfskin leather pieces to make the mosaic, in two different colors, as well as the one in pigskin, which will be used to make the base of the tray.

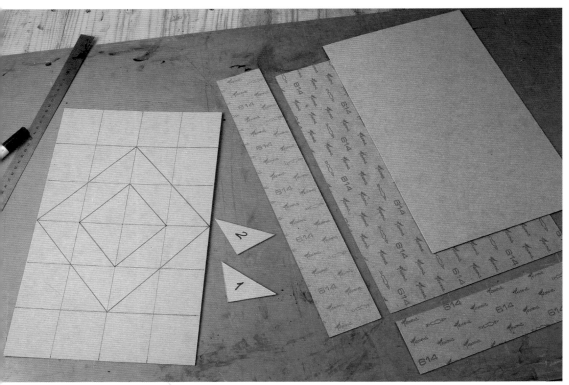

◄ 2. First, we make the design that forms the mosaic. On a piece of cardboard measuring 8 7/8 × 14 3/8 inches (22.5 × 36.4 cm), we mark the design of four by six squares, respectively, which has a double losange in the center measuring 3 1/4 inches (8.3 cm) on the interior side and 6 1/2 inches (16.5 cm) on the exterior side. Then, we proceed with the patterns for the elements of the tray. To do this, we cut two triangles, the first one (1) measuring 2 3/8 × 2 1/8 × 3 3/16 inches (5.9 × 5.5. × 8.1), and the second (2) 2 1/8 × 2 5/16 × 3 1/8 inches (5.45 × 5.9 × 8 cm), which will become the pieces of the mosaic. Then, the patterns to line the sides of the tray are created measuring 2 5/8 × 16 1/2 inches (6.7 × 41.7 cm) and 10 × 2 5/8 inches (25.5 × 6.7 cm), respectively, as well as a 15 1/8 × 9 5/8 inches (38.4 × 24.5 cm) piece. Finally, the support for the mosaic is prepared, and this will have the same dimensions as the project.

► **3.** The pattern for the base is placed over the grain side of the pigskin and the piece is cut with a blade.

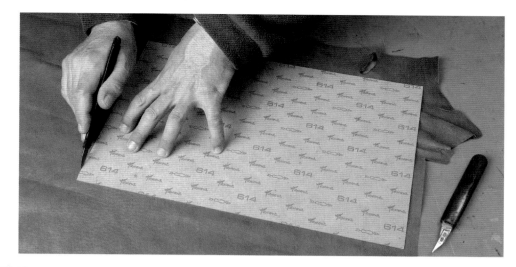

▼ **4.** Then the mosaic pieces are cut, 24 pieces of natural color calfskin with the first pattern (1) and 24 tan-colored pieces with the second (2).

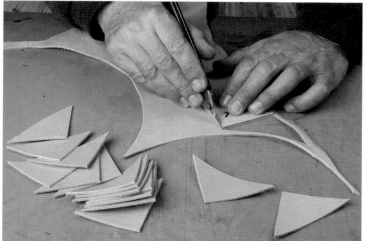

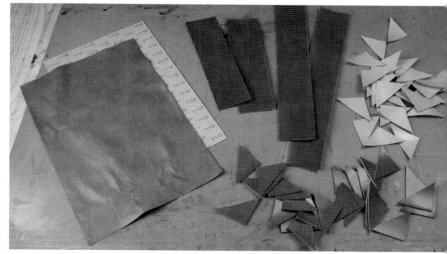

▲ **5.** Now, the pieces to line the sides of the tray are prepared. Two tan-colored calfskin pieces are cut from each rectangular pattern.

◄ **6.** We compose the mosaic on a second support, which will also be adhered to the base of the tray. In this case, we have chosen a sheet of commercial cellulose, which is used to make shoes. The central axes for each side are measured and marked and will serve as the reference for placing the mosaic pieces.

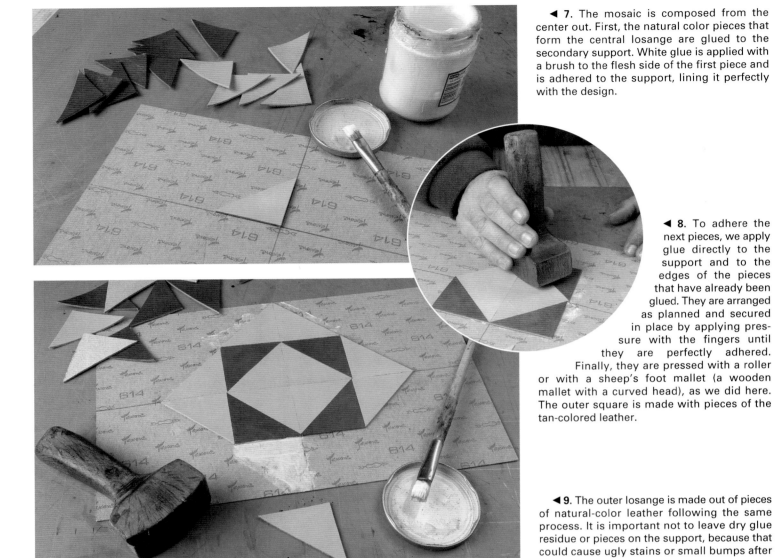

◄ 7. The mosaic is composed from the center out. First, the natural color pieces that form the central losange are glued to the secondary support. White glue is applied with a brush to the flesh side of the first piece and is adhered to the support, lining it perfectly with the design.

◄ 8. To adhere the next pieces, we apply glue directly to the support and to the edges of the pieces that have already been glued. They are arranged as planned and secured in place by applying pressure with the fingers until they are perfectly adhered. Finally, they are pressed with a roller or with a sheep's foot mallet (a wooden mallet with a curved head), as we did here. The outer square is made with pieces of the tan-colored leather.

◄ 9. The outer losange is made out of pieces of natural-color leather following the same process. It is important not to leave dry glue residue or pieces on the support, because that could cause ugly stains or small bumps after the pieces are glued.

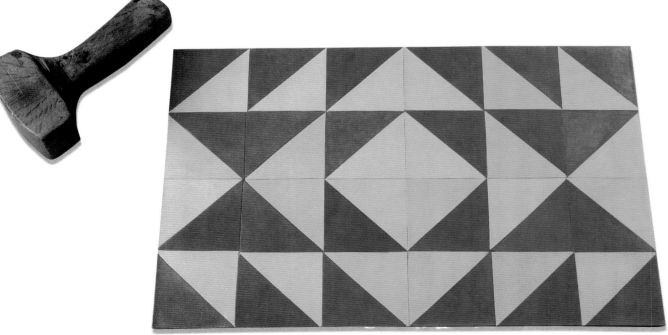

◄ 10. We continue gluing the mosaic pieces alternating the two leather tones, creating a double-symmetry design based on the pattern made by the triangular pieces in the project's square. It is left to dry.

► **11.** Now, we begin to cover the wood tray. First, the pieces are reduced up to 1/64 inch (0.4 mm) thick to cover the sides.

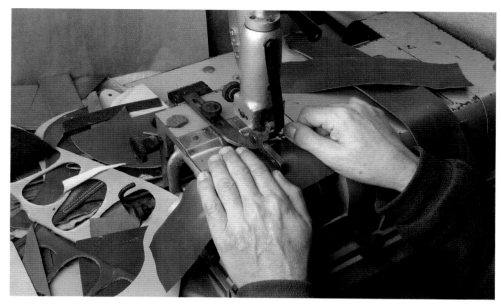

► **12.** The sides of the tray are covered. Rubber cement is applied to the piece, which is adhered to the base about 1/3 inch (0.8 cm) from the edge, centering it perfectly against the side.

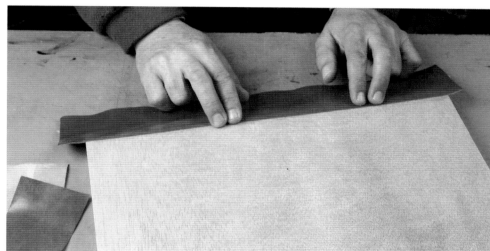

▼ **13.** Now the piece is folded upwards and adhered to the wood by pressing with the fingers.

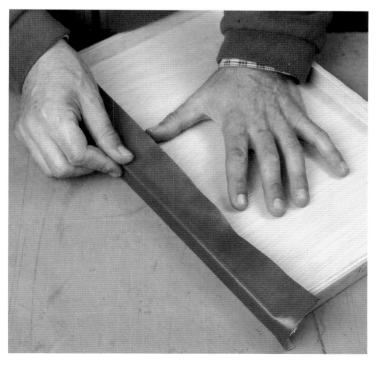

▼ **14.** The piece is cut to size with a blade exactly at the point where this piece meets the piece from the other side.

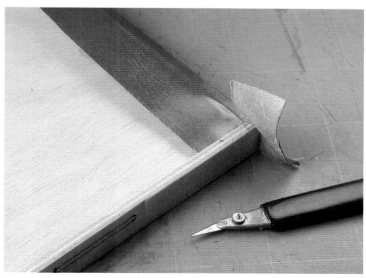

▲ **15.** The piece is tucked in and glued by pressing with the fingers. The joint is secured to the interior base by pressing with the tip of a bone folder.

16. The piece from the other side is glued using the same adhesive and placing it 1/3 inch (0.8 cm) from the bottom side of the tray as well, and folded upwards. Then the ends from both pieces are joined together.

◀ **17.** The excess material from the bottom part, located under the base, is trimmed off with scissors.

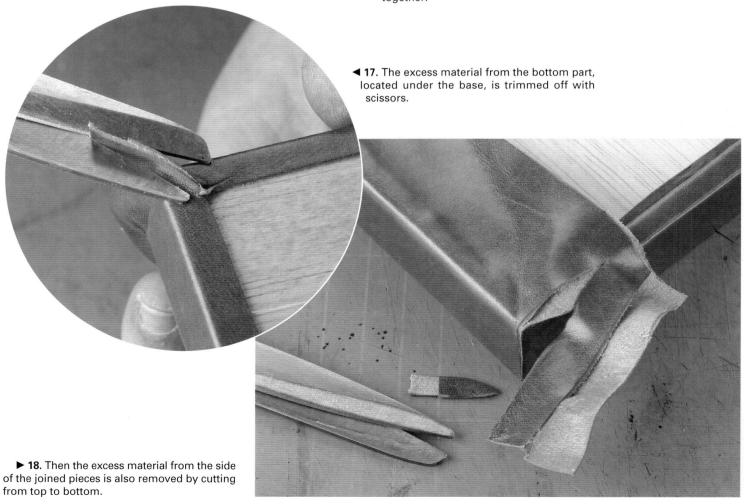

▶ **18.** Then the excess material from the side of the joined pieces is also removed by cutting from top to bottom.

◀ **19.** Now the piece is tucked in by pressing with a bone folder. The same thing is done on the other two sides. To finish, the joints are smoothed by gently tapping with the sheep's foot roller or with a roller. It is left to dry.

▼ **20.** To conceal the joint we apply liquid shoe polish similar in color to the leather. We dry it with a cotton rag to avoid staining the leather.

▲ **21.** We cut out a piece of the commercial board measuring 14 3/8 × 8 7/8 inches (36.4 × 22.5 cm) and we adhere it perfectly centered to the flesh side of the previously cut piece of pigskin with white glue.

▶ **22.** After that we apply rubber cement over the leather and the commercial board. We glue the sides and let them dry.

▲ **23.** The piece for the base is perfectly centered against the bottom part of the tray and marked with the point of an awl.

▲ **24.** We apply rubber cement within the marked area of the wood and on the base.

▲ **25.** The base is adhered following the lines and is secured by pressing firmly with the sheep's foot roller. Then it is left to dry.

▶ **26.** Then the mosaic is placed inside the tray making sure that there is a 3/32 inch (2.1 mm) space on each of the long sides, so it fits the same way all around. The excess material is trimmed off with a blade.

◀ **27.** The interior of the tray is finished off by attaching 3/32 inch (2.1 mm) diameter leather lace with white glue. It is left to dry.

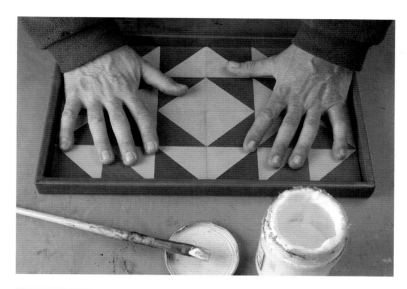

◄ 28. The side joints of the mosaic are painted with liquid shoe polish, and it is glued perfectly centered inside the tray with white glue.

▼ 29. View of the finished tray. Using different colors and arranging the pieces in different ways opens a wide range of possibilities.

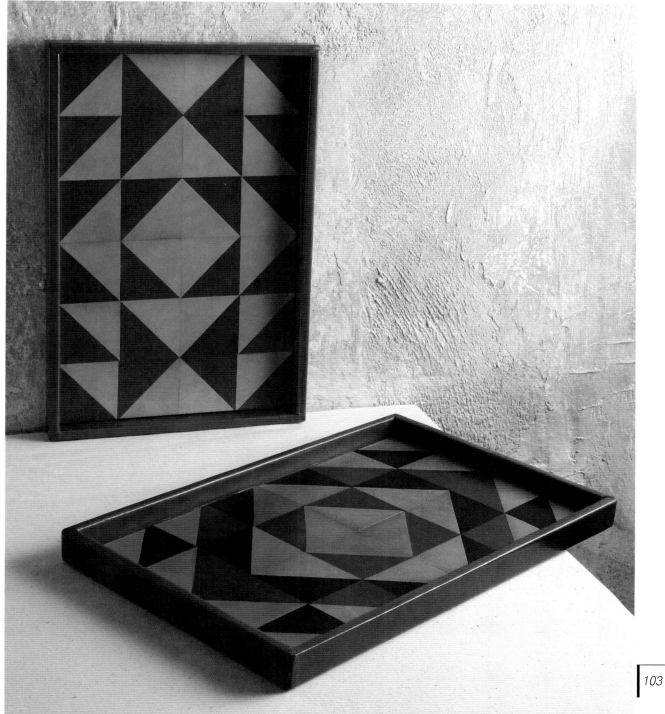

Clock with Appliqués

*I*n this section we will explain how to create a table clock made entirely of sole leather with decorations made of basil and parchment leather. We make a working clock with a piece of sole leather measuring 3/16 inch (0.5 cm) thick, natural in color; the decorative pieces that will be displayed over the entire surface of the clock are made of sole leather with pyrography designs and parchment with punched motifs. This particular piece can be used as a guide for the many design options possible with pyrography and soldering techniques, in other words, with fire engraving, to create individualistic and innovative pieces.

So, the use of heat techniques to work the parchment leather makes it possible to create interesting effects, like this one, to which we can add the traditional components of burnt leather.

◄ 1. The first step consists of designing the clock itself and making the pattern. The total dimensions of the clock will be 13 3/8 × 5 3/4 inches (34 × 14.5 cm), with a 4 3/8 inch (11 cm) diameter face located on the upper part that is held in place by the base and the two side arms that will be bent back. We have a die made from the pattern to create a series of similar pieces, as is the case here, or to use as a guide to cut the piece in the shop with a utility knife.

► 2. A 3 5/16 inch (8.5 cm) circular face is also designed and a plate made to create the print with heat.

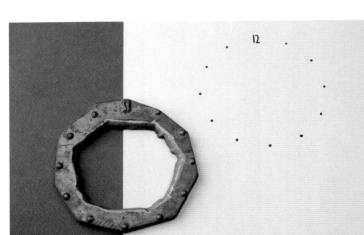

▲ 3. View of the cut leather piece with the face of the clock printed.

► 4. As mentioned earlier, the side pieces will be bent backward to create the rear support for the clock. We mark on the pattern with a fold the lines where the side arms will be bent and that will also frame the clock's face. In this case, the lines from both sides will be set 3 3/4 inches (9.5 cm) from the ends of the piece. We make the pattern for each arm out of cardboard, and this will serve as a guide to cut out the pieces, marking the direction with an arrow.

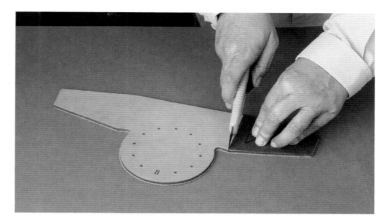

◄ **5.** The inner edges of the piece are beveled.

▲ **6.** We line up the pattern perfectly with the edges of the piece and the piece is scored with a utility knife. We do the same with the other side.

◄ **7.** Next, the scored line is opened by applying slight outward pressure (see page 48), and this step is repeated as many times as needed until both sides can bend backward easily. We will begin by cutting a little bit each time to avoid cutting both sides off completely.

◄ **8.** The side arms are bent backward, making sure they meet perfectly.

► **9.** We make a beveled cut to both sides that serve as supports for the piece with a skiving knife until they are perfectly oblique. The ends of the pieces are placed on a cutting surface, in this case a piece of wood, and cut from top to bottom.

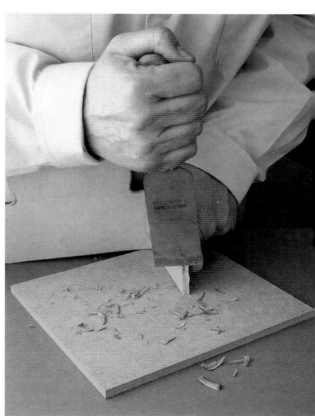

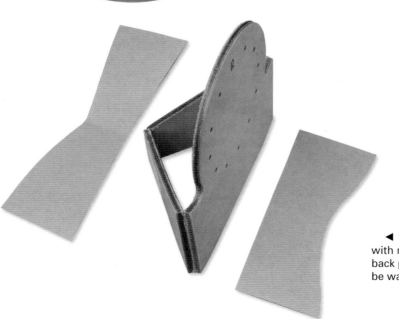

◄ **10.** Now, after holding the piece that forms the clock together with masking tape, we cut out the cardboard patterns for the front and back pieces. They can have any design; in this case, the front piece will be wavy while the back one will be like the support.

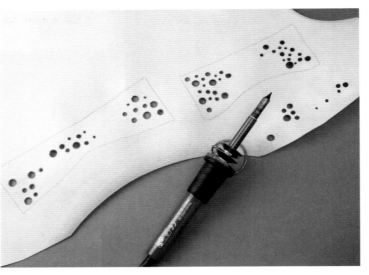

▲ 11. We draw the outline of the pattern with a pencil on the whiter side of the parchment.

◄ 12. We make holes on the piece with a soldering iron pressing with its tip on the upper part of the parchment, and we enlarge them by moving the tip around inside the hole. It is a good idea to do several tests of this process before doing the actual piece to observe how the leather reacts.

◄ 13. The parchment is turned on its back and the ragged edges are eliminated by brushing vigorously with a hard-bristle brush.

◄ 14. We cut out the parchment leather larger in size than the marked pieces.

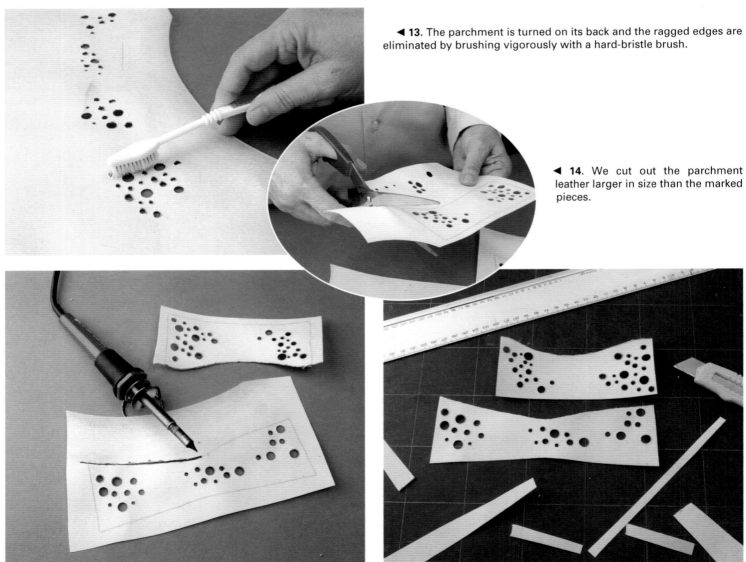

▲ 15. The soldering iron is used again to mark the upper edge of the two pieces. The pieces are cut out along the pencil mark, moving the tip slowly but continuously, without stopping at any time; otherwise it could burn too much and ruin the piece.

▲ 16. Finally, the lower and side edges of the pieces are cut out following the pencil marks with the blade and using the metal rule as a guide.

◄ **17.** We cut out two pieces of sole leather somewhat larger than the two patterns.

► **18.** With the pyrographer set at medium temperature and fitted with a thin beveled tip, we mark the lines guided by a try square. They are marked in two directions forming a thin reticular design.

▲ **19.** The cut-out parchment pieces with the fretwork are placed on the sole leather as if it were a pattern, and we mark the outline with an awl.

▲ **20.** After placing them on a cutting board, we cut with a knife following the outline and guided by a metal rule. Scissors can also be used to cut the insole.

► **21.** Then we apply a layer of white glue on the backside (darker side) of the parchment pieces and we adhere them to the sole. This procedure should be carried out without delay because the parchment absorbs the glue very quickly.

► **22.** To make sure that the leather pieces are properly adhered and completely flat, they can be pressed in a bookbinding press or between two hard surfaces (wood, for example) and placed under weight. It is left to dry for 24 hours.

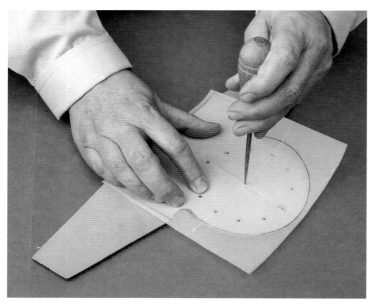

◄ 23. Then we mark the central point of the face where the hands will later be placed. To locate this point, we make a pattern of the clock's face on a piece of tracing paper, tracing the outline of the piece with a pencil. Each side of the paper is folded in half, and where the pieces meet will be the central point of the circumference. This point is marked with a sharp object.

▼ 24. We use a movement piece powered by a battery for the clock. Three little hands are placed, one for the hours, one for the minutes, and one for the seconds. The latter will be thinner than the other two.

◄ 25. The hands are cut to size according to the dimensions of the face. The minute hand should go almost up to the numbers, or in this case the points, and the hour hand will be a little bit shorter.

▲ 26. The hour and minute hands are made of black plastic. To prevent them from contrasting too much against the natural color of the leather, they are sprayed with brown paint. The two hands are secured to a surface with double-sided tape.

▲ 27. The hands are sprayed at close range to achieve a finish that is thick and somewhat textured.

▲ 28. We do the same with the hand for the seconds. It is cut out to size and sprayed with gold paint.

▲ **29.** Now we begin to assemble the clock. First we mark the location of the appliqué designs. We place the pattern on the support perfectly centered with the bottom side of the piece and we mark the perimeter with an awl.

▲ **30.** To ensure proper adherence of the leather, we scrape the outlined surface with a utility knife to remove the grain layer.

◄ **31.** Then, the support arms of the clock are glued with rubber cement.

▼ **32.** After that, the appliqué pieces are glued with the same adhesive, first the piece that goes in front and then the rear support. The pieces adhere instantly and do not allow for any correction; therefore they should be placed exactly where they belong.

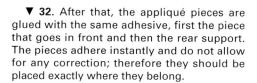

◄ **33.** The excess material from the appliqué pieces is trimmed off with a utility knife so they fit perfectly.

► **34.** Now, we make the hole in the face through which we will insert the piece for the hands. To do this we place the clock on a piece of heavy cardboard and we begin piercing through the back first and then through the front with the hand press fitted with a 3/8 inch (9 mm) diameter drill.

▼ **35.** We apply wax on the edges of the clock with a medium-hair, medium-round brush, not too charged to avoid dripping.

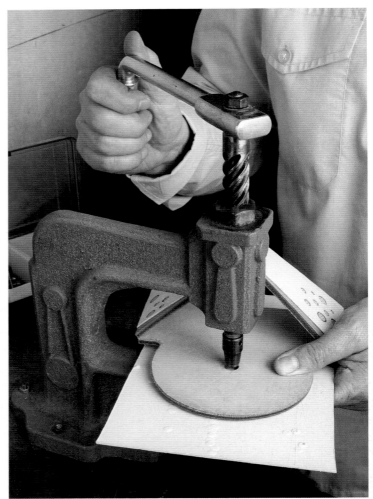

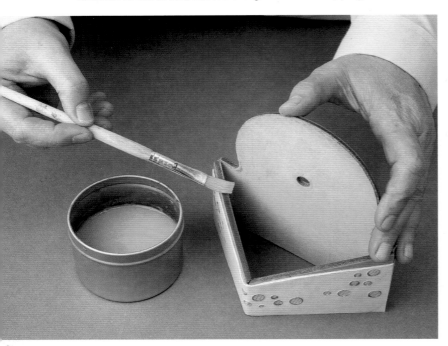

▲ **36.** While the wax is drying, the clock's motor is attached from the back, screwed to the gold nut in the front.

▲ **37.** Next, the hands are attached to the screw that comes through the front.

► **38.** Finally, the edges are finished off with the soldering iron set at medium heat to create a perfectly smooth and even surface.

▼ **39.** View of the finished clock.

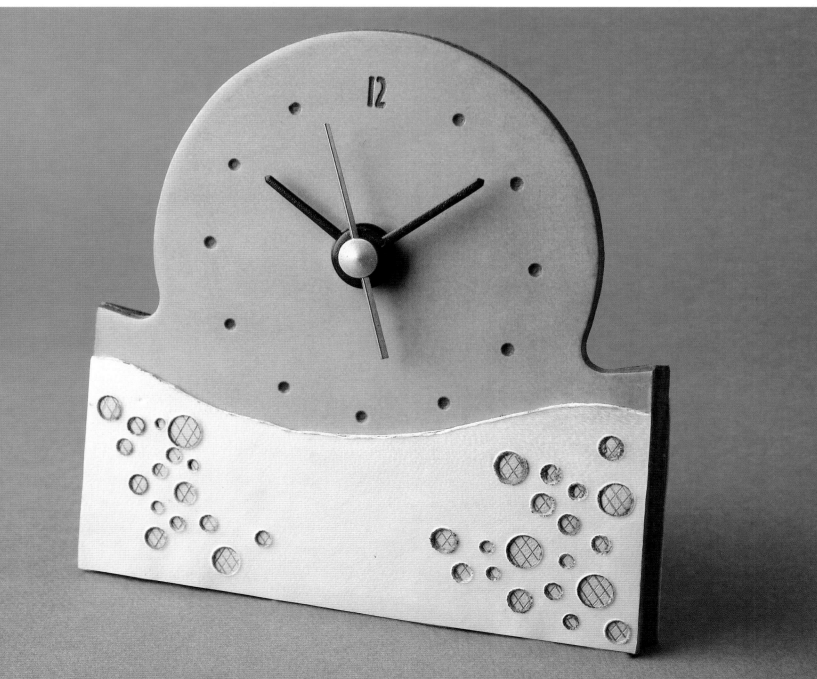

Frame with Sewn Decoration

*I*n this example we present a picture frame with sewn designs. Starting with a medium-density fiberboard (MDF), we make a table picture frame with a sewn motif. We cover the board with a 1/16 inch (1.8 mm) thick piece of cinnamon color vegetable tanned calfskin leather, greased and boarded; the decoration is made of 13 oz. (5 mm) synthetic tanned cow hide and a pre-cut piece of lace. We also make the frame's support with a 13 oz. (5 mm) piece of natural sole leather.

▶ **1.** First, we make a frame measuring 10 1/8 × 11 inches (25.7 × 28 cm) and 1 3/16 inches (3 cm) thick, with a 5 5/8 × 7 11/16 inch (14.3 × 19.5 cm) window, in this case located 2 3/4 inches (7 cm) from the bottom and 1 3/4 inches (4.25 cm) from the sides and top. We also cut a piece that will be the support for the picture from a 3/8 inch (1 cm) MDF board measuring slightly less than the size of the picture window, which will be placed on the back of the frame.

◀ **2.** Using the MDF board as a guide we make the paper pattern for the pieces that will be used to cover the frame. We make a pattern for the calfskin base (which is shown under the frame) that will be used to cover the front, the sides, and the upper part of the frame; therefore it will measure about 13 3/4 × 15 inches (35 × 38 cm). Also, we make another one for the appliqué piece (which is shown in the foreground), measuring about 15 × 7 7/8 inches (38 × 20 cm).

▶ **3.** The frame's back piece is covered with a product used in the shoe industry, which is made of a combination of leather and plastic material. It is extremely durable but thin and has a pleasant appearance that looks like leather, so it is very appropriate for lining. We place the frame on the backside of a piece of this material and we draw the outline with a marker.

◄ **4.** We apply rubber cement inside the marked space (on the underside of the lining) and to the back of the frame and the support for the picture. We put them aside to dry until they are no longer tacky and we assemble them by placing the part of the frame with the support inside, following the marker lines.

▲ **5.** Then the entire piece is placed on the cutting board and the excess lining is cut off with the blade following the perimeter of the board. The blade is placed inside the opening, between the frame and the support for the picture, and the cut is made to separate the piece from the ensemble.

► **6.** We also cut a piece of white bend for the appliqué following the process described in the section of technical processes (see page 48).

◄ **7.** Next, we place the pattern for the base over the flesh side of the calfskin and we mark the edges with a marker. We place it on the cutting board and we cut with a blade guided by the metal rule.

► **8.** Using the MDF as a guide, we mark the outer edges and the window with a marker on the flesh side of the leather. We apply rubber cement on the front side of the frame and the leather, following the lines; then we glue them together.

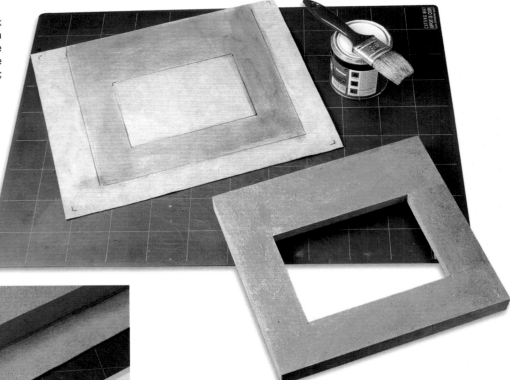

◄ **9.** The corners are covered by placing the leather at a right angle. We mark a line with a marker as the extension of each side, then cut it with a utility knife following the line guided by a metal rule. We cut out the picture window as well.

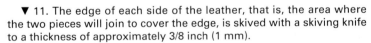

◄ **10.** Then we cut a 1 9/16 × 15 inch (4 × 38 cm) piece of calfskin, which will be used to make the edge of the window's tab.

▼ **11.** The edge of each side of the leather, that is, the area where the two pieces will join to cover the edge, is skived with a skiving knife to a thickness of approximately 3/8 inch (1 mm).

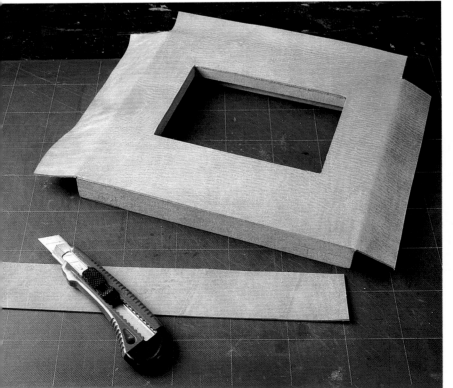

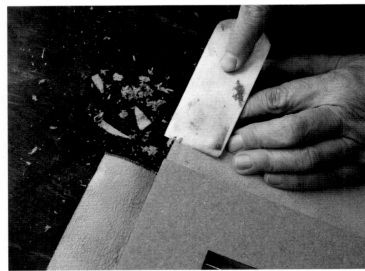

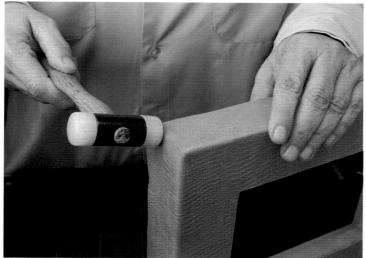

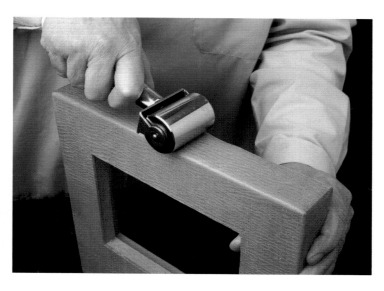

▲ **12.** Next we glue the three sides of the frame (top and sides) with rubber cement. To make sure that the edges are joined together properly, we tap them gently with a nylon mallet.

▲ **13.** The surfaces are flattened and smoothed out with a roller.

▶ **14.** The excess calfskin is trimmed off with a blade by placing it tight against the rear edge of the frame and sliding it from the outside in toward you, while pulling the leather firmly with the other hand to achieve a perfect cut.

▼ **15.** The piece that will become the edge of the window is skived as evenly as possible with the skiving knife down to a thickness of approximately 1/32 inch (1 mm).

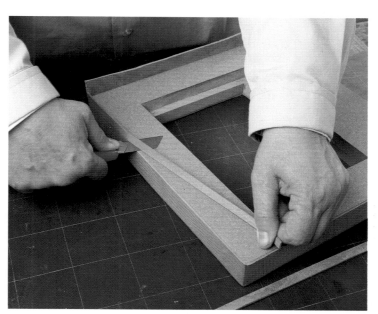

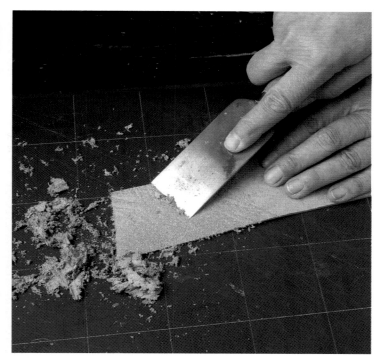

▶ **16.** Then, we apply rubber cement on the flesh side and we leave it to dry for as long as is needed. We fold it in half lengthwise, which will become a 3/4 inch (2 cm) piece and flatten it with the roller.

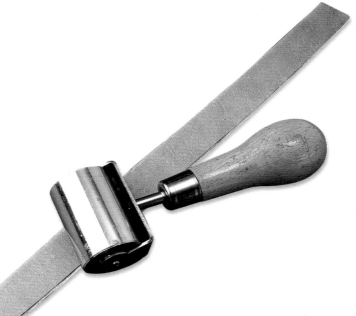

▶ **17.** The edge piece will be placed on the upper part of the window. To make sure it fits the corners perfectly we make a cut inside. We line up the piece on the upper part inside the window, and we mark a line with the marker exactly in the corner of the opening.

▼ **18.** Following the line, we make a perfectly vertical cut without getting to the upper part of the piece and making sure that we cut only one of the sides, that is, not the leather on the underside.

▲ **19.** The piece is folded over with the cut to the outside and is flattened with the nylon-head mallet. We do the same on the other side.

◀ **20.** To make gluing the edge on the MDF support easier, we scrape the surface of the calfskin that has the cuts with the utility knife until the grain is eliminated.

▼ **21.** We glue with rubber cement, placing the edge according to the cuts previously made, and then we smooth it out with the roller. We push the edges at the corners of the window, marking the line with a rounded-point awl.

▼ **22.** Taking the frame as a reference, we make a cut that marks the area that will cover the base and we separate it following the step described for the sole pieces (see page 48). Then, we cut off the excess leather from the window so the edge of the piece fits the support.

▶ **23.** We select the piece that will have the sewn design; in this case it will be 3/16 inch (5 mm) thick, and we place it on the piece to mark the placement of the holes through which it will be inserted. The holes are made on the grain side of the leather using the hand press fitted with a 7/32 inch (6 mm) diameter drill bit.

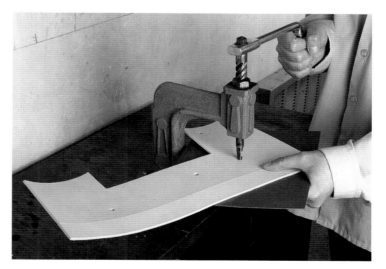

▼ **24.** The holes will mark the trajectory of the lace, which will be inserted through them from the back to the front, as illustrated later.

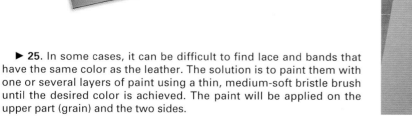

▶ **25.** In some cases, it can be difficult to find lace and bands that have the same color as the leather. The solution is to paint them with one or several layers of paint using a thin, medium-soft bristle brush until the desired color is achieved. The paint will be applied on the upper part (grain) and the two sides.

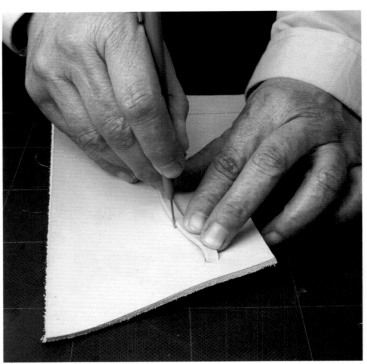

▲ **26.** Once dry, the lace is inserted from behind pushing it alternatively in and out of the holes. We draw the outline of the lace, which will later be carved out, on the flesh side.

▲ **27.** Then, we mark the holes through which the lace that will sew the leather piece will be inserted, with a heavy-duty needle (like the one used for crocheting, for example).

▼ **28.** We pierce through the marked areas with the hand press fitted with a 1/8 inch diameter (3 mm) drill bit on the grain side, the same way we did before.

▼ **29.** Then, the marked area is reduced on the flesh side of the leather (where the lace will be placed) with an edge beveler or French-edge skiving tool until the lace fits perfectly and is flush with the surface of the piece.

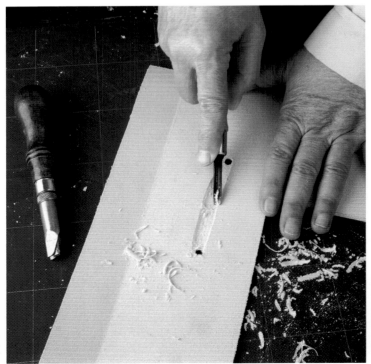

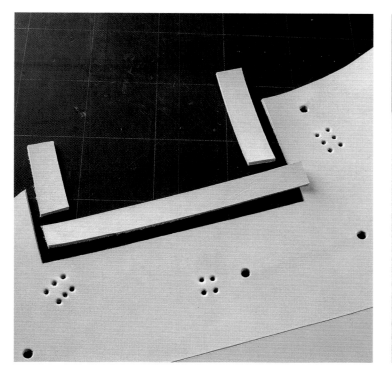

▲ **30.** We cut the bend pieces that will be used to cover the lower and side edges of the window, which will match the top appliqué piece.

▲ **31.** Before assembling the pieces, we will cut down the area on the grain side where the lace will be inserted. Then the lace is inserted making sure that it fits into the reduced area.

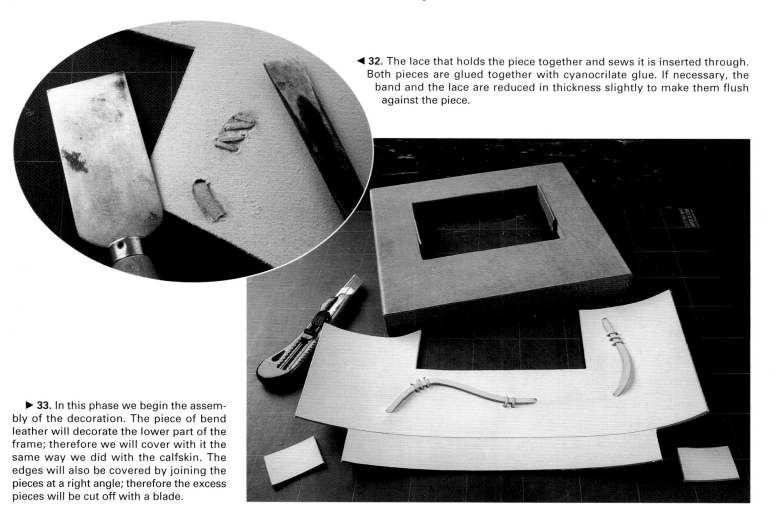

◀ **32.** The lace that holds the piece together and sews it is inserted through. Both pieces are glued together with cyanocrilate glue. If necessary, the band and the lace are reduced in thickness slightly to make them flush against the piece.

▶ **33.** In this phase we begin the assembly of the decoration. The piece of bend leather will decorate the lower part of the frame; therefore we will cover with it the same way we did with the calfskin. The edges will also be covered by joining the pieces at a right angle; therefore the excess pieces will be cut off with a blade.

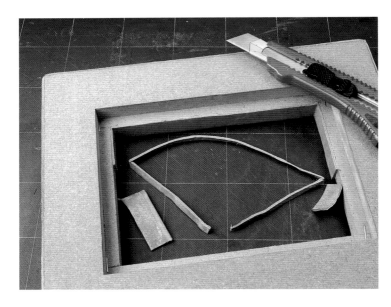

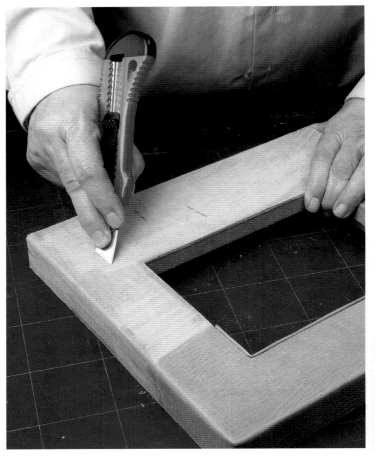

▲ **34.** Taking the appliqué piece as a guide, we mark the inside edges of the window and we cut off the excess; by doing this we make sure that the pieces fit together perfectly. Finally, we cut off the backside of the window's edge.

▶ **35.** We do the same on the front side of the frame, marking the edges of the decorative piece. Then the surface is scraped with the utility knife to eliminate the layer of grain.

◀ **36.** We make small cuts on the sides of the hide following the method described for the lower side of the frame, opening them carefully. Then, the decorative piece is glued with rubber cement: first the front piece, then the lower one, and finally the sides. We also glue the pieces that will cover the inside of the opening, beginning with the bottom side, which will expand the entire length, and then the two sides, that will rest on it.

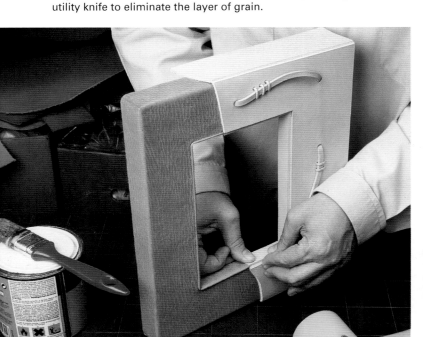

▶ **37.** To finish, we make the back support that will hold the frame. A pattern is made to size with cardboard, in this case measuring 3 × 5 inches (7.5 × 25 cm) with a fold on each side at 9/16 inch (1.5 cm) from the edge and a central one at 4 inches (11 cm) from the previous ones. We cut a piece of natural sole leather with the pattern.

▼ **38.** We make the cuts that will help bend the folds—the central one on the grain side of the piece and the side ones on the flesh side—and they are opened carefully.

▼ **39.** The assembly is completed by attaching with screws the holders that will support the picture and the backing on the underside of the frame (where holes will have been made beforehand).

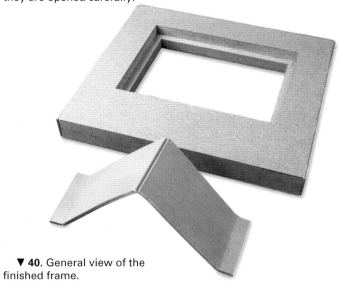

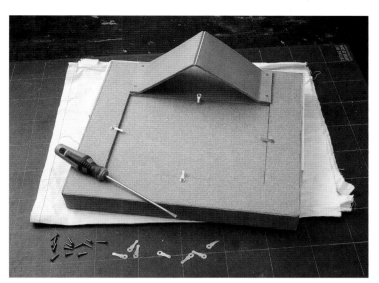

▼ **40.** General view of the finished frame.

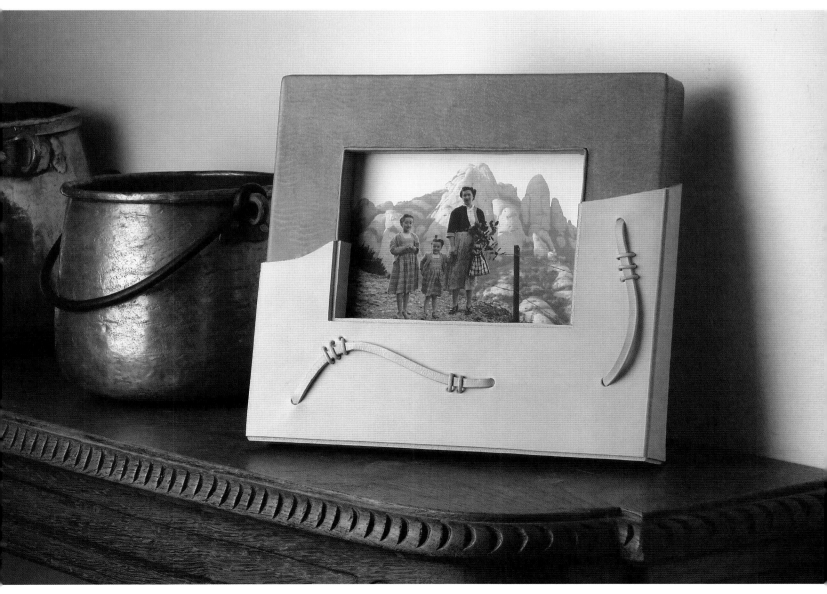

Coin Caddy

*I*n this project we explain the process for creating a table caddy. It consists of a medium-size container, which resembles a bag, with a design that stands for its simplicity and that can be used to store small personal items or strictly for decorative purposes. The piece is made entirely of leather and lined with fabric and has a wooden base to make the piece stronger. We have chosen vegetable tanned calfskin leather in two colors, one dyed tan and the other one black. For the base, a 5/64 inch (2 mm) thick piece of coffee-color pigskin will be used.

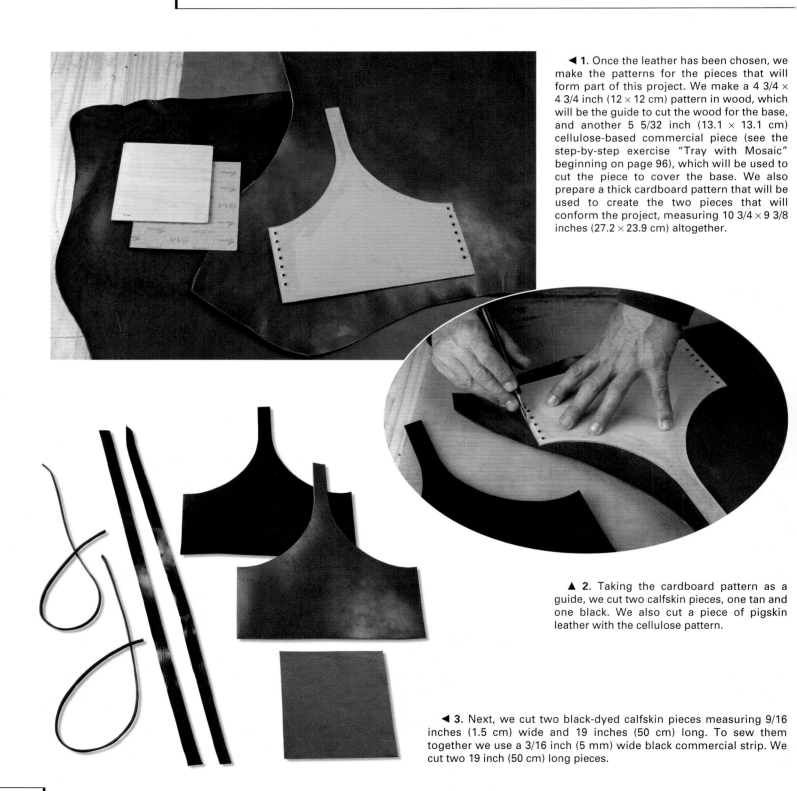

◀ **1.** Once the leather has been chosen, we make the patterns for the pieces that will form part of this project. We make a 4 3/4 × 4 3/4 inch (12 × 12 cm) pattern in wood, which will be the guide to cut the wood for the base, and another 5 5/32 inch (13.1 × 13.1 cm) cellulose-based commercial piece (see the step-by-step exercise "Tray with Mosaic" beginning on page 96), which will be used to cut the piece to cover the base. We also prepare a thick cardboard pattern that will be used to create the two pieces that will conform the project, measuring 10 3/4 × 9 3/8 inches (27.2 × 23.9 cm) altogether.

▲ **2.** Taking the cardboard pattern as a guide, we cut two calfskin pieces, one tan and one black. We also cut a piece of pigskin leather with the cellulose pattern.

◀ **3.** Next, we cut two black-dyed calfskin pieces measuring 9/16 inches (1.5 cm) wide and 19 inches (50 cm) long. To sew them together we use a 3/16 inch (5 mm) wide black commercial strip. We cut two 19 inch (50 cm) long pieces.

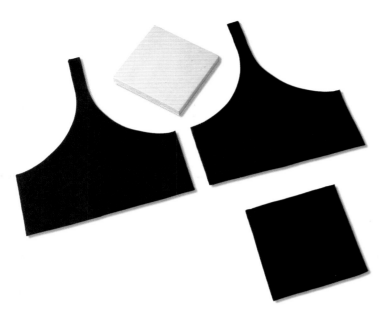

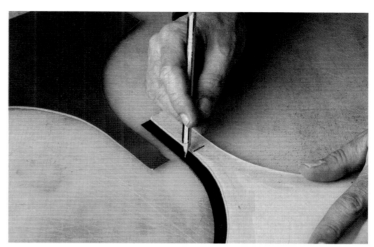

◄ 4. Finally, we cut the pieces for the base and for the lining. With the first pattern we cut a 1/2 inch thick (1.4 cm) piece of fiberboard, then we cut the black lining fabric, which will cover the base, guided by the cellulose piece. Finally, we cut the two pieces of lining fabric for the sides of the caddy with the cardboard patterns.

► 5. The pieces are attached first on the handle side, layering them over. We make a mark on the pattern at 2 3/8 inches (6 cm) from the upper edge, which will serve to mark the joint. This point is traced on to the pieces, flesh side on the tan leather and grain side on the black one, because the first piece will overlap the second one.

► 6. Then, the areas marked on both pieces (flesh side on the tan and grain side on the black one) are skived with the skiving tool down to 1/32 inch (1 mm) thick. The two strips are also skived down to 5/32 inch (0.4 mm).

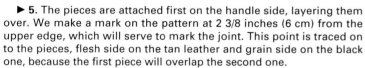

► 7. Now the two pieces are attached by gluing the flesh side of the tan to the grain side of the black piece on the skived area with white glue. It is left to dry.

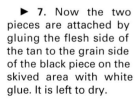

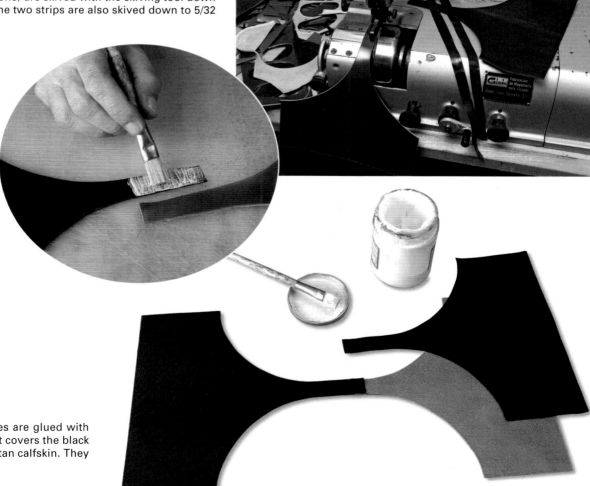

► 8. The two lining pieces are glued with white glue, first the one that covers the black calfskin piece and then the tan calfskin. They are left to dry.

▲ **9.** The placement of the trim is marked with a divider. The opening of the tool is set at 3/16 inch (0.5 cm). With one of the tips flush against the edge of the piece, we move the divider along the grain side of the leather, marking with the other tip the line that will define the border.

▲ **10.** We brush the borders of the trims that will go on the outside of the caddy with liquid shoe polish. The ends of the strips are cut at a 45-degree angle and we dye all the sides with the shoe polish.

▼ **11.** We spread rubber cement on the grain side of the area defined by the divider, where the trim will be located.

▼ **12.** Then, the trim pieces are attached following the lines made with the divider.

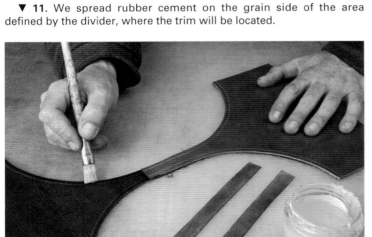

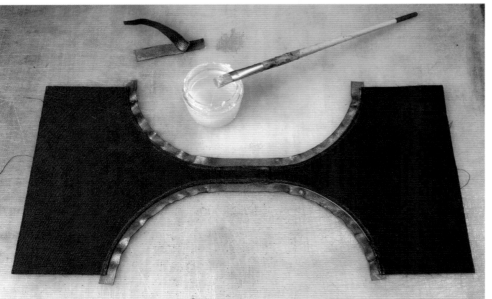

◄ **13.** The trim that goes on the inner side of the caddy is also adhered. It is left to dry.

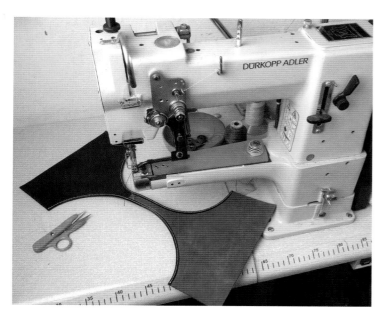

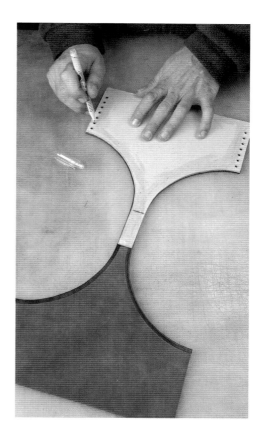

◄ 14. Once the glue is completely dry, the trim is sewn in the middle with a double stitch using white thread on the outside and black thread on the inside of the caddy.

► 15. The holes that will be used to apply the decorative sewn motifs are marked with a pattern approximately 15/32 and 9/32 inch (1.2 and 0.7 cm) from the upper edge. The holes are marked on both sides of the caddy on the grain side, in this case with a silver color marker.

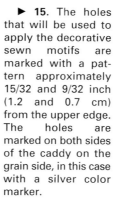

▲ 16. Following the marks, the holes are made with a drill bit 5/32 inch (4 mm) in diameter, piercing from the grain side.

▲ 17. Next, we cover the base by gluing the pigskin on one of its sides with rubber cement and the black lining material on the other.

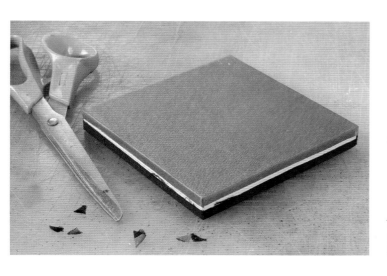

◄ 18. We trim off the excess material from the edges with scissors. The pieces do not cover the sides of the base completely, but this is not a problem because they will not be visible when the caddy is assembled. It is left to dry.

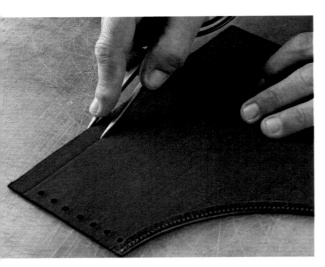

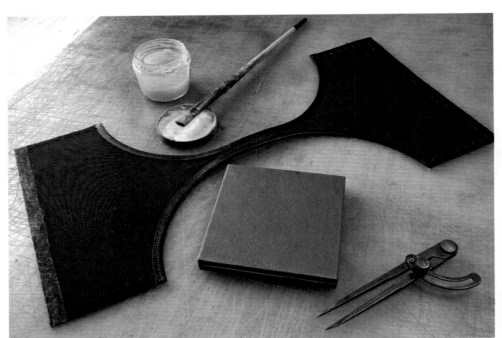

◄ **19.** We measure the thickness of the base with a divider. With one of the tips placed flush against the lower edge of the piece, we slide the divider along, marking a line on the lining with the other tip. This line will define the area where the base will be attached.

► **20.** We apply rubber cement on the defined area, on both sides of the piece.

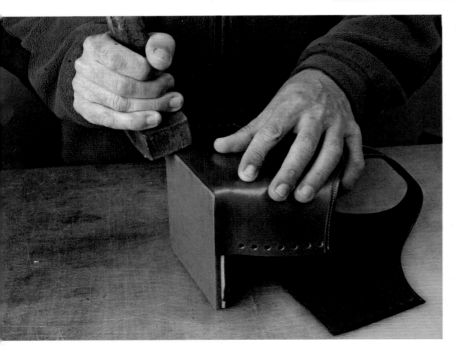

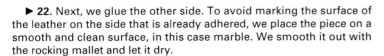

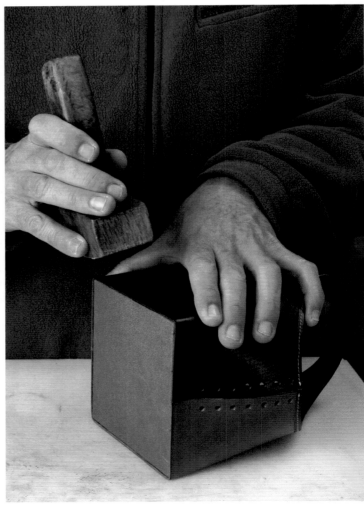

▲ **21.** With the side of the base that is lined with pigskin facing outward, we prepare to glue one of the sides of the coin caddy. To do this, we place the edge centered exactly on one of the sides and we turn it to glue it around the base, making sure that they line up perfectly. We smooth it out with a roller or with a rocking mallet (a wood mallet with a rounded head).

► **22.** Next, we glue the other side. To avoid marking the surface of the leather on the side that is already adhered, we place the piece on a smooth and clean surface, in this case marble. We smooth it out with the rocking mallet and let it dry.

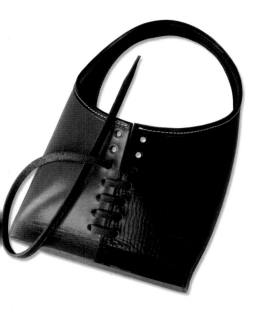

◄ **23.** To finish, the sides are joined together with decorative stitches. The lace is inserted from the back (inside out) through the first hole on the left (tan side), and then it goes through the first hole on the right (black side). Next, it crosses over on the inside to the second hole of the opposite side (tan), the one located above the first one, and comes out in front through the second hole of the opposite side (black). This procedure is followed until the sewing is complete.

► **24.** The sewing is finished off by tucking the ends of the laces under two of the stitches and then cutting off the excess.

▼ **25.** View of the finished coin caddy. Using different-color leathers creates interesting contrasting effects.

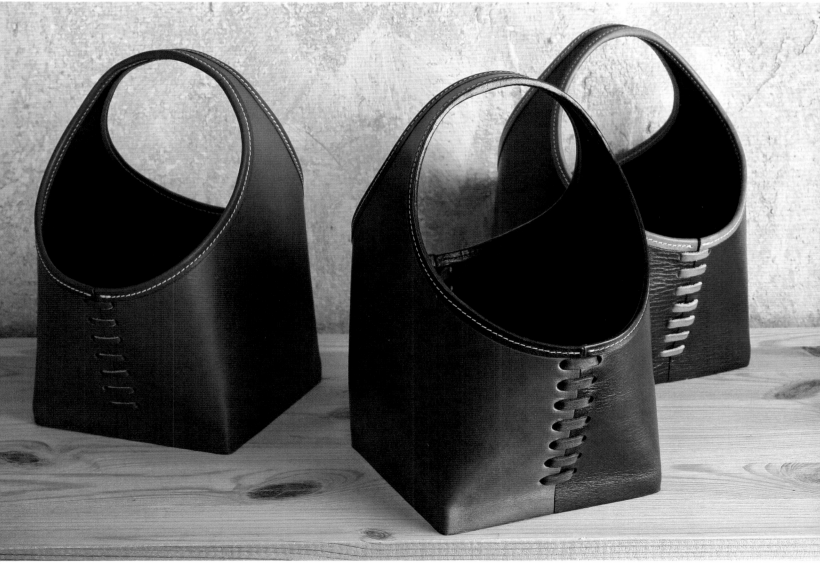

Box with Repoussé

In the following pages we will explain how to make a box with a large embossed design on the lid. Starting with a simple pre-made octagonal wood box, we create the design with the embossed technique and by piercing some areas with awls, which are later painted. The design selected for the decorative motif is from an oil painting on canvas by Sonia Delaunay entitled Color Rhythm, known as grand round board, from 1967, measuring 88 inches (225 cm) in diameter, which is reinterpreted here with the leather working techniques.

In this case, we have used normal 3/64 to 1/16 inch (1.2 to 1.5 mm) matte calfskin, although it would also be possible to make this project with semi-glossy calfskin.

▲ **1.** We purchase a pre-made octagonal box 3/16 inch (0.5 cm) thick and measuring 3 inches (7.5 cm) on the side of the base, 3 5/32 inches (8 cm) on the side of the lid, and 4 inches (10 cm) tall. We select the calfskin piece that will be used to cover the outside of the box and to make the embossed design.

▲ **2.** First, we make the patterns that will be used as guides to cut the calfskin. We place the box on a sheet of construction paper and trace the outline of the base with a pencil. We do the same for the lid.

▲ **3.** We also draw the patterns for the sides of the box and the sides of the lid by making two rectangles, that is, the octagonal shapes in one piece of 3 1/2 × 23 5/8 inches (9 × 60 cm) and 1 1/4 × 25 3/16 inches (3.2 × 64 cm), respectively. All the pieces are cut out leaving a 3/4 inch (2 cm) margin around them.

▲ **4.** Next, we mark the forms in pencil on the flesh side of the calfskin following the outline of the patterns.

▲ **5.** We cut out the pieces with the utility knife using a metal rule as a guide.

▲ **6.** To make the embossed design, first we make an enlarged color photocopy of the painting measuring 6 1/2 inches (16.5 cm) in diameter. Then we trace the design on vegetable paper with a marker.

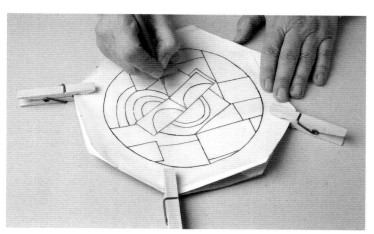

▲ **7.** Using the pattern of the lid's cover as a guide, we cut out the outer perimeter of the traced design to the same size as the piece of calfskin. We also cut out a similar piece from the same pattern on paper and the traced motif is placed centered on the paper, holding it in place with adhesive tape.

▲ **8.** The design is transferred onto the piece of calfskin leather. To do this, first we spray the surface of the leather (on the grain side) evenly with cold water. Then we attach the design to it with clothespins and we transfer the lines (see page 56).

▶ **9.** The design is printed on the grain side of the calfskin leather. After studying the original painting we define the volumetric feeling of the embossed design. We mark on the drawing the areas that will be flush with the surface by shading them with pencil, the areas that will be stippled are identified with a grid, and the white areas will be embossed to give the piece some volume.

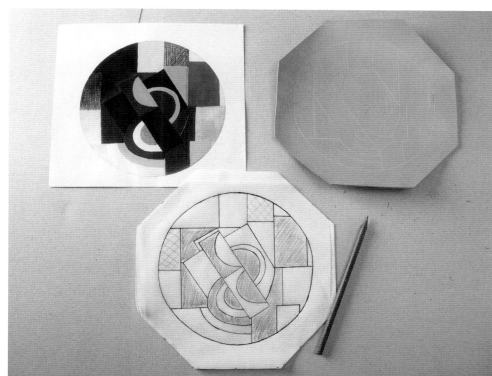

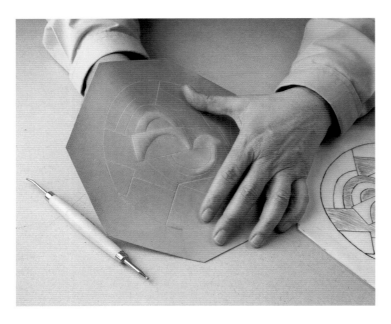

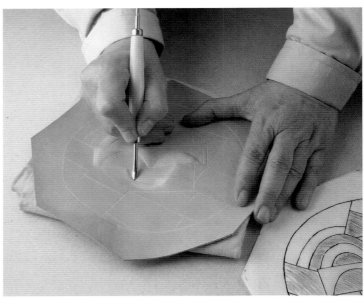

▲ **10.** Using the pattern as a model, we first emboss the areas to form a volume by pressing from the flesh side with a ball-tip embossing tool.

▲ **11.** Then, the shapes are outlined by pressing from the grain side. Each part of the design is marked right against the line that defines them using a modeler that in this case has a diamond shape.

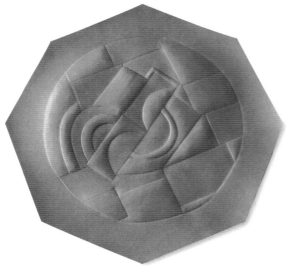

◄ ► **12.** We continue the process by alternating the grain side and the flesh side until the desired volume is achieved (see from page 56 on).

◄ **13.** To stamp the areas marked on the pattern with a grid, we use a large square-tip punch that will create a design with small square shapes. We place the leather on a hard and resistant surface (in this case marble) and we tap gently on the punch with the mallet to avoid piercing through the leather (see page 52).

▲ 16. The areas that have light tones (white, gray, and blue gray) are painted, because we can cover the entire surface with them and conceal the leather's natural color. They are also applied with a touch-up brush.

◀ 14. We apply a layer of white glue on the underside of the design to make the leather harder, which will help keep the shape. It is left to dry for about 12 hours.

▼ 15. We use a variety of media to apply the desired colors and tones. Some areas are painted with dyes applied with a soft, flat, and narrow bristle brush (touch-up brush); others are colored with professional markers that are resistant to light and that do not bleed on the leather.

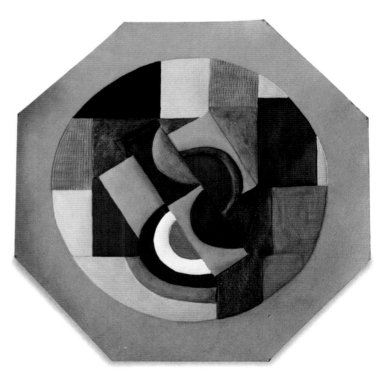

▲ 17. Other areas are left unpainted. This makes the leather stand out against the surrounding colors, emphasizing their volume.

◀ 18. The inside of the box and the lid are painted with green acrylic paint.

131

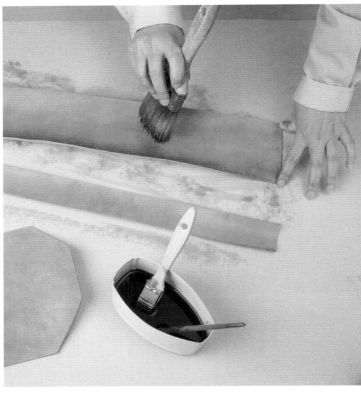

▲ 19. With a household, soft-bristle brush we apply an even layer of carnauba wax dissolved in water (1 part wax to 3 parts water) on the grain side of the remaining pieces and leave them to dry.

▶ 20. A very diluted reddish orange dye is prepared and applied as evenly as possible on the pieces with a medium, soft-bristle household brush. The surface is evened out quickly by tapping gently and repeatedly with a soft, wide household brush, and then it is left to dry.

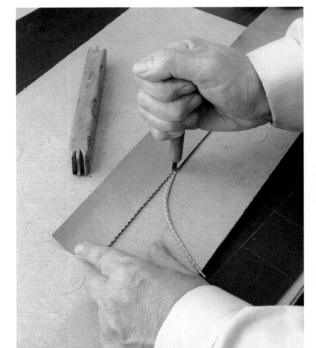

◀◀ 21. The pieces that will be used to cover the sides of the box will be finished off with a fretted edge. The piece is placed on a marble surface with a heavy cardboard, and the design is marked and cut by pressing firmly on the gouge (see page 49).

◀ 22. The central area of each crest is decorated with a decorative stamp. We place the piece on a marble surface and we stamp it using a narrow punch with a round tip. The tapping should be gentle to avoid piercing the leather.

▶ 23. The two finished pieces.

▶ **24.** We dye the edge of the fretted piece with the same product used before to approximate the color of the grain, to prevent it from standing out too much against the overall color of the box. We use a wide household brush, without too much charge to avoid dripping on the grain side of the piece.

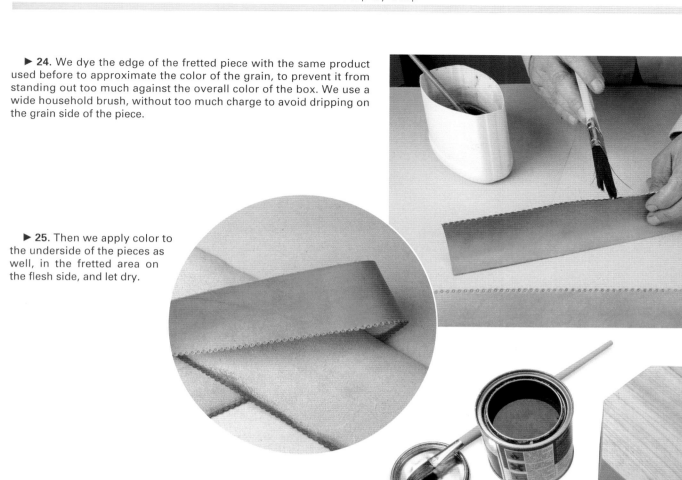

▶ **25.** Then we apply color to the underside of the pieces as well, in the fretted area on the flesh side, and let dry.

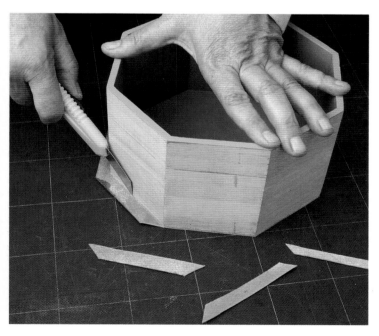

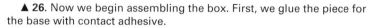

▲ **26.** Now we begin assembling the box. First, we glue the piece for the base with contact adhesive.

▲ **27.** We place the box on the cutting board and trim off the excess material by cutting against the sides with a utility knife.

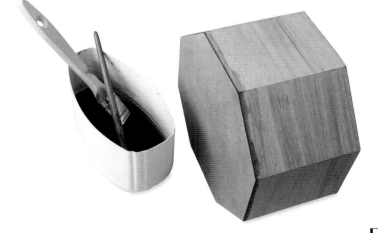

▶ **28.** We paint the edge of the leather piece with a medium round, medium-hair bristle brush without too much charge to avoid dripping. We also apply a small amount over the wood area that is located immediately above.

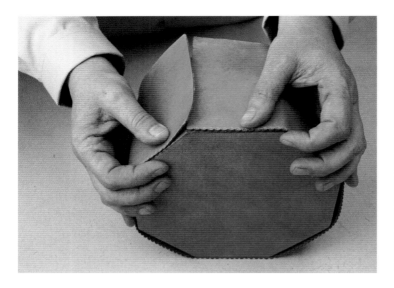

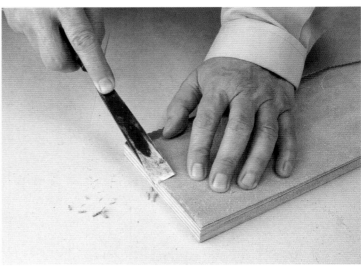

▲ **29.** Next we place the piece over the wood to make sure it fits. If necessary, we can use double-sided adhesive tape to hold the pieces together temporarily while we check; it will later be removed. We cut off the excess material so the sides do not overlap.

▲ **30.** Then, before we cover the side of the box, we skive down one of the sides with a skiving knife. We place the edge on a hard surface (in this case wood) and bevel it on the flesh side with a very sharp skiving knife down to a size of approximately 1/16 inch (1 mm). Then we dye it.

▶ **31.** The piece is glued with rubber cement. We place it perfectly centered against the bottom edge of the wood and glue the beveled side first. Then we continue all around the piece until all the surfaces are covered; it is smoothed out with a roller and left to dry.

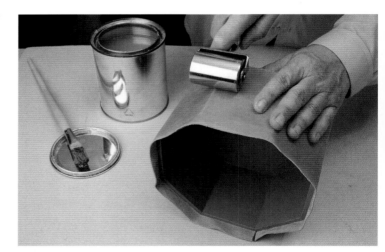

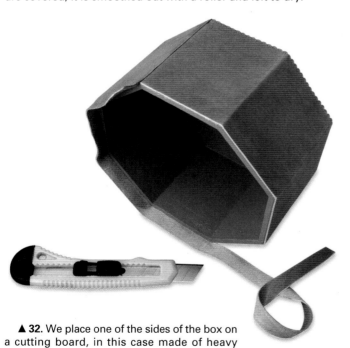

▲ **32.** We place one of the sides of the box on a cutting board, in this case made of heavy cardboard, and we cut the excess leather by sliding the blade against the wood carefully to avoid scratching the paint. We do the same on all sides.

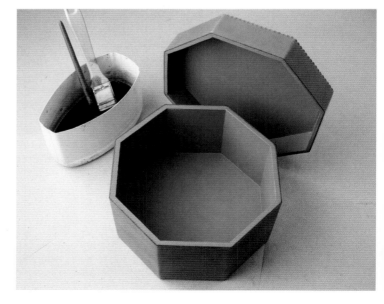

▶ **33.** We repeat the process to cover the lid. First we glue the top (the piece with the design) and then the side with rubber cement, following the previous steps. We dye the cuts, avoiding dripping, and we let it dry.

► **34.** Finally, we apply a layer of carnauba wax over the cuts with a medium round, medium-hair round brush.

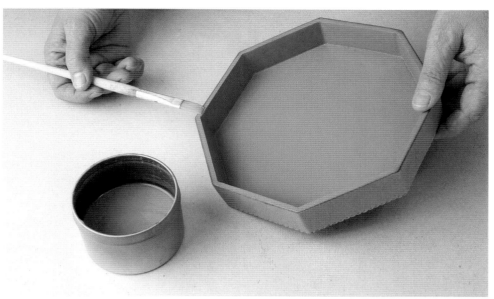

▼ **35.** View of the finished box.

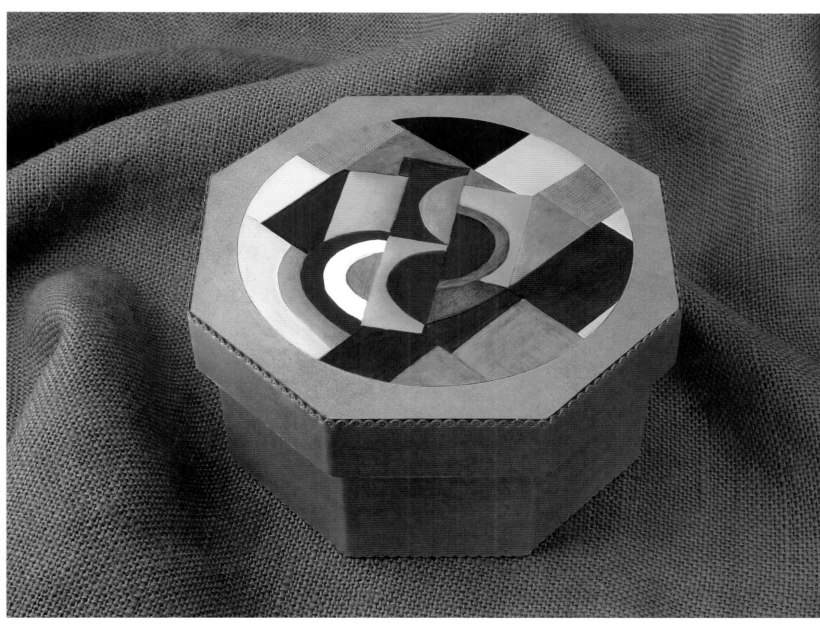

Embossed Album with Appliqué

*I*n this exercise we will demonstrate the complete process for making a photo album. We explain in detail how to make the covers in full grain leather, with the top one decorated with an embossed design inspired by Catalan Modernism. The edges of this binding are complemented with structural stitches that will also be decorative when the piece is finished. Finally, an interesting appliqué is added to the binding area that is an example of the many possibilities that leather offers for creating relief pieces. To make this project we have chosen a 3/64 to 1/16 inch (1.2 to 1.5 mm) piece of natural calfskin with a matte leather.

◄ **1.** After the piece of leather has been selected, we make the boards for the covers. We cut an 8 1/4 × 11 inch (21 × 28 cm) piece to make the bottom cover, a second one measuring 8 1/4 × 10 1/8 inches (21 × 25.75 cm) for the top cover, and another one 8 1/4 × 9/16 inches (21 × 1.5 cm) where the sewn joint will be located, all of them from a 5/64 inch (0.2 cm) thick piece of gray heavy board.

▼ **2.** We also prepare all the pages for the album using the cover as reference. We cut out 25 pages from heavy paper measuring 8 1/4 × 11 5/8 inches (21 × 29.5 cm). We fold each edge 9/16 inch (1.5 cm) over and we adhere a piece of vegetable paper to the side, under the fold. Finally, we punch holes in each one individually with a hand press fitted with a drill bit 3/16 inch (5 mm) in diameter. The holes must be 3/8 inch (1 cm) apart from each other, 1 5/8 inches (4.2 cm) from the top and bottom, and 1 3/4 inches (4.4 cm) from the center.

◄ **3.** Now we make the embossed design to decorate the cover of the album. To do this, we draw the design with markers on vegetable paper. In this case, we recreate a floral motif inspired by modern decorative styles. The total dimensions are approximately 5 15/16 × 5 11/16 inches (15 × 14.5 cm).

▶ **4.** First, we cut two 8 7/8 × 11 7/16 inch (22.5 × 29 cm) pieces of calfskin leather, which will become the top and bottom covers.

▼ **5.** After moistening the grain side of the leather slightly with a spray bottle full of cold water, we place the design with the drawing side facing up arranged as desired (approximately 1/16 inch [1.5 cm] from the sides). We hold it in place with clothespins to prevent it from moving and we go over the drawing with a tracer.

▼ **6.** We emboss the design (see from page 56 on) working from the flesh side to create a relief defining the forms from the grain side.

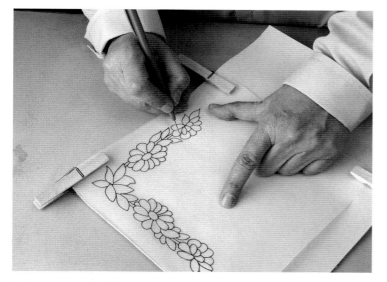

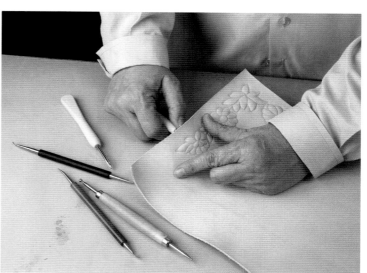

◀ **7.** Embossing recreates the design in relief.

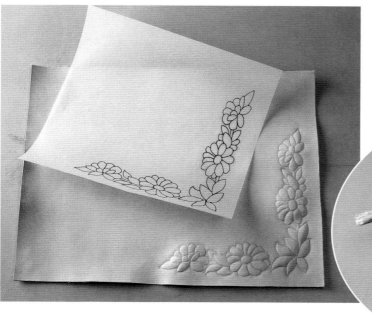

◀ **8.** Then we apply a layer of white glue to the underside of the design, on the flesh side, to give the leather a level of hardness that will make it possible to hold the shape of the relief, and leave it to dry for 12 hours.

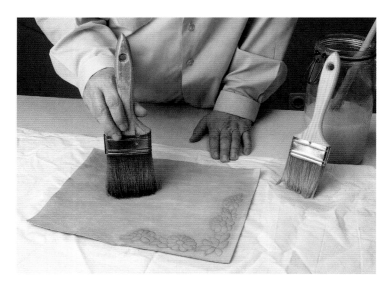

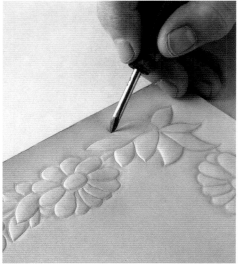

◄ 9. With this the embossing will be finished, ready to be painted. First, we apply an even layer of carnauba wax diluted in water (in a proportion of approximately 1 part wax and 3 parts water) with a wide, soft-bristle brush. Without waiting, the surface is evened out by tapping gently with a household-type soft-bristle brush to avoid leaving brush marks on the leather.

◄ 10. Next, we go over the outlines of the shapes with an awl by marking them with the cutting tip.

▼ 11. With a wide, soft-bristle brush, we apply an even layer of very diluted dye in an orange tone on the grain side of both pieces. Without waiting for them to dry, we even out the surface by tapping repeatedly and gently with a wide brush. They are then left to dry.

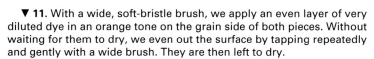

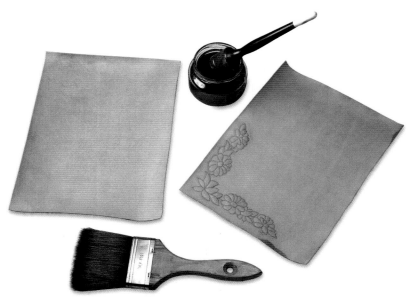

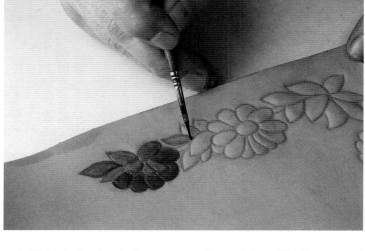

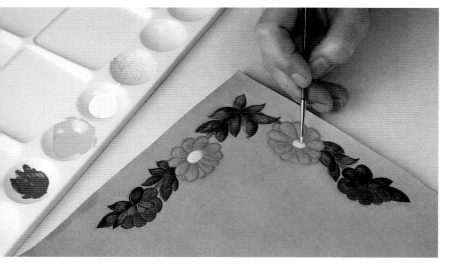

▲ 12. To paint the design we use paint and dyes. The flowers and the leaves are painted with different dyes applied with a very thin, round soft-bristle brush (touch-up brush).

◄ 13. Now we paint the central buds of the yellow flowers. We have made the mix beforehand to achieve the desired color because pure white would contrast too much with the other colors.

▶ **14.** We place a piece of heavy cardboard on a support (in this case wood) with the edge aligned with the border and we sand the edge with fine-grain sandpaper fitted on a wood block. By doing this we make sure that there are no sharp edges giving the binding a cushioned effect.

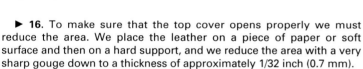

▶ **15.** Then we place the card-board on the flesh side of the top piece, the one with the embossed design. We place the larger board measuring 8 1/4 × 10 1/8 inches (21 × 25.75 cm) at a distance of approximately 3 inches (7.5 mm) from the three sides, and then the other piece measuring 8 1/4 × 9/16 inches (21 × 1.5 cm) at a distance of 3 inches (7.5 mm) from the first one. We mark the location of both by tracing the inside line with a marker. This area will function as a hinge to open the cover.

▶ **16.** To make sure that the top cover opens properly we must reduce the area. We place the leather on a piece of paper or soft surface and then on a hard support, and we reduce the area with a very sharp gouge down to a thickness of approximately 1/32 inch (0.7 mm).

▲ **17.** Now we make the holes for the sewing of the outer perimeter of the album. To do this we mark their location on the top area of the cover against the edge of the piece with the creaser; then we mark their exact location with the spacing wheel (see page 70).

▲ **18.** Now we cut out the pieces that will be used to line the inside of both covers, according to the previous dimensions, except that one of them will be 1/4 inch (6 mm) larger to allow for the opening of the top cover. We apply wax and dye them following the process previously described.

▶ **19.** We make the holes from the grain side with a hand press, fitted in this case with a drill bit 5/32 inch (4 mm) in diameter. The holes will be located at 3/16 inch (5 mm) from the edge and approximately 3/8 inch (1 cm) apart from each other. First we make the holes on the upper part of the top piece; then we pair this with the inside piece of the cover grain to grain and trace the exact placement with a marker, maintaining the 1/4 inch (6 mm) wide gap for the three holes on the right side. We make the holes where marked.

▼ **20.** We mark the location of the holes following the procedure explained, and we make the holes of the inside pieces, one of which is reduced the same way as the cover, following the same procedure.

▶ **21.** At this point we begin assembling the covers. First we attach the cardboard pieces to the flesh side of the top cover with rubber cement, making sure they are perfectly aligned following the lines of the reduced area. Then we glue the inside piece, the one that has the reduced area, trying to match the holes.

▲ **22.** Then we slide the ballpoint modeler along the joint of both pieces of cardboard to make sure that the leather fits perfectly.

▶ **23.** We flatten out the entire area. To do this, we press the joint with the handle and then press the roller to flatten the surface.

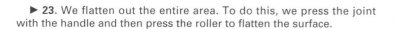

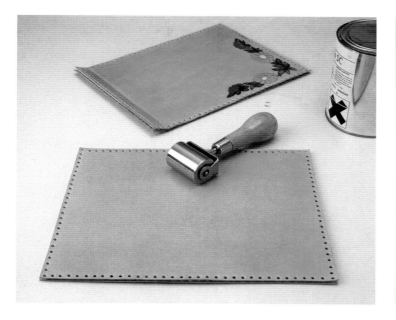

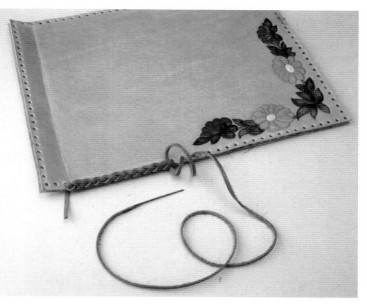

▲ **24.** Finally, we glue the back covers of the album as well with rubber cement, press it with the roller, and let them dry. As before, it is very important to make sure that the holes are aligned.

▲ **25.** To join the covers together we do a cross-stitch (see page 73) with an 1/8 inch (3 mm) wide lace. We insert it from the same side several times to create a double stitch.

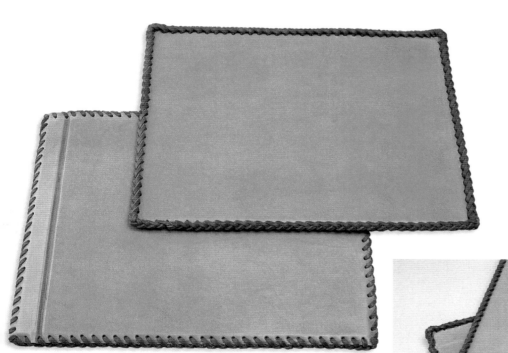

◀ **26.** The result is a very durable and decorative design with stitches forming a crisscross design.

▶ **27.** We apply a layer of carnauba wax over the sewn area with a brush that is not overly charged to avoid dripping on the leather. Then it is left to dry.

► **28.** Next we make the decorative appliqué pieces, which in this case are two bellflowers. We draw a 1 3/4 × 1 3/8 inch (4.5 × 3.5 cm) three-lobed triangular pattern for the petals, and a 2 3/8 × 1 3/16 inch (6 × 3 cm) oval one for the leaves with two cuts 9/16 inch (1.5 cm) apart.

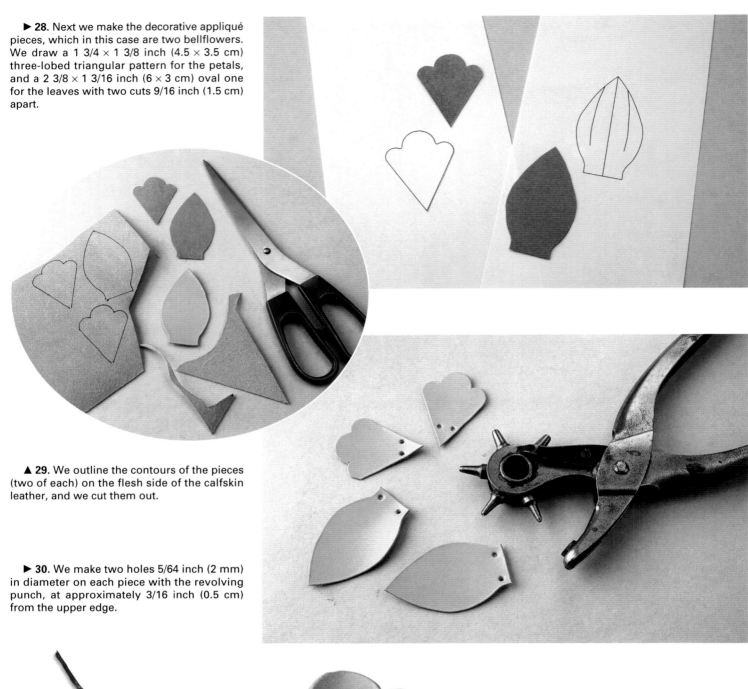

▲ **29.** We outline the contours of the pieces (two of each) on the flesh side of the calfskin leather, and we cut them out.

► **30.** We make two holes 5/64 inch (2 mm) in diameter on each piece with the revolving punch, at approximately 3/16 inch (0.5 cm) from the upper edge.

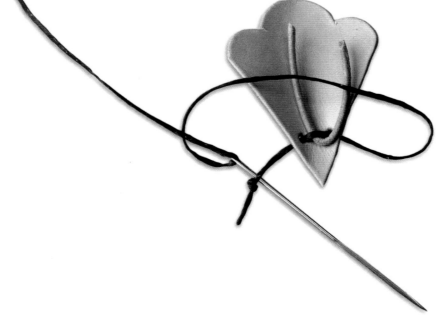

◄ **31.** We cut a small 5/64 inch (2 mm) thick piece of lace and place it inside the petal piece. Then, we sew it with waxed thread with the grain side facing in.

▶ **32.** We sew both flowers with the lace, and then we tie a knot to make sure they are held together tightly.

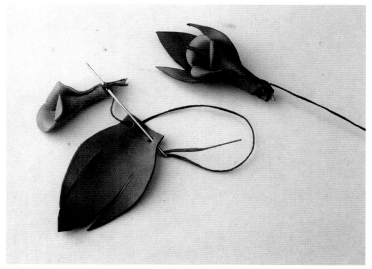

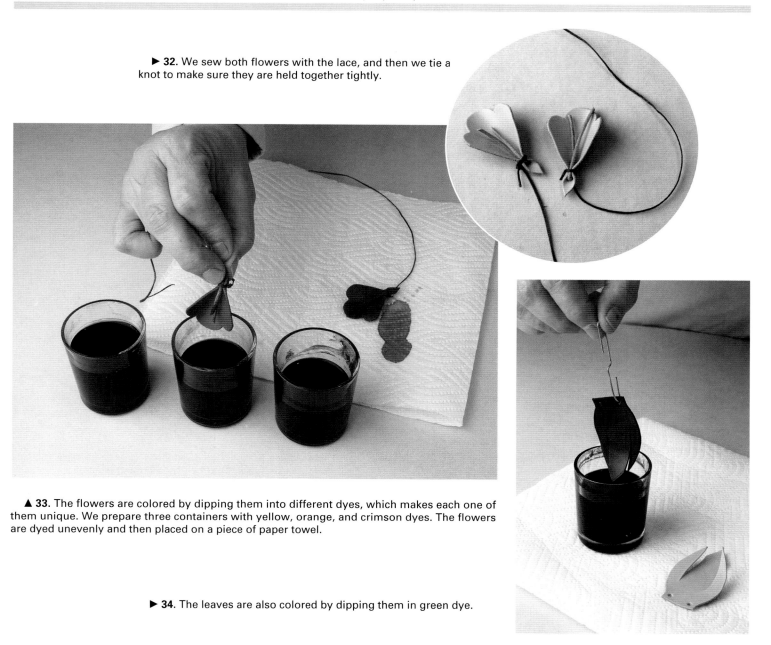

▲ **33.** The flowers are colored by dipping them into different dyes, which makes each one of them unique. We prepare three containers with yellow, orange, and crimson dyes. The flowers are dyed unevenly and then placed on a piece of paper towel.

▶ **34.** The leaves are also colored by dipping them in green dye.

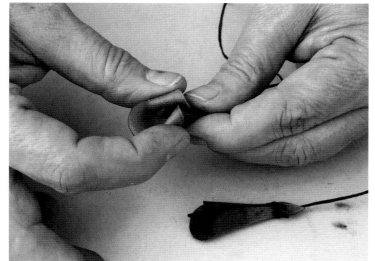

▲ **35.** Before they dry completely, we shape the flower lobes. Then they are left to dry.

▲ **36.** When the leaves are completely dry, the flowers are sewn with the grain side facing in. We make a knot to make a strong joint.

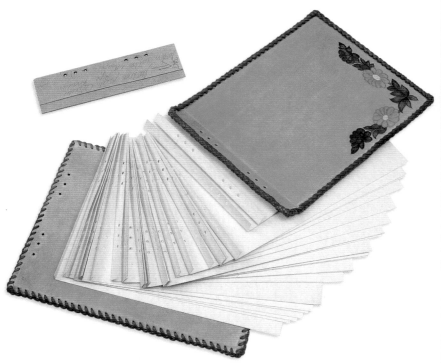

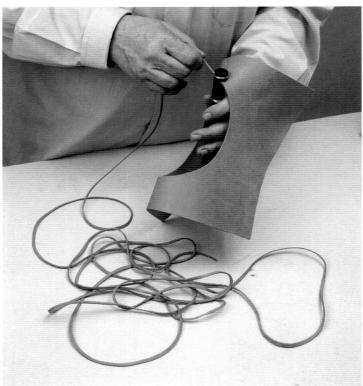

▲ **37.** The final phase of the process is putting the album together. First, we make the holes on the cover where we will insert the lace that will keep the piece together. To do this, we make a cardboard pattern as a guide to mark the location of the holes, which will be lined up with the pages as explained in step two. The pages are assembled.

▲ **38.** We make a 5/32 inch (4 mm) cord out of calfskin for the lace with the lace-making tool. The cord should be at least 55 inches (140 cm) long.

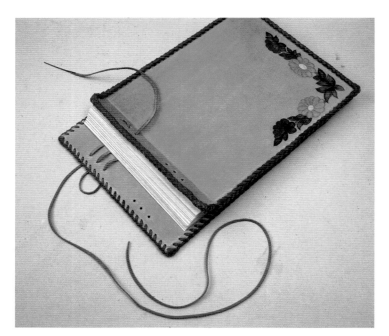

◄ **39.** To make the bow, first we do the backside. We insert the lace through the upper hole of the underside to the front, cross it over, and insert it through the next one back. It crosses over to the next one again and comes out of the front through the last one. We leave it like this and proceed with the other side, with the three holes of the lower part.

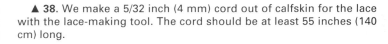

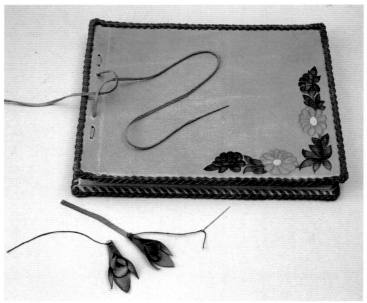

► **40.** We sew a small 3/16 inch (5 mm) thick strip of leather to the end of one of the flowers, and then we sew the other end to the other flower. We then trim off the excess thread.

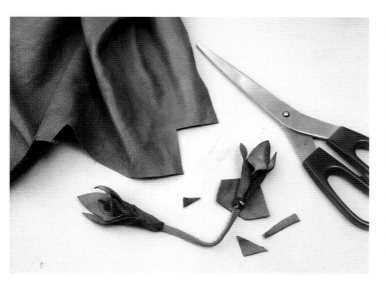

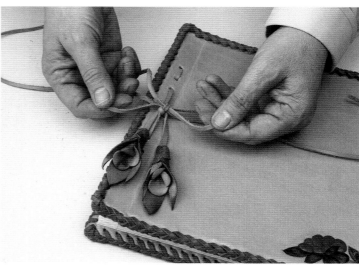

▲ 41. To finish off the piece we cut out a small piece of green suede and attach it around the base of the leaf with rubber cement.

▲ 42. Finally, we place the appliqué inside the knotted part, and the bow that holds the piece together is completed. We cut off the excess trim.

▼ 43. The finished album.

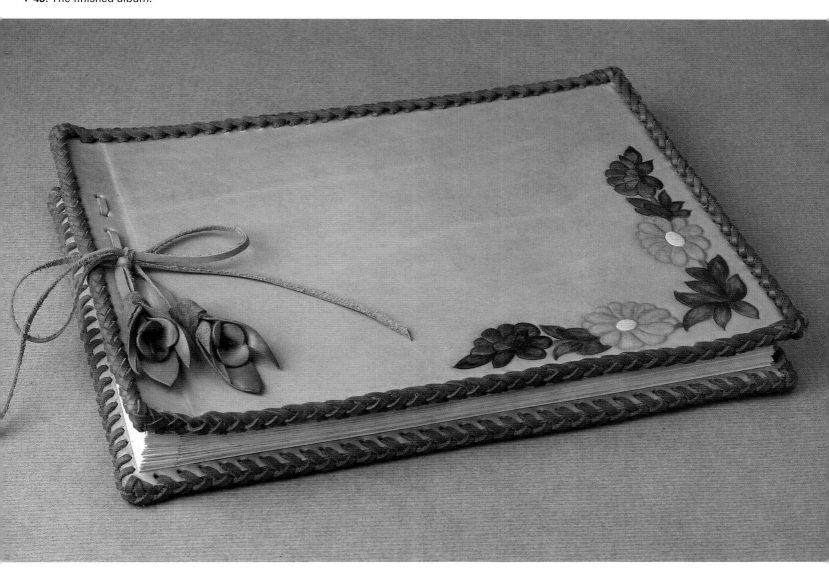

Mirror with Landscape

*I*n this project we explain how to make a wall mirror decorated on its lower part with a layered landscape made of leather. This is a decorative piece that has an appliqué made of wood covered with different types of leather 5/64 inch (2 mm) thick, and a central element, the tree, created with techniques from other disciplines. This is an excellent example of the use of chromium tanned leather, which does not offer as many possibilities as the vegetable tanned leather (see page 28), but also of how to recycle, in this case pieces that have some tanning or color irregularities. The recycling of material that has problems or defects opens up a world of possibilities for creating unique pieces.

▶ **1.** The first step is to make the piece for the mirror, which will be 33 7/8 × 17 3/4 inches (86 × 45 cm). On a piece of paper we draw the elements for the decorative design, a landscape with a tree in the center. Then we make life-size patterns for the mountains out of heavy cardboard.

▼ **2.** We cut out several fiberboard pieces: two 1/4 inch (6 mm) thick and 3 5/16 and 4 13/16 inches (8.5 and 12.2 cm) high, respectively, for the first two levels of the composition; and two others 3/8 inch (9 mm) thick and 7 7/8 and 10 1/4 inches (19.9 and 26 cm) high for the third and last levels of the composition. All the pieces will be 17 5/8 inches (44.7 cm) long. Next, we mark the outline of the patterns with a marker. The ones for the first levels are 5 9/16 and 10 1/4 inches (14.1 and 26 cm), respectively.

▼ **3.** We cut out the shapes along the marked lines with a fretted saw fitted with a blade for cutting wood. We place the board on the workbench and hold one of its sides in place with a clamp. We cut out the piece, beginning at one end and following the marker line.

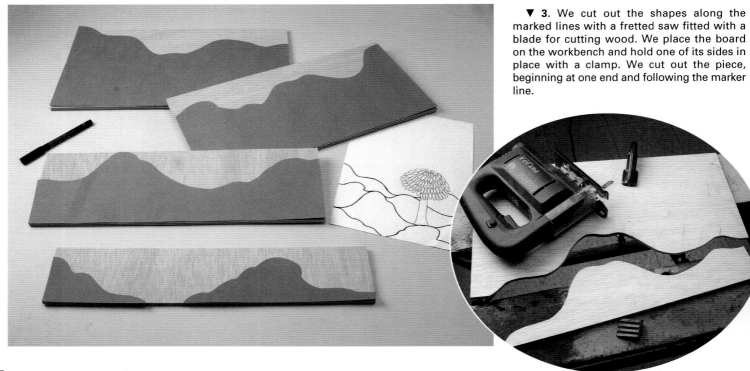

▶ **4.** To round off the pieces that will later become the mountains, we sand the upper outline of each piece. First, we sand the pieces that will be placed in the foreground, and when they are finished we place them against the wood on the second level and outline the contour with the marker. Then we sand the piece that will form the second level without touching the marks. The same procedure is used for the two remaining pieces.

▼ **5.** Then, we proceed with the central design of the landscape, the tree. To create the leaves, we choose from among different green and beige chromium tanned leather. Next, we cut out different pieces with the scissors in double-leaf shapes of various sizes, between 2 3/8 and 2 3/4 inches (6 and 7 cm) long overall.

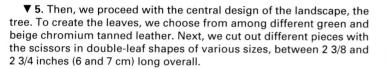

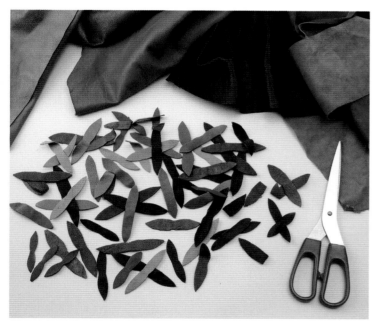

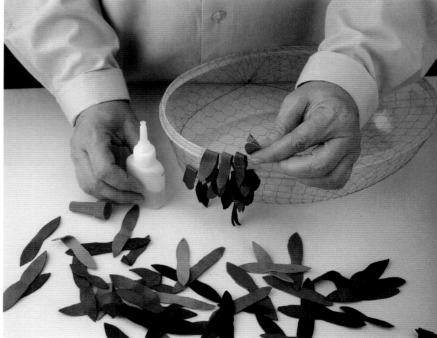

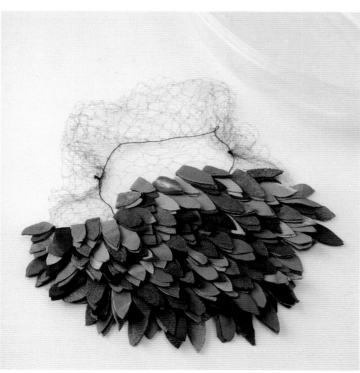

▲ **6.** To create the treetop we use a hair net as support for the leaves. We open the net and place it completely extended over a container with a very large opening, in this case a plastic tray, which serves as the support. We glue the leaves of one of the sides in order around the net's threads with cyanocrilate glue. First, we insert the leaf from behind the thread, and then we glue it in the front with a small drop of glue, making sure we do not touch it with our fingers.

◀ **7.** We glue the leaves to make sure that they are perfectly layered on top of each other.

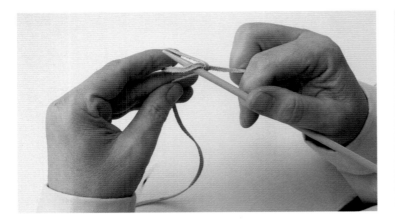

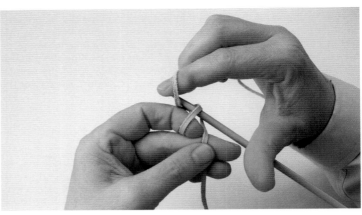

▲ 8. The tree trunk is covered with a knit material made with a knit stitch (also called garter stitch or moss stitch), knitted with 1/8 inch (3 mm) wide leather lace. We begin by casting the stitches on the needle. To do this, we hold the needle with the right hand and the lace with the left, leaving a section of loose lace approximately 8 1/4 inches (21 cm) long. We form a loop between the thumb and the index finger through which we insert the needle.

▲ 9. We slip the index finger of the left hand through the loop and with the index finger of the right hand we yarn the working lace around the needle from bottom to top and from left to right.

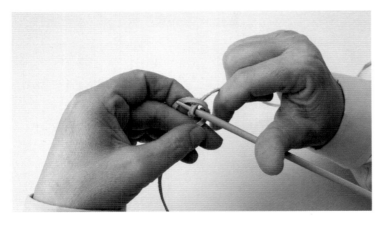

▲ 10. With the index finger of the left hand we bring the loop in front of the needle and pass it over from below while tensing the working lace firmly with the right hand.

▲ 11. Then, by pulling on the lace with the left hand, we make the first slip knot.

▲ 12. We repeat the procedure until the ten stitches of this knit piece are completed.

▲ ▲ 13. The stitches are always pulled from front to back. We hold the needle with the stitches with the left hand and pull the needle in the right hand through the first loop from front to back. With the index finger of the right hand we wrap the lace around the needle from behind. We pull the right needle out slightly and slip the old stitch off, pulling it to the front. This procedure is repeated until we get a 6 5/16 inch (16 cm) long piece. We leave five stitches on the stitch holder, knit one side, and then the other. The end is trimmed off and glued with cyanocrilate adhesive.

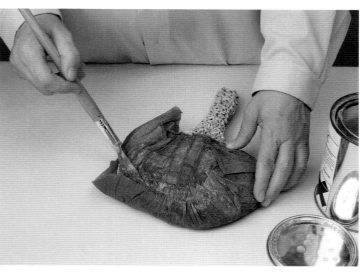

▲ **14.** We make the support for the 1 inch (2.5 cm) wide tree trunk with wire mesh filled with twine, and we cover it with the knitted piece, sewing the joint on the rear with wax thread. Next, we prepare the support for the treetop by making two oval pieces out of papier mâché, measuring no more than 5 1/2 × 6 7/8 inches (14 × 17.5 cm) with one rounded side and the other flat. Then we cover them with green tissue paper, glued on with white glue.

▶ **16.** We cover the treetop with the leaves. We slip the mesh onto the treetop, making sure that the leaves stay in the front part, and we tug firmly until the piece fits snuggly. The entire piece is secured in place by sewing the mesh on the back with wax thread.

▲ **15.** We find the appropriate placement for the tree trunk and insert the upper part of the support between the flat sides of the papier mâché pieces, adhering it with white glue. Next, the sides of the tissue paper are glued onto the piece with rubber cement, covering also the front side of the treetop.

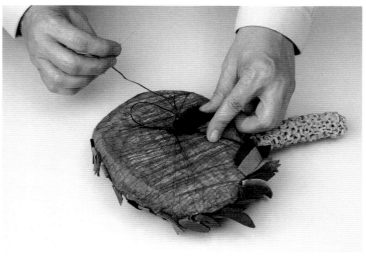

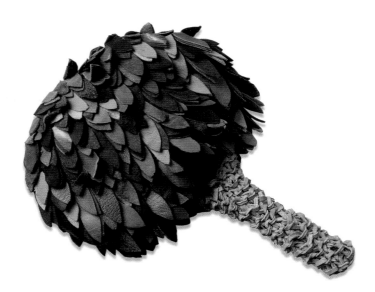

▲ **17.** Here we see the 11 7/16 inch (29 cm) tall tree with approximately a 1 3/16 inch (3 cm) wide trunk .

▶ **18.** Using the tree as reference, we cut out the area of the third layer where the trunk measuring approximately 3 3/4 × 1 3/16 inches (9.5 × 3 cm) will be located, at 6 1/2 inches (16.6 cm) off the right side. Then, we skive 5/32 inch (4 mm) off the last layer measuring the same and placed exactly at the same location. This will provide the perfect fit for the piece in the composition.

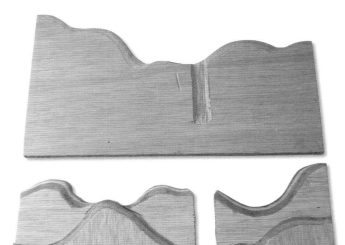

◄ 19. At this point we begin the covering process. We select the leather; in this case we have chosen a dark gray piece of leather that has a few tanning irregularities, surface cracking, for the mountains located in the foreground. We cut out with the scissors two pieces a little bit larger than the wood, and we mark the outline of the wood with its front part (with the sanded edges) pressed against the flesh side of the leather using a marker.

▼ 20. We apply contact glue in the front part of the wood and the flesh side of the leather, inside the marked areas.

► 21. We glue the leather to the fronts of the wood pieces followed by the edges. To fit the leather around the wood's edge we trim it first with a blade and then we fold it over.

▲ 22. When all the edges are glued, we trim the excess leather until it is perfectly flush against the wood.

◄ 23. To cover the wood that forms the third level of the composition we follow the process described using beige chromium-tanned leather. This time we place the flesh side out to create a different look from the other pieces and color variation. Next, we make an inverted Y shape cut on the flesh side of the leather for the tree.

◄ **24.** We cover the wood for the mountain located on the second level with the light gray chromium-tanned leather that has a dyeing irregularity, some areas of darker color. Finally, we cover the mountain in the background with dark yellow leather that has a dark crackled effect done on purpose.

► **25.** Overall view of the appliqué pieces.

◄ **26.** We make the support for the mirror out of 3/8 inch (1 cm) thick, 33 7/8 × 17 3/4 inch (86 × 45 cm) fiberboard with a beech veneer. To minimize the weight of the piece we have made four rectangular openings 2 3/8 inches (6 cm) apart from each other and from the top, and 7 7/8 inches (20 cm) off the bottom edge.

◄ **27.** Next, we finish off the edges of the mirror with 5/64 inch (2 mm) thick vegetable-tanned leather in natural color. We cut two strips measuring 35 1/2 inches (90 cm) and two 19 9/16 inches (49 cm) long and 1 inch (2.5 cm) wide. They are aligned perfectly and glued with contact cement to the sides of the support, making sure they are flush against the back.

◄ **28.** The excess leather is trimmed off with a blade making it match with the perpendicular from the other side. We do the same with the other edges.

► **29.** When the pieces are finished off, we purchase a 1/8 inch (3 mm) custom cut mirror measuring 28 3/8 × 17 3/4 inches (72 × 45 cm). We trim the excess leather to fit the mirror and up to 10 1/4 inches (26 cm) on the lower part.

151

▲ **30.** To bypass the mirror's change in height and to make sure that the appliqué pieces fit perfectly on the support, we add with contact cement a 1/8 inch (3 mm) thick 5 1/2 × 17 3/4 inch (14 × 45 cm) piece of plywood between the mirror and the sides.

▲ **31.** We trim the excess leather as we did before to make it flush with the wood surface.

▶ **32.** Finally, we mount the decorative pieces by gluing them together with contact cement. In this case we begin with the bottom piece, followed by the pieces located in the foreground. First we place the third level over the bottom one and mark the outline with the tip of a gouge, then we raise the grain of the leather with a blade within the confines of the marks to ensure proper adhesion. We apply contact cement in that area and place the piece on it.

▼ **34.** To finish, we glue on the mountains in the foreground. To make sure that the pieces are properly adhered, we tap gently with a nylon mallet over a piece of scrap leather to avoid marking the surface. We glue the piece on the support with contact cement and the treetop onto the mirror with silicone.

▼ **33.** We do the same with the piece for the third level of the compositions, applying the glue inside the slit and on the back of the tree as well. Then we proceed with the second level of the composition.

▼ 35. We secure the piece by driving screws through the back. First we make the holes with a drill somewhat smaller in size than the screws. It is important that the screws be a little bit shorter than the overall thickness of the piece to prevent them from breaking through the front.

▶ 36. General view of the finished mirror.

Gallery

◀ Rex Lingwood. Untitled, 2000. Sculpture in leather. 15 × 7 × 12 5/8 inches (38 × 18 × 32 cm).

▶ Mar Cadalso. *Taforal,* 2003. Vegetable tanned cowhide. 27 1/2 × 13 3/4 × 7 7/8 inches (70 × 35 × 20 cm).

▼ Luces Montoya, *Fortaleza y fragilidad en el ser humano* (Fortitude and fragility in humans), 2004. Hollow human figures in parchment leather on a volcanic rock surface. Buried for 15 days. Man 70 7/8 inches (180 cm), woman 64 3/8 inches (163 cm) tall. Series of 7.

▼ Juan José García Olmedo. *Utopía I*, 1999. Iron sulfide and acrylic on leather worked with *guadamecí* details. 64 3/8 × 64 3/8 inches (163 × 163 cm). Photograph by Calixto Hidalgo.

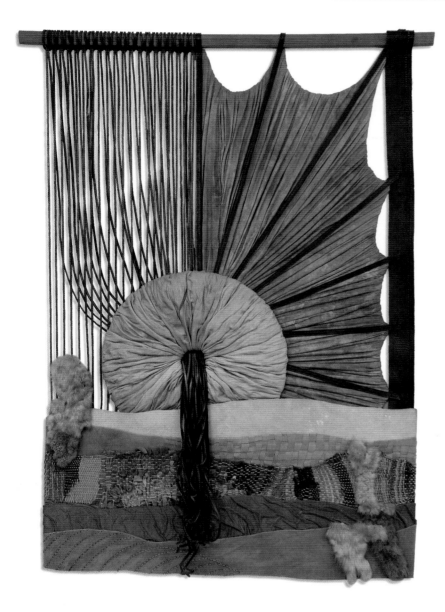

▲ Maria Teresa Lladó i Riba, *Ponent,* 1990. Tapestry made of goatskin, split leather, lambskin, and hides, woven on the loom, sewn, modeled by torsion and folded, finished with glazing. Support made of batting, cardboard, and wood. 65 3/8 × 43 5/8 inches (166 × 110 cm).

▼ José Luis Bazán, Artenazari. *Cuencos hondos* (Deep bowls), 2006. Molded grain calfskin. 3 3/4 × 10 5/8 inches (9.5 × 27 cm) in diameter and 1/8 to 3/16 inch (3 to 5 mm) thick.

◄ Dalia Marija Šaulauskaité. Crosslink 1–4, 2004–2005. Leather, metal, and acrylic. 70 × 70 inches each piece (80 × 80 cm).

◀ Dalia Marija Šaulauskaité. *Despaced 1–4,* 2005. Leather, metal, and acrylic. 39 × 71 inches (99 × 180 cm).

▶ Juan Antonio Fernández Argenta. Bookbinding of the book *Parabolas y circunloquios del Rabí Isaac Ben Jehuda* (Parabolas and Circumlocutions of Rabi Isaac Ben Jehuda), by José Jiménez Lozano, 2003. Binding in printed full grain cowhide, with imprinted vegetable fiber appliqués and color film lines. Labeled with bronze movable type. 13 3/4 × 19 inches (35 × 48 cm).

▼ Enrique Moreno, *Bufón,* 1995. Theater mask of embossed leather made out of a single calfskin piece, stuffed with batting and sheepskin, metal bells. 8 3/4 × 9 7/8 inches (22 × 25 cm).

▶ Maria Teresa Lladó i Riba. Guest book of the Igualada City Hall, 2006. Cardboard support and veneer, bound in vegetable tanned full grain unfinished semi-glossy cowhide, formed and embossed with appliqués. 21 1/4 × 16 3/8 × 4 3/4 inches (54 × 41.5 × 12 cm).

◀ Miguel Díaz de Castro. Reproduction of the work *Corrientes* (Currents) (original by Bridget Riley, 1964), 1995. Engraved and dyed leather. 31 × 27 inches (79 × 69 cm).

▼ José Luis Bazán, Artenazari. *Nazarene Jewelry Box*, 2006. Modeled calfskin leather on the grain side, aluminum knob. 4 3/8 × 6 1/2 inches diameter (11 × 16.5 cm) and 1/8 inch thick (3 mm).

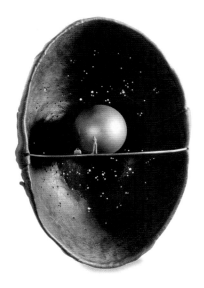

◀ Luces Montoya. *Un cuento para Valeria* (A story for Valeria), 2004. Leather, iron, soils. 11 × 8 5/8 × 8 1/4 inches (28 × 22 × 21 cm). Series 7. Sculpture selected to represent Colombia in the TOYAMURA International Sculpture Biennale, 2005, Japan.

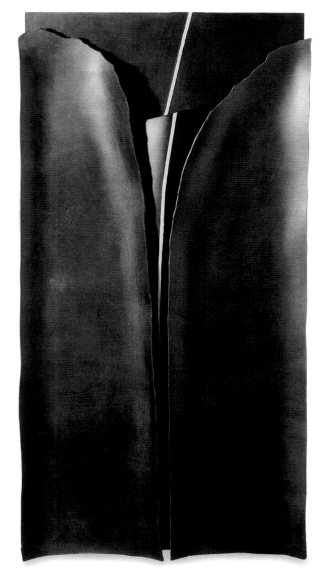

▶ Juan Ignacio Martínez Escó. *Trencament XIV*, 1986. Mixed techniques on leather. 64 × 33 inches (163 × 84 cm). Photograph by A. de Avalo, J. M. Roset, and E. Marsol.

▶ Ana Serra García. *Necklace, bracelet, and hair brooch,* Lola series, 2005. Vegetable-tanned hide, dyed by immersion and burnished. 1 3/16 × 1 3/16 inches (3 × 3 cm). Photograph by Manuel Suárez Barreiro.

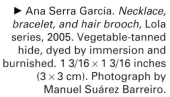

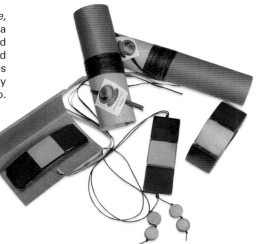

Glossary

Butt. This refers to the part of the leather from the dorsal and lumbar region of the animal. It is the most homogenous part in respect to thickness and structure, and also the most compact and most valuable.

c

Cordovan. Vegetable tanned goatskin (with sumac) that results in a high quality material, thin and elastic, flexible, soft, very durable, that can be worked and decorated with a great variety of techniques.

Chromium Tanned. A tanning process that uses chromium salts, a mineral tanning agent. Skins and leathers tanned with chromium have different characteristics from the vegetable tanned products. Their greatest advantage is their ability to accept dye of many different colors, and a large number of finishes are also possible. They are of limited use in the studio because some techniques cannot be used with them. The tanning process uses heavy metals in small concentrations that can be bad for the environment, but nowadays they are easily treated.

d

Die. A template or metal form with sharp edges used for precision cutting leather.

e

Embossing. The technique of marking the surface of natural color leather with tools using heat and water, to create motifs of a darker color and with a slight bas-relief.

f

Ferreteado. This is a Spanish technique where lines and textures are drawn on gilded and polychrome leather with a stylus to create relief and different tones.

Finish. The surface treatment applied to leather with specific treatments to give it different qualities, depending on what it will be used for, and to give it an attractive appearance so it can be sold. The function of these treatments is to improve the leather and give it special properties on the grain side as well as the flesh side.

Flesh Side. The underside of the leather, the opposite of the grain. This is the lower part of the dermis, the reticular zone of the skin that would cover the endoderm.

g

Gilded. Leather covered with gold leaf, and by extension leather covered with silver leaf that was later covered with a yellow varnish to look like it was gilded.

Grain Side. The top surface of the leather, or the dermis, which has a characteristic texture of the pores visible on the surface after the hair has been removed. Each type of animal has a particular grain pattern.

Guadamecí. A leather working technique, specifically sheepskin, that begins with gold or silver leaf followed by the addition of polychrome and decorated with the *ferreteado* technique.

i

Imprinting. The technique that is based on working the leather on the grain side pressing with awls and hot dies and pyrography.
Incision. A slit in the surface of the leather made with a cutting instrument.

l

Leather. The skin of a mature or fully developed animal after it has been tanned. Generally, leather does not have hair; the word skin is used when speaking of furs and hair-on leather.

Liquid Polish. A mixture of liquid ingredients, based on waxes, oils, and some petroleum derivatives, that is used for polishing shoes.

m

Molding. Leatherworking technique that uses molds to shape the leather into different forms.
Mosaic. This is the technique of applying or juxtaposing skins and leathers of different colors, looks, textures, and qualities to create a design.

o

Outlining. A technique related to repoussé and polychrome, where designs are chromatically differentiated from the background. This is done by cutting into the grain and later using dyes.

p

Patina. Tone and color that leather acquires over time.
Piercing. Work done by boring holes in the leather or cutting out pieces to create different designs and motifs.
Pigments. Finely ground colored substances used to color other materials. They can be inorganic (minerals or artificial), or organic (of animal or vegetable origin), or even mixtures of the two.
Polychrome. Leather painted with various colors.
Pyrography. A technique of marking the leather surface with heat, burning it to create design motifs in darker tones.

r

Repoussé. This is a technique of creating relief in leather by causing one or several designs to stand out in three dimensions. The process is used to work both sides of the leather.
Rocking Mallet. A mallet made entirely of wood with a rounded head that is used for pressing and smoothing leather lining and covering projects.

s

Stamping. The technique of working leather from the grain side where the design is outlined with incisions and relief is created by stamping or flattening certain areas.

t

Tack. The belts and straps and other effects that are put on horses so they can pull carts, be ridden, or carry loads.

Tanning. A group of chemical processes that use various products to stabilize leather, making it an imperishable, durable, and esthetically attractive material. There are a large number of tanning materials: grease, silicon, oil, formaldehyde, alum, sulfur, chromium, vegetable, combinations of minerals and organics, depending on the product or products required.

v

Vegetable Tanned. A tanning process that uses vegetable agents like bark, wood, fruit, and leaves of different plants. These substances determine the leather's color. It is easy to work using many techniques in the studio, but it is limited in the ability to take dye and color.

Further Reading
and acknowledgments

GRANT, Bruce. *Leather Braiding.* Cornell Maritime Press, 1980.

GRONEMAN, Chris H. *Leather Tooling and Carving.* Dover Publications, 1974.

STHOLMAN, Al, Patten, A.D., and Wilson, J.A. *Leatherwork Manual.* Tandy Leather Company, 1984.

MAGUIRE, Mary. *Craft Workshop: Leatherwork.* Southwater, 2005.

MICHAEL, Valerie. *The Leatherworking Handbook.* Cassell Illustrated, 2006.

WEST, Geoffrey. *Leatherwork.* Crowood Press, Ltd., 2005.

The authors would like to thank:

Parramón Ediciones, María Fernanda Canal and Tomás Ubach for the trust they put in us for this project. Also to Joan Soto and to the entire team at Nos & Soto for their dedication and good work.

The institutions that have collaborated:

Museu de l'Art de la Pell de Vic
Arquebisbe Alemany 5, 08500 Vic
www.ajvic.ed

Museu de la Pell d'Igualada i Comarcal de l'Anoia
Dr. Joan Mercader, s/n. 08700 Igualada
www.aj-igualada.net/editables/visitar/interes/museu

Escola UIniversitària d'Enginyeria Tècnica Industrial d'Igualada
UPC
Plaça del Rei, 15. 08700 Igualada
http://www.anota.net/artcamps

The individuals and professionals who have helped us generously and who have contributed their valuable technical advice:

Anna Bacardit, Andreu Colomer Munmany, Felip Combalia, Jordi Enrich, Félix de la Fuente, Rosa M. Junyent, Francesc Lladó, Pere Marí, Elena Martí, Antoni Palmés, Magí Puig, Montserrat Solà, Anna Soler, and Jaume Soler.

The companies who have contributed generously:
BASF CURTEX
Ctra. Del Mig, 219, 08907 L'Hospitalet de Llobregat
www.basf.es

Curtidos Gràcia, S.A.
Montmany, 38-42, 08012 Barcelona
www.curtidosgracia.com

Curtidos Magín Puig
Sant Antoni de Baix, 98, 08700 Igualada

Manufacturas del cuerto Eugenio Gabarró
Sant Francesc, 3, 08700 Igualada
eugeniga@yahoo.es

The collaborating artists:

José Luis Bazán, Artenazarí
www.artenazari.com

Mar Cadarso
marcadarso@hotmail.com

Miguel Díaz de Castro. Taller de cuero Jorongo
jorongolpa@hotmail.com

Juan A. Fernández Argenta
jfargenta@hotmail.com

Juan José García Olmedo
olmedo@web.cajasur.es

Rex Lingwood
http://makersgallery.com/rexlingwood

María Teresa Lladó
www.mteresallado.net

Luces Montoya
http://lucesmontoya.com

Enrique Moreno
http://perso.wanadoo.es/emorenomask/

Dalia Marija Saulauskaité
dmsaul@takas.lt

Ana Serra. Medialua
Serra-medialua@wanadoo.es